No Such Thing as Silence

YALE UNIVERSITY PRESS NEW HAVEN & LONDON

No Such Thing as Silence

John Cage's 4'33"

Kyle Gann

Published with assistance from the Louis Stern Memorial Fund.

Set in Janson type by Tseng Information Systems, Inc.
Printed in the United States of America.

Library of Congress Cataloging-in-Publication Data
Gann, Kyle.
No such thing as silence : John Cage's 4′33″ / Kyle Gann.
p. cm. — (Icons of America)
Includes bibliographical references and index.
ISBN 978-0-300-13699-9 (hardcover : alk. paper)
1. Cage, John. 4′33″, no. 1. I. Title.
ML410.C24G35 2010
784.18′9—dc22 2009031472

A catalogue record for this book
is available from the British Library.

This paper meets the requirements of
ANSI/NISO Z39.48-1992 (Permanence of Paper).

10 9 8 7 6 5 4 3 2 1

ICONS OF AMERICA

Mark Crispin Miller, *Series Editor*

Icons of America is a series of short works written by leading scholars, critics, and writers, each of whom tells a new and innovative story about American history and culture through the lens of a single iconic individual, event, object, or cultural phenomenon.

The Big House
STEPHEN COX

Andy Warhol
ARTHUR C. DANTO

Our Hero: Superman on Earth
TOM DE HAVEN

Fred Astaire
JOSEPH EPSTEIN

Wall Street: America's Dream Palace
STEVE FRASER

Frankly, My Dear: Gone with the Wind *Revisited*
MOLLY HASKELL

Alger Hiss and the Battle for History
SUSAN JACOBY

Nearest Thing to Heaven: The Empire State Building and American Dreams
MARK KINGWELL

The Liberty Bell
GARY NASH

The Hamburger: A History
JOSH OZERSKY

Gypsy: The Art of the Tease
RACHEL SHTEIR

King's Dream
ERIC J. SUNDQUIST

Inventing a Nation: Washington, Adams, Jefferson
GORE VIDAL

Small Wonder: The Little Red Schoolhouse in History and Memory
JONATHAN ZIMMERMAN

Forthcoming titles include:
Toni Bentley on George Balanchine's *Serenade*
Leo Braudy on the Hollywood sign

To Larry Polansky—
in admiration,
gratitude,
and friendship

Contents

Preface ix

ONE
4′33″ at First Listening 1

TWO
The Man: 1912–1949 32

THREE
Dramatis Personae (Predecessors and Influences) 71

FOUR
The Path to *4′33″*: 1946 to 1952 121

FIVE
The Piece and Its Notations 167

Contents

SIX
The Legacy 188

APPENDIX
4′33″ Discography 215

Notes 219
Bibliography 233
Index 241

Preface

On May 18, 1973, a young man stood on a high school stage in Dallas, Texas, and proclaimed, "In order to even begin to understand the music of John Cage, it is necessary to examine some of his most important philosophies and ideas whether you agree with them or not. First of all is his use of silence. Cage considers silence a very integral part of a piece of music, given equal importance with the sounded notes. And in conjunction with this I would like to remind you that there is no such thing as total silence, except in a vacuum; that wherever there are people or any life at all, there is some kind of sound. Cage therefore never uses in his pieces *absolute* silence, but instead, the varieties of sound such as those caused by nature or traffic, which ordinarily go unnoticed, and aren't usually

regarded as music . . ." And so on—I've spared you the less felicitous verbiage. The young man then sat down at the piano, closed the lid, and sat in quiet meditation, as his audience, made up of friends, parents, and teachers, doubtless listened to the hum of the school H-vac system. At the end, with no further disturbance, the audience generously applauded me—for I was the young man. I was seventeen, and it was my senior high school piano recital, featuring also works by Brahms, Chopin, Scriabin, myself, and friends.

I had discovered Cage's book *Silence*, along with recordings of his prepared piano music and *Variations IV*, at age fifteen, and I was a Cage fanatic. I don't believe I had yet heard anyone else play *4'33"*. I regaled my music theory class with the Everest recording of Cage's *Variations IV*, as students and poor Ms. Schulze alike worried for my sanity. A year later, as a freshman at Oberlin, I organized and conducted a performance of Cage's *Imaginary Landscape No. 4* for twelve radios, and I also played one of the pianos (with composer Doug Skinner) in Cage's *Experiences No. 1*. Soon afterward, I met Cage in person, at an appearance he made in Dallas in the fall of 1974. Chance processes of various kinds were increasingly creeping into my own music. Eventually I decided, or realized, that Cage's persuasive persona was swamping my own, and that I had to

expunge him from my life in order to regain some sense of myself. This I did—but every few years I would come back and reread *Silence* and *A Year from Monday*, always amazed at how Cage's apparent meanings changed as I matured. There were a dozen or more Cage pieces I never quit listening to. And of course, I was always pleased to run into him at concerts over the years.

After putting away Cage in college, I spent nineteen years as new-music critic for the *Village Voice* in New York. As a music writer I did plenty of scholarly work on composers younger than Cage, and on important figures (La Monte Young, Conlon Nancarrow) who were getting less attention. A pioneer rather than crowd joiner by temperament, I left Cage to the musicological industry that was mushrooming up around him. So I never considered myself a Cage scholar, but when Yale University Press editor Jonathan Brent offered me the opportunity to write this book, I starting thinking that I had put too much distance between myself and Cage, and that writing about *4′33″* would put me back in touch with my musical roots. I soon realized that one of my challenges would be to explain—for readers who still think of *4′33″* as some kind of provocative stunt—a piece that, to me, long ago entered the realm of concert-life normalcy. It was, after all, a repertoire piano piece that I played at my high school recital.

I had to consciously remember that not every music lover out there has *4′33″*, as I do, in his blood.

I ran into Cage many times until the end of his life but never interviewed him. As a latter-day Cage scholar, then, I have been dependent on the research of others, and it is my great fortune that so much excellent material on Cage has been published in the past ten years. I am indebted to a generation of superb scholars, whom I list here with the dates of the most recent articles and books of theirs that I used: David W. Patterson (2002), Douglas Kahn (1997), William Brooks (2008), David Nicholls (2007), Austin Clarkson (2001), Philip Gentry (2008), David Revill (1992), Larry J. Solomon (2002), Marjorie Perloff (2002), Michael Hicks (1990), John Holzaepfel (2002), Liz Kotz (2007), William Fetterman (1996), James Pritchett (1996), Christopher Shultis (1995), Thomas Hines (1994), and several others. As the dates show, this is a book that couldn't have been written in the twentieth century. I make no claims of original insight or new facts, but I am proud that so much fine research by others is gathered here into one book for the first time. I can't think of an answerable riddle about *4′33″* that came up in my writing that one of them didn't eventually solve.

In addition, I have been blessed with the tremendous good luck of having had the John Cage Trust move from

New York City to Bard College, where I teach, hardly a year before I began the book. I thank its director Laura Kuhn for deluging me with more information than I could use, while engaging me in jovial conversations on all things Cagean. I thank Dragana Stojanovic-Novicic, who worked alongside me at the Trust on her own Cage projects, for drawing my attention to articles I might have missed. I thank Paul Rudy and William Alves for information given personally. I thank John Kennedy for reading through the manuscript, and Bard's religion professor Richard Davis for keeping me from falling over cliffs in the sections on Zen. Most of all I thank Larry Polansky for being a hardass philosophy debater and not letting me get away with casual expressions where precise ones were needed.

As we say, any remaining mistakes are my fault, not theirs. I thank my old Chicago friend Jonathan Brent—who edited my first published article back in 1982—for coming back into my life with the request to write the book for Yale, and Sarah Miller at Yale for her help. I thank my wife, Nancy Cook—who cherishes a memory of Cage once telling her all about the sex life of mushrooms—for once again, as she's been doing for a quarter century, creating a cocoon within which I can work undisturbed by even the cats.

4′33″ *at First Listening*

The Maverick Concert Hall is a lovely open-air theater just south of Woodstock, New York, rustically fashioned to blend with its natural environment. Built like a large barn but with a more gradually pitched roof and striking diagonal windows, the hall opens in the back through four double doors onto additional rows of wooden benches in the open air. There are about as many seats outside as in. Oak, maple, hemlock, and shagbark hickory trees intrude gently on the listening space.[1] The hall, and the concert series founded there in 1916, were the vision of novelist, poet, and entrepreneur Hervey White, who broke away from an earlier arts organization to found it (thus the name *Maverick*). Tucked away in a residential sector of the Catskill mountains, Maverick Concert Hall isn't easy

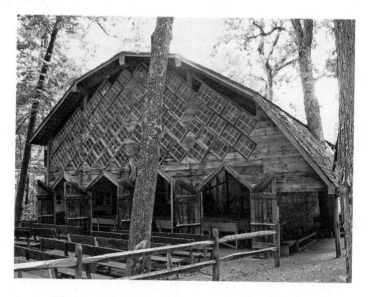

The Maverick Concert Hall in 2008. Photo: Kyle Gann.

to locate from the main road; even once you've found the right dirt path, you creep your car into the parking lot without getting much reassurance that there's anything there. But for over ninety years the Maverick concerts have remained a prized venue for classical chamber music in a lovely natural setting.

The most famous event in the history of the Maverick series occurred in the late evening of August 29, 1952: the premiere of John Cage's *4′33″*. Pianist David Tudor sat down at the piano on the small raised wooden stage, closed the keyboard lid over the keys, and looked at a stopwatch. Twice in the next four minutes he raised the

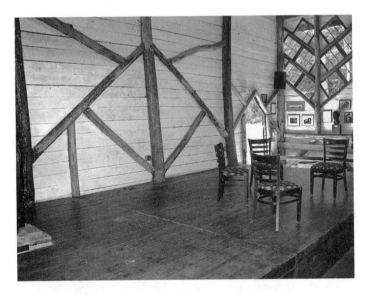

The Maverick stage. Photo: Kyle Gann.

lid up and lowered it again, careful to make no audible sound, although at the same time he was turning pages of the music, which were devoid of notes. After four minutes and thirty-three seconds had passed, Tudor rose to receive applause—and thus was premiered one of the most controversial, inspiring, surprising, infamous, perplexing, and influential musical works since Igor Stravinsky's *Le sacre du printemps*.

Of course, what the audience heard during the work entitled 4′33″ (*Four Minutes and Thirty-three Seconds*, or just "four thirty-three" as Cage tended to call it) was not literal silence. Years later, Cage described the sounds heard

during the 1952 performance, which conveniently fell into three movements, paralleling the intended structure: "What they thought was silence, because they didn't know how to listen, was full of accidental sounds. You could hear the wind stirring outside during the first movement. During the second, raindrops began pattering the roof, and during the third the people themselves made all kinds of interesting sounds as they talked or walked out." In 1985 Cage said to Ellsworth Snyder, "I had friends whose friendship I valued, and whose friendship I lost because of that. They thought that calling something you hadn't done, so to speak, music was a form of pulling the wool over their eyes, I guess." And again: "They didn't laugh — they were irritated when they realized nothing was going to happen, and they haven't forgotten it 30 years later: they're still angry."[2]

One can get an idea from the program what it was that shaped people's expectations. The first work of the evening was a theatrical piece by Cage that was at the time intended to be retitled at each new performance for the current date; the program listed it as *Aug. 29, 1952*, but he later more conveniently gave it the permanent title *Water Music*. This was a theater piece notated with a single page of instructions rather than a musical score, and involving a radio, whistles, a duck call, and a deck of cards, along with other paraphernalia. Lasting six minutes and forty

seconds, the piece directs the performer to perform certain actions at given times determined beforehand by chance methods: blowing the duck call into a container of water, shuffling and dealing the playing cards, playing the radio, sticking objects into a piano's strings to alter the sounds, and blowing a siren whistle. *Water Music* may well have seemed pure comedy, a mini-play reminiscent of the nonsense of the Dadaist movement of the early twentieth century. Yet, as noted on the concert program, the performance was a benefit for the Artists Welfare Fund. The audience was made up partly of sophisticates of the avant-garde, partly of local music lovers, and partly of vacationing members of the New York Philharmonic;[3] for the first group, even the soggy duck call wasn't quite beyond the pale, and perhaps even the others found it entertaining. Moreover, Cage was not an unknown figure in the area. The previous year, a film festival hosted by the Woodstock Artists Association had awarded a certificate for Best Musical Score to his music for the film *Works of Calder.*[4]

Following *Water Music*, the bulk of the program consisted of brief pieces by three younger composers closely associated with Cage: Morton Feldman, Earle Brown, and a precocious teenager named Christian Wolff, who was only eighteen at the time of the performance. (Cage, the oldest composer, was a week shy of forty.) All of these

Woodstock Artists Association

presents

john cage, composer

david tudor, pianist

PROGRAM

aug. 29, 1952 john cage
for piano christian wolff
extensions #3 morton feldman
3 pieces for piano earle brown
premier sonata pierre boulez
 2 parts
5 intermissions morton feldman
for prepared piano ... christian wolff
4 pieces john cage
 4' 33"
 30"
 2' 23"
 1' 40"
the banshee henry cowell

PATRONS: Mrs. Emmet Edwards, chairman; Mr. and Mrs. Sidney Berkowitz, Dr. and Mrs. Hans Cohn, Mr. and Mrs. Henry Cowell, Mr. and Mrs. Rollin Crampton, Mr. and Mrs. Roland d'Albis, Mr. and Mrs. Pierre Henrotte, Dr. and Mrs. William M. Hitzig, Mrs. Charles Rosen, Dr. and Mrs. Harold Rugg, Mr. and Mrs. Alexander Semmler, Mr. and Mrs. John Striebel, Mr. and Mrs. Richard Thibaut, Jr., Capt. C. H. D. van der Loo, Miss Alice Wardwell.

MAVERICK CONCERT HALL

Friday, August 29 8:15 P. M.

BENEFIT ARTISTS WELFARE FUND

The program of the premiere concert, August 29, 1952.
Courtesy of the John Cage Trust at Bard College.

were modern, abstractly titled, pointillistic pieces in which notes were disconnected from each other, giving little sense of melody, harmony, or even cohesion. Feldman's *Extensions #3* would have stood out for its steady tempo and seemingly unmotivated pianissimo reiteration of sonorities and brief motives. One of Wolff's pieces, *For Prepared Piano*, involved objects placed in the piano strings to mute the sound, an innovation Cage had developed several years before. In the middle of the program came the huge and difficult First Piano Sonata of Pierre Boulez, a twenty-seven-year-old Frenchman who would become very famous in a few years—would someday conduct the New York Philharmonic, in fact—but who was not yet well known. This violent and more ambitious work, couched in the twelve-tone idiom developed by Arnold Schoenberg before World War II, would have been a stark contrast with the rest of the program.

Cage's more controversial piece came next to last and is listed mistakenly on the program: it was not "4 pieces" but one piece with three movements, the title being *4′33″* and the lengths of the three movements being 30″, 2′23″, and 1′40″, adding up to 4′33″.

The final work was Henry Cowell's *The Banshee*, a classic of the 1920s avant-garde by one of Cage's teachers, made up entirely of eerie noises coaxed and scratched directly from the piano strings, without use of the keyboard.

No one seems to have left any document of how *The Banshee*'s performance went or, indeed, whether it managed to get played at all; though one supposes it did, because following the concert there was a tumultuous question-and-answer session with the composers, climaxing in one artist's exhortation, "Good people of Woodstock, let's run these people out of town."[5]

However unconventional, this was a piano recital, and the pianist was a twenty-six-year-old named David Tudor who would become a legend in the international world of contemporary music. Born in Philadelphia in 1926, he began as an organist and served in that capacity at Swarthmore College from 1944 to 1948.[6] He also studied composition (as did Morton Feldman) with Stefan Wolpe, an émigré Jewish composer of fiercely atonal yet whimsically intuitive proclivities. In December 1950 Tudor had given Boulez's Second Sonata of 1948 its American premiere. Having trouble internalizing the work's relentless yet fragmented continuity, he learned that Boulez had been inspired by the avant-garde French dramaturge Antonin Artaud, and so Tudor pored through Artaud's book *Le théâtre et son double,* leading to a realization that what Artaud called affective athleticism was the key to playing Boulez.[7] Such devout preparation and total immersion in a composer's aesthetic forecast the level of devotion to his repertoire for which Tudor would later become known.

He was quickly gaining a reputation as a leading pianist for the most avant-garde and difficult new music around — the musical page "could be black as sin [with notes] and I could still play it," he later said, and it was no boast, just fact—and at the moment he was on the faculty of the eccentrically progressive Black Mountain College in North Carolina.[8] (Later, in the 1970s, Tudor would desert the piano to return to composition, becoming a pioneer in the field of electronic performance and sound installations.)

Cage, at the time, was best known as a California composer of percussion music and the inventor of the prepared piano—a piano with bolts, screws, rubber erasers, weather stripping, and other objects inserted between the strings to alter the timbre and pitch. Such preparations turned the piano into a percussion orchestra playable by one person. Though still nearly indigent, Cage had already enjoyed a certain amount of notoriety, notably a well-publicized 1943 concert at New York City's Museum of Modern Art which was written up in *Life* magazine. Cage met Tudor in 1949 through dancer Jean Erdman; Cage sometimes supplied music for Erdman's dances, and Tudor was her accompanist. That same year, Cage also visited Paris and met Boulez, and it was Cage (with Feldman's help) who arranged for the premiere of the Second Sonata. Though Cage was fourteen years older than

Tudor, the two were tremendously simpatico and, following the Boulez premiere, formed a close artistic bond that would last until Cage's death. In 1951 his younger friend's volcanic pianism inspired what was easily the most difficult piano piece Cage had written, a forty-five-minute tour de force of violent and systematic randomness titled *Music of Changes;* Tudor premiered the work on New Year's Day, 1952. When Cage had the wild idea for *4′33″*, an unflinching Tudor encouraged him to finish the piece for his upcoming concert on the Maverick series.[9]

At this point Cage's infamy as a proponent of chance techniques and Zen paradoxes, and the widespread influence of his provocative writings, still lay several years in the future. He had so far been indulged as an amateurish but entertaining proponent of percussion noises. With *4′33″*, the controversy that afterward surrounded his life and work was just about to begin.

John Cage's *4′33″* is one of the most misunderstood pieces of music ever written and yet, at times, one of the avant-garde's best understood as well. Many presume that the piece's purpose was deliberate provocation, an attempt to insult, or get a reaction from, the audience. For others, though, it was a logical turning point to which other musical developments had inevitably led, and from which

new ones would spring. For many, it was a kind of artistic prayer, a bit of Zen performance theater that opened the ears and allowed one to hear the world anew. To Cage it seemed, at least from what he wrote about it, to have been an act of *framing*, of enclosing environmental and unintended sounds in a moment of attention in order to open the mind to the fact that all sounds are music. It begged for a new approach to listening, perhaps even a new understanding of music itself, a blurring of the conventional boundaries between art and life. But to beg is not always to receive.

What was this piece, this "composition" *4′33″*? For so famous and recent a work, the number of questions that still surround it is extraordinary—from its lost original manuscript, to its multiple notations, to unexplained deviations in the lengths of the movements, to the peculiar process of adding up silences with which it was composed, to the biggest ambiguity of all: How are we supposed to understand it? In what sense is it a composition? Is it a hoax? A joke? A bit of Dada? A piece of theater? A thought experiment? A kind of apotheosis of twentieth-century music? An example of Zen practice? An attempt to change basic human behavior?

Let's try the hoax hypothesis. Here are some definitions for *hoax:*

1. An act intended to deceive or trick;
2. Something that has been established or accepted by fraudulent means;
3. Deliberate trickery intended to gain an advantage (synonym: *fraud*);
4. A deception for mockery or mischief.

In what was Cage trying to deceive the audience? Attempting to make them think they had heard something when they hadn't? The audience was fully aware that Tudor was sitting onstage and neither touching the keyboard nor making any audible sounds. If Cage was trying to fool the audience into thinking he had written a piece when he really hadn't, who was deceived? One could argue that Cage was mocking the audience, but he wasn't doing so by *deceiving* them. There was no attempt to cover up what *4′33″* was: a man sitting at a piano for four and a half minutes without playing. There was no moment following the performance at which listeners learned that what they'd heard was not what they thought.

Perhaps it was trickery intended to gain an advantage? Ah yes, the advantage! And what was that advantage? Why, money, of course! Every time I have ever played or explained *4′33″* to a class, one student has always exclaimed indignantly, "You mean he got *paid* for that?" According to the common understanding of how musicians

lead their careers, the musician makes some music, it gets played, and the musician is given some money through some means or another. But Cage wasn't paid for writing *4′33″*; the piece wasn't commissioned. The concert was a benefit for a good cause. The money people paid to hear David Tudor play did not go to Cage, or even to Tudor.

And in fact, while songwriters usually get paid for their performances and receive royalties for the use of their songs, classical composers like Cage sometimes compose for commissions, but also often write pieces with no commission at all. Often they compose simply because they have an idea, or they're building up a portfolio for future performances, or they're trying to advance their careers by doing something impressive, or—quite often—they compose for the sheer love of composing, which can be an enjoyable and fulfilling activity. At that time, Cage was, as he said, "poor as a church mouse," and he had been so for many years. He had spent the year 1951 composing his piano piece *Music of Changes* on the sidewalk and on the subway, and asking friends and strangers to support him by buying shares in his music in case it ever did actually make some money. The year following the *4′33″* premiere, the old Lower West Side apartment house Cage was living in was scheduled for demolition, and he was forced to relocate. Not affluent enough to find another place in the city (even with cheap 1950s rents), he eventually moved

with friends to an artists' collective upstate at the community of Stony Point, where he could enjoy two small rooms for $24.15 a month (about $194 in 2008 dollars).[10] Not until the 1960s would Cage gain any measure of financial security. The idea that he might have made any money off an avant-garde gesture like *4′33″* is a raw caricature of a composer's life. (In the 1960s, however, when he was much more famous, Cage did sell the manuscript of *4′33″* for a large sum of money, much as one might sell any document that had come to have historical significance.)

Or perhaps Cage was just lazy, "writing" a piece that took no work at all and hoping to make some money off it later. Any such impression is belied by the sheer volume of Cage's lifelong output, the detailed complexity of many of his scores, and the loving care he put into copying his manuscripts. He would later say that *4′33″* took longer for him to write than any other piece, because he worked on it, as a concept, for four years. And in 1951 he had written the tremendously virtuosic and complex *Music of Changes*, more difficult to conceive and compose than anything a lazy person would have ever contemplated.

In 2004 the BBC broadcast an orchestral version of *4′33″*—which meant that the BBC Symphony Orchestra sat onstage for four and a half minutes without making sounds, and people listened to their silence in the hall and

over the radio. Some of the comments the BBC received over the Internet played into the "hoax" theme:

I'm sorry, but this is absolutely ridiculous. The rock 'n' rollers and the punks were wrongly bashed in their day, but this genuinely deserves a big thumbs down.

This is clearly a gimmick, when he 'wrote' this piece he was testing who was stupid enough to fall for it. I think you'll find he wrote it on 01 April 1952.

I find it quite patronising and disturbing that self proclaimed intellectuals are trying to convince us that this is art—just another nail in the coffin for the world of art!

Is this how our licence fee money is being used? I've never heard of such a stupid thing in my life! God rest his soul, but this 'composition' by Cage smacks of arrogance and self importance . . .

Emperor's new clothes anyone?[11]

Yet for the rest of his life, Cage talked about *4'33"* as his most important work, the one he returned to again and again as the basis for his other new works. He knew what it consisted of and was well aware of the range of receptions it generated.

How about the "joke" theory? Well, Cage was certainly

afraid it would be taken as a joke, which is why it took him four and a half years (nice coincidence) from conceiving the piece to actually presenting it publicly. ("I have a horror of appearing an idiot," he once told a critic.)[12] In a 1973 interview he admitted, "I was afraid that my making a piece that had no sounds in it would appear as if I were making a joke. In fact, I probably worked longer on my 'silent' piece than I worked on any other."[13] Cage explained the "joke": "I think perhaps my own best piece, at least the one I like the most, is the silent piece. It has three movements, and in all of the movements there are no sounds. I wanted my work to be free of my own likes and dislikes, because I think music should be free of the feelings and ideas of the composer. I have felt and hoped to have led other people to feel that the sounds of their environment constitute a music which is more interesting than the music which they would hear if they went into a concert hall."[14] For a joke, this is an awfully earnest philosophical program.

How about Dada? Dada was an art movement, or perhaps anti-art movement, associated with the period during and after World War I. Disillusioned by the great world of European culture being plunged into war, artists like Tristan Tzara, Hugo Ball, Hans Arp, Sophie Täuber, Erik Satie, and others dove into a world of nonsensical art that eschewed reason and logic in favor of chaos, random-

ness, and paradox. In the foreword to his seminal early book *Silence,* Cage acknowledges a debt to Dada, and Satie was one of his favorite composers. Cage also notes that "what was Dada in Duchamp's day is now just art," but on Cage's own authority the possibility that *4′33″* was a Dada-inspired gesture, even if also more than that, cannot be entirely dismissed.

How about theater? One of the crucial aspects of *4′33″*, at least in the first performances, is that there was a pianist onstage, whose presence, and whose behavior in the previous pieces on the program, clearly led the audience to expect that his hands would at some point engage the keyboard, and that they would hear deliberately made sounds coming from the stage. That this did not happen, that the listeners' expectations were deliberately flouted, cannot be entirely divorced from the sonic identity of the piece, even though the way Cage talked about *4′33″* later in life—claiming, for instance, that he often "performed" the piece while alone—seems to suggest that it can. As *New York Times* critic Edward Rothstein suggested in a rather unsympathetic obituary of Cage, had Cage simply wanted his audience to listen, he could always have instructed them to do so.[15] In fact, following *4′33″*, Cage's music, by his own enthusiastic admission, began tending more and more toward theater, and during the 1960s in particular he became very interested in the physical and

cognitive relationship between performers and audience members.

The description of *4′33″*'s theatrical recontextualization can hardly be phrased more delicately and thoroughly, I think, than Douglas Kahn has done:

> Ostensibly, even an audience comprised of reverential listeners would have plenty to hear, but in every performance I've attended the silence has been broken by the audience and become ironically noisy.
>
> It should be noted that each performance was held in a concert setting, where any muttering or clearing one's throat, let alone heckling, was a breach of decorum. Thus, there was already in place in these settings, as in other settings for Western art music, a culturally specific mandate to be silent, a mandate regulating the behavior that precedes and accompanies musical performance. As with prayer, which has not always been silent, concertgoers were at one time more boisterous; this association was not lost on Luigi Russolo, who remarked on "the cretinous religious emotion of the Buddha-like listeners, drunk with repeating for the thousandth time their more or less acquired and snobbish ecstasy." *4′33″*, by tacitly instructing the performer to remain quiet in *all* respects, muted the site of centralized and privileged

utterance, disrupted the unspoken audience code to remain unspoken, transposed the performance onto the audience members both in their utterances and in the acts of shifting perception toward other sounds, and legitimated bad behavior that in any number of other settings (including musical ones) would have been perfectly acceptable. *4′33″* achieved this involution through the act of silencing the performer. That is, Cagean silence followed and was dependent on a silencing. Indeed, it can also be understood that he extended the decorum of silencing by extending the silence imposed on the audience to the performer, asking the audience to continue to be obedient listeners and not to engage in the utterances that would distract them from shifting their perception toward other sounds. Extending the musical silencing, then, set into motion the process by which the realm of musical sounds would itself be extended.[16]

Kahn is right: *4′33″* cannot be bracketed as a purely sonic phenomenon. It called upon the audience members to remain obediently silent under unusual conditions. The pianist's refusal to play calls a whole network of social connections into question and is likely to be reflected in equally unconventional responses on the part of the audience.

How about a "thought experiment," a kind of "meta-music" that makes a statement about music itself? For many people, including me, *4′33″* is certainly that, if not only that. One story about Cage recounts his sitting in a restaurant with the painter Willem de Kooning, who, for the sake of argument, placed his fingers in such a way as to frame some bread crumbs on the table and said, "If I put a frame around these bread crumbs, that isn't art." Cage argued that it indeed *was* art, which tells us something about *4′33″*.[17] Certainly, through the conventional and well-understood acts of placing the title of a composition on a program and arranging the audience in chairs facing a pianist, Cage was *framing* the sounds that the audience heard in an experimental attempt to make people perceive as art sounds that were not usually so perceived. One of the most common effects of *4′33″*—possibly the most important and widespread effect—was to seduce people into considering as art phenomena that were normally not associated with art. Perhaps even more, its effect was to drive home the point that the difference between "art" and "non-art" is merely one of perception, and that we can control how we organize our perceptions. A person who took away nothing from *4′33″* but this realization would, in my view, already be taking home something revolutionary.

From a broader perspective, how about *4′33″* as the

apotheosis of twentieth-century music? There is something intriguing about the piece's position as a kind of midpoint of the century. The years just following World War II had seen a resurgence of the twelve-tone music invented by Arnold Schoenberg. Composers like Karlheinz Stockhausen, Pierre Boulez, and Milton Babbitt were expanding the twelve-tone idea from the realm of pitch to include rhythm, dynamics, and timbre, and in the process creating music of unprecedented complexity. Such hyperstructured music began to verge on the realm of incomprehensibility, a kind of perceptual chaos arising paradoxically from rational processes. It's true that most of this development appeared in the years just following *4′33″*, but in the 1960s it became common to talk about how little different the super-controlled music of Stockhausen and Babbitt sounded from the totally chance-controlled music Cage was writing. And indirectly *4′33″* led to the developments from which grew the simpler and more accessible new style of minimalism. As a locus of historical hermeneutics, *4′33″* can be seen as a result of the exhaustion of the overgrown classical tradition that preceded it, a clearing of the ground that allowed a new musical era to start from scratch.

And how about *4′33″* as an example of Zen practice? This, I think, may be the most directly fertile suggestion, but it is too early in the book to develop it as it deserves.

Cage first spoke of the possibility of a silent piece in 1948, and several steps in his thinking led him, over the next four years, to the inevitability of presenting such a work in public. These steps will be covered, one by one, in Chapter 4. First, in Chapter 2, we need to consider who John Cage was and how he became such a remarkable, and remarkably influential, person. Chapter 3 will give the history of people and ideas that formed the ladder of precedents that Cage climbed, and in Chapter 5 we will finally examine the work itself. For now, suffice it to say that there are many levels on which *4′33″* can be understood, and many simultaneous meanings to be grasped within it—which, after all, is one of the signs by which any great work of art can be recognized as such.[18]

But first, a few more thoughts about where *4′33″* fits in American cultural history. Whatever else one can say about *4′33″*, the piece can be understood as a beginning point, or perhaps the final beginning point from a series, of a particularly American process: the imitation of nature as a way of locating an indigenous American aesthetic. The development of American music was little different from that of painting or of the novel in this respect, but less accelerated. The first generation of American painters to aim for an indigenous American style, the so-called Hudson River School—Thomas Cole (1801–1848),

Frederic E. Church (1826–1900), Jasper Cropsey (1823–1900), Martin Johnson Heade (1819–1904), and others—achieved originality by painting a native landscape that did not look like Europe and that few Europeans had ever seen. Cropsey, for instance, painted autumn maple forests so red that European audiences believed he was falsifying the color, until he began exhibiting red maple leaves next to his paintings to prove that he was coloring from life. American novelists could step away from Europe by choosing American subjects like the American Indians (James Fenimore Cooper's *The Last of the Mohicans*), the whaling industry (Herman Melville's *Moby-Dick*), or the early Puritan settlers (Nathaniel Hawthorne's *The Scarlet Letter*).

For American composers, the path to national authenticity was not so obvious. Formal models were inherited from Europe, and there was no clear American auditory model to learn from. The Boston tanner and composer William Billings (1746–1800) imitated what he knew of Continental musical style so ineptly, yet with such vigorous musicality, that he fell into what now seems an almost original choral idiom, which would spread throughout the eastern United States as shape-note singing. In his dissonance-filled choral piece "Jargon," he even flirted with radical experimentation—although "Jargon," a response to critics, was more evidently a joke than *4′33″*.

By contrast, most prominent nineteenth-century American composers modeled themselves as closely as possible after the "modern Romantic" European school—Robert Schumann, Frédéric Chopin, Felix Mendelssohn. A few, however, tried to discover an inherently American sensibility in their music, and those composers turned for inspiration to nature.

For instance, born in Bohemia but tramping through Pennsylvania and Kentucky from 1810 on, Anthony Philip Heinrich (1781–1861) wrote programmatic works on subjects of American nature: *The Ornithological Combat of Kings* (1836), *Trip to the "Catskill Mountain House"* (1851), *The Mocking Bird to the Nightingale* (1834), and, more socially, the *Barbecue Divertimento* and *The Treaty of William Penn with the Indians* (1834). William Henry Fry (1813–1864), best known today for the *Santa Claus Symphony*, wrote in 1854 a heavily onomatopoetic *Niagara Symphony* (not performed until the beginning of the twenty-first century). Louis Moreau Gottschalk (1829–1869), a New Orleans native, was the first to turn for American authenticity to rhythms of the various non-Caucasian races that settled on this continent, in his symphony *Night in the Tropics* (1861) and piano pieces such as *The Banjo* (1855). The *Arcadian Symphony* (1872) of George Frederick Bristow (1825–1898) begins strikingly with a long violin solo suggesting the loneliness of the American wilderness.

Between 1892 and 1895, the famous Czech composer Antonin Dvořák lived in America, as director of New York's National Conservatory of Music. In 1893, just as he was finishing his own *New World* symphony, supposedly based on Negro themes learned from one of his students, Dvořák made a statement to the press, quoted in the *New York Herald:* "I am now satisfied . . . that the future music of this country must be founded upon what are called negro melodies. . . . There is nothing in the whole range of composition that cannot be supplied with themes from this source."[19] Some American composers, resenting this didactic intrusion from a foreigner, responded with other strategies: Arthur Farwell (1872–1952) set American Indian melodies for the piano, and Amy Beach (1867–1944) wrote a Gaelic Symphony based on the Irish tunes of her family background.

The generation of Americans who came of age after World War I took more sophisticated approaches. For the seminal genius Henry Cowell (1897–1965), nature in music meant numbers and especially the harmonic series. Between the ages of nineteen and twenty-one, Cowell wrote a groundbreaking book titled *New Musical Resources,* which argued for treating rhythm, tempo, and meter with the same freedom that composers traditionally applied to pitch and harmonies. The book wasn't published until 1930 and stayed in print only a few years, but it had an

impact on Cowell's student Cage, who helped transmit its ideas to the European musical world of the 1950s. Unbeknownst to Cowell, the great American recluse Charles Ives (1874–1954) had already written in a thoroughly experimental idiom full of unprecedented rhythmic complexities and massive dissonances in an astonishing body of music, often programmatically depicting characteristically American events such as a Fourth of July celebration seen through a child's eyes. Many of Ives's most important works, however, would not be heard publicly until the 1940s, or even the 1960s.

Other American modernists such as Edgard Varèse (1883–1965, born in France) and George Antheil (1900–1959) achieved nationalism by drawing inspiration from the fast-paced traffic and impersonally energetic machinery of American industrial cities like New York. Frederick Shepherd Converse (1871–1940), habitually rather conservative, stepped out of character to write a dissonant tone poem, *Flivver Ten Million* (1927), to celebrate the Ford company's ten-millionth car. John Alden Carpenter (1876–1951) wrote *Skyscrapers* (1924) from a similar impulse and *Krazy Kat* (1921) in honor of an American comic strip. Truly, the creation of an American classical music differentiated from European tradition was a self-conscious enterprise to which a host of diverse strategies was applied.

The Great Depression brought a temporary halt to the modernist agenda and inspired Americanist composers like Aaron Copland (1900–1990) to quote folk songs in a simpler musical idiom that evoked rural America. But it was the Cowell-Varèse-Antheil generation that had already set its mark upon Cage, who remained more in sympathy with experimentalist tendencies than with nationalism per se. The son of an inventor and self-consciously an inventor himself, Cage would rarely stress Americanness, but he put considerable emphasis on innovation. ("I can't understand why people are frightened of new ideas," he liked to say. "I'm frightened of the old ones.")[20] Specifically North American musical sources such as ragtime and Latin American rhythms held no particular interest for him, though he did arguably follow Cowell in shifting the interest of his early music to rhythm.

Still, in midcareer it would be Cage who made the most radical turn toward nature of any composer: nature as associated with chance and environmental sounds (the latter found not only in *4′33″* but also in works with taped ambient sounds, like *Etcetera* and *Score [40 Drawings by Thoreau] and 23 parts: Twelve Haiku followed by a Recording of the Dawn at Stony Point, New York, August 6, 1974*). In *4′33″*—at least in terms of its outdoor premiere—he took the controversial step of simply listening to what the American environment sounded like. For all that the

rhetoric surrounding *4′33″* urges us to listen to our environment no matter where we are, it is difficult to resist the idea that the place of the work's premiere seems particularly Romantically chosen: an open-air space in the woods, half of its seats outside under the sky, in which rural nature—rather than the traffic and machinery of an urban area—was pretty much guaranteed to assert itself. In setting *4′33″* for the first time in the sylvan deciduous forest of the Catskill mountains, Cage asked his audience to listen to the murmur of American nature as music, much as Frederic Church, Jasper Cropsey, and others had created a newly luminous aesthetic by capturing that same landscape in paint. The coincidence that Cage and the Hudson River School had started with the same landscape is a delicious one.

Significantly, however, Cage would not be able to arrive at the bold apostasy of *4′33″* until he had turned away from Europe and European music toward the thought and aesthetics of Asia. Cage was part of a generation of composers who grew up or lived on the West Coast—along with Cowell, Lou Harrison (1917–2003), Harry Partch (1901–1974), and Alan Hovhaness (1911–2000)—and whose orientation was less dominated by European thought than was that of the far more numerous and conventional composers along the Atlantic seaboard. Cowell grew up hearing the music of Chinese immigrants; Partch, the son of

former missionaries to China, was lulled to sleep by Chinese lullabies and, growing up in Arizona, heard songs of the nearby Yaqui Indians; Harrison would become, along with the Canadian Colin McPhee, the composer mostly closely associated with the percussion orchestra of the Indonesian gamelan. For many composers nurtured along the Pacific Rim, European music held no special prestige.

Cage moved to New York a decade before finally committing himself to the boldness of *4'33"*, but during that decade he revitalized his ideas on music, rebuilding his aesthetic from the ground up, based on ideas garnered from Zen and Buddhist and Hindu mysticism. Additionally, as World War II ended, the defeat of Japan by the United States drew the two countries into a closer relationship than they had had before, and a new consciousness of Japanese thought and philosophy flowed into American intellectual circles just as Cage was searching for new ideas. In assimilating the writings of R. H. Blyth on haiku (which poetic form swept the New World in the 1940s and 1950s), Ananda K. Coomaraswamy's writings on Indian art, and Aldous Huxley's comparisons of Zen and medieval mysticism, Cage synthesized an aesthetic that could only have arisen in America, drawn from both Eastern and Western sources and yet explainable in neither European nor Asian terms. For all its seeming indivisible

A cartoon like the one pictured here, however "alternative" its intended audience might be, shows how far the piece has sunk into cultural consciousness. *Rhymes with Orange*, June 25, 2008. © Hilary B. Price. King Features Syndicate.

simplicity, *4′33″* was a thoroughly American product of the clash of Asia and Europe in the New World.

And, fittingly, *4′33″* cleared the deck for a new American music, freer from European influence than the nationalist streams of music of the 1920s and 1930s. From *4′33″* younger composers imbibed a freer attitude toward sound, adding their own processes into Cage's emptiness (in ways that will be documented in Chapter 6) and leapfrogging over his logical constructs to create the conceptualist and sound art movements of the 1960s, the minimalist movement of the 1960s and 1970s, and the postminimalist and totalist movements of the 1980s and 1990s. The rise of experimental American music in the late twentieth century can be traced to the lineage of composers who took *4′33″* very seriously indeed. Nor were they the only ones. Yoko Ono and John Lennon paid homage to *4′33″*, as have

a number of pop musicians and rock bands. Despite all those who still call it the "emperor's new clothes," it has become a cultural icon, a beginning point, a permission to dart off in any new imaginative direction.

4′33″ was born, on one hand, of European classical concert conventions and formal structure and, on the other, of Asian philosophy, brought together in a specifically American mix. One of the paradoxes of Cage's life, though, is that he absorbed the European influences in his youth in California and discovered Asia later in New York, as I shall now relate.

The Man: 1912–1949

It is a curious contradiction that, for someone who eventually tried to expunge all personality from his music, John Cage was a phenomenally distinctive personality himself. Musicians of my generation (I first met him in 1974) remember his gentle and omnipresent laughter, his refusal to argue, his ability to turn away wrath with soft answers, his delight in the details of any nonmusical subject he didn't know about—and most of all, perhaps, his personal generosity toward young composers. His youthful good looks turned rugged in old age, masked later in life by a beard that suggested an old philosophical woodsman more than a nose-thumbing New York aesthete. Tall, square-jawed, he was once aptly described by an Italian reporter as "pleasantly reminiscent of Frankenstein."[1]

He was a charming and reassuring presence in the new-music world of the 1970s and 1980s, a superb personal role model around whom younger musicians (and nonmusicians) spontaneously crowded.

Yet evidence suggests that the calm, smiling, "bodhisattva-like" Cage (to apply Peter Yates's description) of the late decades was an altered person from the more truculent and opinionated Cage of the 1930s and 1940s. His youthful writings are certainly not afraid to argue and sometimes seem intended to shock. He was always persuasive—Morton Feldman gives us a story from the early '50s of the sculptor Richard Lippold moving out of Cage's apartment building, saying, "I have to get out of here. John is just too persuasive"—but his manner of persuasion changed.[2] His involvement with Zen in his late thirties seems to have bred in him a calmer, less confrontational style.

Take the following oft-repeated story about his studies with Schoenberg, in an account from 1958:

> After I had been studying with him for two years, Schoenberg said, "In order to write music, you must have a feeling for harmony." I explained to him that I had no feeling for harmony. He then said that I would always encounter an obstacle, that it would be as though I came to a wall through which I could not

pass. I said, "In that case, I will devote my life to beating my head against that wall."[3]

David W. Patterson draws a contrast between this well-known version of the story and one that was quoted in a 1946 newspaper interview:

> For two years, Cage told us, he had studied composition with Arnold Schoenberg, the German composer who writes atonal music for a 12-tone scale, and who is generally regarded in musical circles as a pretty radical fellow. Schoenberg wasn't radical enough for Cage, though. Cage finally quit because his instructor insisted he must have a sense of harmony to be a composer. "To me," Cage says indignantly, "that was like my grandmother saying I should be born again. It may have been true and it may not have been, but it didn't have anything to do with what I was doing."[4]

In 1958, Cage poses as a kind of incompetent saint, a Sisyphus willing to fail forever rather than give up. In 1946, however, he shrugs off Schoenberg's criticism and rebels against what he interprets as his mentor's irrelevance. It's entirely possible that he replied to Schoenberg what he claimed he did, but if so, the 1946 quotation suggests that inside he might have been thinking something different.

Not all of Cage's friends were pleased by the newfound

saintly persona. One who had known him in the 1940s remarked on his lecture style of the '50s,

> I didn't believe my ears. The whole reaction on campus was, "He can't be serious." It was all in this super-pontifical tone. "Our new music is this. Our new music and dance." Come off it. We know you. I mean, this is John. I remember at a party I said, "What do you mean by this? What's going on?" Then all this business about silence, silence, silence. What I didn't know then is he'd gotten into the Zen thing. Also, he's an operator, and it was the thing that was in the wind.[5]

A more temperate view is expressed by musicologist Peter Yates:

> When I first knew John Cage [in the early 1940s] he was stubborn, gifted, argumentative. As the gift took hold, he became more silent, preoccupied with himself and the growing of his thought. He entered the room like a bodhisattva, floating. After he had studied Japanese Zen philosophy and learned by it to master himself, he became, as he has remained, the man of the great smile, the outgoing laugh, willing to explain but not, in my recent experience, to argue, tolerant of misconception, self-forgetful, and considerate. Around him everyone laughs.[6]

Let us now trace the history of how John Cage became John Cage—after which the story of his change in personality will be, essentially, the story of *4′33″* itself.

Cage's genealogy has been traced back to an English colonel, William Cage, in colonial Virginia. The next generation produced a John Cage who worked for George Washington as a surveyor and fought in the Revolutionary War.[7] Cage himself claimed that he was basically English with some Scottish and French blood. His not-very-English-sounding grandfather Gustavus Adolphus Cage was a Methodist Episcopal minister who traveled to Utah to preach against Mormonism but, finding he "had no listeners" as the composer later put it, left to establish the First Methodist Episcopal Church in Denver. John Cage would later remember his grandfather as "very tall and terribly self-righteous."[8] The man's self-denying Protestantism, and his tendency to preach, would put a strong mark on the composer.

Gustavus's son John Milton Cage (the composer's father) grew up in Denver. Rebellious, he showed a penchant for running away from home, but he fell in love with the pianist at his father's church, Lucretia "Crete" Harvey, and married her. Crete had been married twice before, and one of Cage's favorite stories about her was that when he asked her the name of her first husband, she

said, "You know, I've tried and tried, but I can't remember."[9] John and Crete's first two children died at birth or soon after, but their third, born September 5, 1912, in Los Angeles, survived to become John Milton Cage Junior.[10]

Few biographical facts about Cage are so widely known as that his father was an inventor; he joins the ranks of composers such as Mozart, Beethoven, and Charles Ives whose fathers figure heavily in their biographies. Most famously, John Senior built a submarine that held the world's record for length of time underwater. However, since its motor left bubbles on the surface, it wasn't considered sufficiently stealthy for use in World War II; the project bankrupted him. Among his more successful inventions were an inhaler for treating colds and the first radio to run on alternating current. Crete worked as a club editor and court reporter and sometimes wrote for the *Los Angeles Times*. The submarine bankruptcy precipitated a temporary move from Long Beach, California, to Detroit, Michigan, where John Senior worked as an engineering consultant for automotive and aircraft companies. Following an accident that left his arm partly incapacitated, the family returned to Santa Monica.[11]

Young Cage excelled in school but was bullied by other boys. He was, he said, "terrified, because as a child I was precocious and the other children in my grade considered me a sissy, and they made fun of me at every opportunity,

so much so that . . . if I read one of the papers I had written they would simply respond by laughing. . . . People would lie in wait for me and beat me up and I would never defend myself because I had gone to Sunday school and they had said to turn the other cheek, which I took seriously."[12] Cage's parents transferred him to an experimental school at UCLA in hopes of ending the torment, but even here, "'my teachers also would be put off by my behavior.' They 'found me too interested in reading,' and urged that 'instead of reading, I should play games' and 'become better adjusted.'"[13]

Although Cage showed interest in music as early as the age of five, the first two decades of his life offered little evidence that it might become his avocation. His mother recalled his being transfixed by the sound of a live symphony orchestra, though Cage later recalled that he appreciated the theatrical aspects of the performance, such as the horn player emptying his spit valve, more than the melodies. He took piano lessons from his aunt Phoebe, then from a composer named Fannie Charles Dillon, who used notated bird songs as the melodies for her compositions. Cage soon became enamored of the music of Edvard Grieg—partly because of Grieg's defiant use of parallel fifths, which were forbidden by traditional theory—and considered devoting his life to playing them because "they did not seem to be too difficult and I loved them." In sixth

grade, however, the director of the school glee club told Cage that his voice wasn't good enough to sing. As a piano student, he disliked practicing technical exercises, but he was told, "I had what was called a beautiful touch, which means that you have a sense of continuity." At twelve Cage started his own radio program at the station KNX, acting as master of ceremonies for local Boy Scout performers and sometimes playing piano himself. The program lasted for two years, until finally the Boy Scout organization insisted on taking it over, whereupon the show did so badly that it was canceled in two weeks.[14]

In 1928, Cage won the Southern California Oratorical Contest with an address on Pan-American relations, delivered at the Hollywood Bowl, titled "Other People Think." The talk, as Douglas Kahn has pointed out, intriguingly foreshadows what would later become Cage's fascination with silence and listening: "One of the greatest blessings that the United States could receive in the near future would be to have her industries halted, her business discontinued, her people speechless, a great pause in her world of affairs created, and finally to have everything stopped that runs, until everyone should hear the last wheel go around and the last echo fade away . . . then, in that moment of complete intermission, of undisturbed calm, would be the hour most conducive to the birth of a Pan-American Conscience. Then we should be

capable of answering the question, 'What ought we to do?' For we should be hushed and silent, and we should have the opportunity to learn what other people think." Did the fifteen-year-old Cage already harbor an intuition that stopping one's own inner monologue and listening was the key to finding harmony with the universe? In any case, he was sufficiently proud of this youthful nonmusical essay to have it published in Richard Kostelanetz's 1968 anthology *John Cage*.[15]

Cage graduated high school as valedictorian of his class, excelling in Latin, Greek, and oratory. At first, like his grandfather, he was more drawn to religion than to the arts. The earliest career plan he seems to have contemplated was following in his grandfather's footsteps by becoming a Methodist Episcopal minister, though he also flirted with the idea of joining the grand new Liberal Catholic Church in town. He studied Greek with the idea of reading the Bible in the original, but his parents balked when he proposed to study Hebrew with a rabbi.[16]

In 1929 Cage enrolled in Pomona College. There the intention of becoming a minister survived only a year, and he turned to writing; he was described as a "prominent campus writer" by *The Student Life*, the campus daily. Gertrude Stein became his new hero. A description of a character from a short story from this time, titled "The Immaculate Medawewing," has been cited as an early hint

of a Cagean preoccupation: "Verlaine Medawewing hates dirt of any kind with a passion. Although strongly attracted to beauteous Dorothy, he refuses to share with her a sandwich on which flies have crawled. He recoils from her young brother because chocolate has dirtied the boy's sticky fingers. She urges him to see beauty even in books with soiled covers and grimy pages."[17] The phrase "to see beauty even in . . ." or its equivalent will recur many times in Cage's writings and conversation.

In his second year of school Cage's grades dropped as his rebellious side emerged. Rather than reading a textbook assigned by one professor, he systematically selected materials at random from the library and read those instead—and received an A on his examination anyway. "That convinced me that the institution was not being run correctly," he later wrote. "If I could do something so perverse and get away with it, the whole system must be wrong."[18] He made the decision to leave Pomona and travel to Europe for experience. His parents agreed to support him temporarily, and in the spring of 1930 he hitchhiked to Galveston, Texas, took a boat to Le Havre, France, and then boarded a train to Paris.[19]

Paris imbued Cage with a love for gothic architecture, and, on the advice of one of his Pomona professors whom he ran into there, he began studying with and working for the architect Ernö Goldfinger (1902–1987), a Hungarian

who had moved to Paris in 1920 following the collapse of the Austro-Hungarian Empire. (Ian Fleming would base one of his most infamous James Bond villains on Goldfinger's name and personal characteristics.)[20] Cage also became interested in expressionist and abstract painting, trying his own hand at the brush, and he took a couple of piano lessons at the Paris Conservatoire. Astonished at his student's ignorance of Bach and Mozart, the teacher sent Cage to a Bach festival, where he came to appreciate the German master, and, on his own, he checked out music by Stravinsky, Alexander Scriabin, and Paul Hindemith.[21] One day Cage overheard Goldfinger make the comment that, in order to be an architect, one had to devote one's life to architecture. Alarmed, Cage told Goldfinger that he had many interests to pursue, and he left his employ soon after.

In the following months of 1931 Cage wandered aimlessly—Capri, Biskra, Madrid, Berlin, Italy, North Africa.[22] At this time he tried his hand at composing music, using elaborate compositional systems in a more mathematical attempt to update Bach. "It didn't seem like music to me," he later wrote, "so that when I left Mallorca I left it behind to lighten the weight of my baggage. . . . The trouble was that the music I wrote sounded extremely displeasing to my own ear when I played it."[23] Returning to Los Angeles in fall of 1931, he wrote a trio of repetitively proto-minimalist

songs, set to music a chorus of Aeschylus's *The Persians* in Greek, and made an extended piano work with voice from the first chapter of the biblical book of Ecclesiastes—all of which survive, though they were temporarily lost.

Cage found himself back in America just in time for the downswing of the Great Depression. His parents were forced to give up their house and move into an apartment. Cage worked as a gardener, cooked exotic meals, washed dishes, farmed himself out as a library researcher, and gave a series of lectures on modern art and music for housewives, researching the subject each week in the public library. Despite his disappointment with his first experiments, he became persuaded that his talents lay more in the musical direction than in painting. "The people who heard my music," he said later, "had better things to say about it than the people who looked at my paintings had to say about my paintings. And so I decided to devote myself to music." He found part-time employment providing music for a dance group and the underwater swimmers at UCLA, and he was listed as "assistant" to UCLA's experimental elementary school. With his aunt Phoebe, he taught a course in "Musical Accompaniments for Rhythmic Expression."[24] Thus began the early phase of his career, in which he would make a sparse living writing percussion music for dancers and involve himself in music as social work.

Meanwhile, Cage had become particularly interested in the music of the towering Austrian composer Arnold Schoenberg (1874–1951), whose international reputation was in the ascendant. Schoenberg had started out as a composer of extremely chromatic late Romantic tendencies, like Johannes Brahms, only more tonally ambiguous. More and more dissatisfied with what was coming to feel like the arbitrary confines of European tonality, Schoenberg took a decisive step in 1908 and wrote, in his Second String Quartet, the first music that was freely atonal, without key signature and without conventional chord progressions. For a decade he wrote densely psychological music without key, without melody, without articulated form, without harmonic method. At last, in 1921, Schoenberg invented a rigorous technique intended to give coherence to atonal materials: the twelve-tone method. The idea was to begin with the twelve tones of the chromatic scale in a certain order and to derive all pitch elements of the piece from that order—which could be transposed, turned backward, or turned upside-down. Schoenberg's twelve-tone method would find only a handful of adherents in the 1920s and 1930s, but after World War II it mushroomed into a dominant musical force across Europe and America.

Schoenberg's formalist methods have a surface similarity to the mathematical techniques Cage experimented

with in his early music, though it is unclear how much Cage would have known about Schoenberg at that point. Preparing to lecture about Schoenberg to his housewives, Cage wanted to present the op. 11 piano pieces (an early masterpiece of free atonality) but realized they were beyond his pianistic capability. However, the pianist who gave those pieces their American premiere was living in Los Angeles: Richard Buhlig. Showing his characteristic chutzpah, Cage called Buhlig out of the blue, asked him to contribute a performance, and was predictably turned down. He persevered, however, and later prevailed upon the pianist to teach him composition. When in 1933 Cage wrote a sonata for clarinet, Buhlig sent it to Henry Cowell for possible inclusion in Cowell's New Music Edition. Cowell declined to publish the work but included it on a concert. Thus was a connection made between two of the great minds in American music.

Henry Cowell had grown up in poverty in San Francisco but was encouraged by patrons who considered him a young genius. At the age of fifteen Cowell had included in his piano work *The Tides of Mananaun* chords of adjacent notes played with the palm or forearm, which he termed tone clusters. His even more radical *The Banshee*—endpoint of the 1952 Maverick concert—was performed on the piano strings directly, by strumming them, rubbing them, and scraping them with the fingernails, as directed

via notations Cowell invented for the purpose. Between 1923 and 1932 Cowell created a sensation with his unconventional piano playing, highlighted in five European tours, and in 1929 he became the first American composer invited to the young Soviet Union. No less a figure than Béla Bartók wrote to Cowell (around 1923) asking his permission to use tone clusters.

Cowell was also notable for his tireless efforts in promoting other composers; he directed the vital Pan American Association of Composers from 1928 to 1934 and founded New Music Editions to publish scores of the most "ultramodern" music (as it was termed at the time), including music by Ives, Varèse, Carl Ruggles, and Ruth Crawford. He was one of the first ethnomusicologists and did much to promote awareness of music of non-Western cultures. This last aspect would bear fruit in the later career of his student and protégé John Cage.

Cage would later recall, "Henry Cowell looked at my work, and told me that of all the living masters, the best one for me would be Schoenberg." First, however, he recommended that Cage study with Schoenberg's first American student, Adolph Weiss (1891–1971). From the spring of 1933 to the fall of 1934, Cage moved to New York to work as Cowell's assistant, study with Weiss, and play cards with Weiss, Cowell, and the American twelve-tone symphonist Wallingford Riegger. There, at the New

School for Social Research, where Cowell was teaching, Cage took courses in modern harmony, contemporary music, and non-Western musics. He made a living during this time by washing walls at a Brooklyn YWCA.[25]

On March 1, 1933, Germany's new Nazi government announced that all Jewish professors in Germany would be removed from their university posts. Schoenberg treated this announcement as his dismissal and left the country. Arriving in Boston on October 31, he taught there for a year and, in search of a warmer climate, moved to Los Angeles in September of 1934. Cage headed back out to Los Angeles to study with him. According to Cage, "Schoenberg was a magnificent teacher, who always gave the impression that he was putting us in touch with musical principles. I studied counterpoint at his home and attended all his classes at USC and later at UCLA when he moved there. . . . In all the time I studied with Schoenberg, he never once led me to believe that my work was distinguished in any way. He never praised my compositions, and when I commented on other students' work in class he held my comments up to ridicule. And yet I worshipped him like a god." Years later Peter Yates told Cage that in conversation Schoenberg had named Cage as his one interesting American pupil, adding (in words that have been perhaps too often quoted in trying to diminish the profile of Cage's music), "Of course he's not

a composer, but he's an inventor—of genius."[26] However, Schoenberg never named Cage in any public discussions of interesting American composers, and in 1950 he listed his twenty-eight best students, Cage not among them. His comment to Yates (related to Cage in a letter after Schoenberg's death) doesn't seem to typify any long-held opinion.[27]

During this period, Cage fell in love. Returning to California gave him entrée into the homosexual life of Los Angeles, and for a while he had a series of lovers of both sexes. Then one day he was tending his mother's arts and crafts shop when a young Reed College graduate from Juneau, Alaska, came in to browse. Cage would later recall, "Into the shop came Xenia, and the moment I saw her I was convinced we were going to be married. It was love at first sight on my part, not on hers. I went up and asked her if I could help her and she said she needed no help whatsoever. And so I retired to my desk and my music, and she looked around and finally went out. But I was convinced that she would return. Of course, in a few weeks, she did. This time I had carefully prepared what I was going to say to her. That evening we had dinner and the same evening I asked her to marry me. . . . She was put off a little bit, but a year or so later she agreed." Cage and Xenia Kashevaroff had a wedding in the desert at Yuma, Arizona, at 5 A.M. on June 7, 1935. Xenia was a

sculptor, collage artist, and bookbinder. Cage was open with her about his partly homosexual past, so that "even though the marriage didn't work any better than it did, there wasn't anyone to blame." The couple first lived with Cage's parents in Pacific Palisades, then moved to a place in Hollywood.[28]

In 1938, as Cage's studies with Schoenberg were winding down, Cowell recommended contacting Lou Harrison in San Francisco. Five years younger than Cage, Harrison would later be known as a large, jolly bearded man who wrote melodious music incorporating many influences from Pacific coast cultures, and who in his last decades was a kind of patron saint of California new music. For now, he had taken Cowell's ethnomusicology class at the University of California Extension at San Francisco and, also at Cowell's urging, had begun preparing for performance many of the manuscripts of the reclusive Charles Ives.[29] Like Cage, Harrison was interested in rhythm and percussion music, and he took work as a dance accompanist at Mills College. Cage and Harrison would become lifelong friends.

Harrison obtained for Cage a summer teaching job at Mills College and then recommended him to Bonnie Bird, a dancer who had started out with the Martha Graham troupe and with whom Harrison had collaborated, and who was now teaching at the Cornish School in Seattle.

So Cage and Xenia moved to Seattle for two years of in-tense work involving percussion music and dance, which would form the beginning of Cage's career. At Cornish Cage would meet dancers Doris Dennison, Syvilla Fort, and especially Mercier (later Merce) Cunningham, with whom he would form one of the great artistic partner-ships of the twentieth century.[30] Here he would also come across what many still consider his most successful inno-vation: the prepared piano.

The writing of percussion music was a growing pre-occupation in the 1930s, and Cage was not in on the ground floor. For centuries, classical music had been scored for ensembles of strings, woodwinds, and brass, punctuated by the occasional bass drum rumble or cym-bal crash. The emphasis in classical music was invariably on melody and harmony, with percussion relegated to a coloristic role. Use of percussion in eighteenth-century symphonies even carried "Turkish" connotations, for per-cussion instruments came from the Middle East. Then, in 1924 and 1925, inspired by Igor Stravinsky's janglingly primitive *Les noces* with its four pianos, American-in-Paris composer George Antheil wrote a *Ballet mécanique* that included, besides pianos, three xylophones, drums, wood and steel airplane propellers, electric bells, and a siren, among other percussion. In the same year, Danish com-poser Carl Nielsen included in his Sixth Symphony an

odd little *Humoreske* scored entirely for percussion plus a few woodwind solos.

Edgard Varèse's *Ionisation* of 1931—a noisy piece that required more than thirty players at its premiere but can be performed by any good college ensemble of thirteen players now—is often credited with being the first piece entirely for percussion ensemble, and Cage had heard the work's West Coast premiere at the Hollywood Bowl.[31] However, Varèse seems to have been anticipated by the *Rítmicas V* and *VI* (1930) of Cuban composer Amadeo Roldan (1900–1939), who, along with his countryman Alejandro García Caturla (1906–1940), was bringing musical elements of black Cuban folklore—such as the tango, conga, son, and rumba—into notated Western music for the first time. In any case, the repertoire for percussion had already made a splash before Cage became involved. One review he would later receive condescended to say, "I can only say that we went thru all this once before in this [*sic*] 1920s, when George Antheil and Edgar Varèse were at work, and I suppose we can go thru it again."[32]

In Seattle Cage organized a percussion orchestra, commandeering Xenia and the dancers as performers, and, soliciting additional works from other composers, arranged his first percussion concert for December 9, 1938. In order to write percussion music, which was mostly made up of

unpitched instruments and thus not susceptible to the traditional harmonic models of European music, Cage had to arrive at some new idea of rhythmic structure. His earliest compositions had been mathematical in nature—formalist, rather than expressive—and though he abandoned the pitch-permutational ideas that had so displeased his ear in his earliest experiments, he continued to believe that the arithmetical structuring of rhythm might be more fertile. Thus, in his first piece to experiment with rhythmic structure, *Imaginary Landscape No. 1* for percussion (1939), he employed a simple expanding sequence over four sections (given here as numbers of measures):[33]

5	5	5	1
5	5	5	2
5	5	5	3
5	5	5	4

In his *First Construction in Metal* (1939), he arrived at what he would call macro-microcosmic rhythmic structure, meaning that the rhythmic structure of the entire piece had the same proportions as each part of the piece. The rhythmic structure of *First Construction in Metal* is a sequence of time units in the pattern 4, 3, 2, 3, 4, adding up to 16. There are 16 sections to the work, and each section contains 16 measures. Each of the 16 sections articulates a measure pattern of 4, 3, 2, 3, 4, and the work as a whole

is divided into 5 sections with these proportions. Having predetermined these section guidelines, Cage then filled them in with rhythmic motives drawn from a chart he had made, articulating some of the sectional boundaries by switching from a solo by one player to a solo by another, or from one type of percussion instrument to another.

In some form or another, this macro-microcosmic rhythmic structure would remain one of Cage's primary compositional tools from 1939 to around 1956. He came to make a mental division between structure and content: structure being, for instance, the fourteen-line rhyme scheme of a sonnet, and content being the words and images with which it is filled. From this starting point he developed a four-part division of music, first outlined in his "Defense of Satie" lecture at Black Mountain College in 1948, into:

Structure, the empty form into which everything is put;

Form (formerly called content), the "morphological line of the sound continuity";

Method, the means used to produce continuity (such as, in Schoenberg's case, the twelve-tone row, or any orderly way of proceeding); and

Materials, the actual sounds or musical entities arranged into a continuity.

The purpose of this division, at least by 1948, was to render it possible to discuss two contradictory human needs: that for originality in music and that for the uniformity of opinion that made works communicative and compelling and rescued them from being merely private utterances. Form, for Cage, came from the heart and was the individual part of music that every composer needed to find for himself. Structure, the empty whole into which music was poured, was the socially agreed-upon part, such as sonata form or, in his case, rhythmic structure. "Sameness in this field is reassuring," he would write. "We call whatever diverges from sameness of structure monstrous."[34] A rhythmic structure was an empty stretch of time to be filled with sounds, or with sounds and silences.

In the idea of filling a time-space entirely with silences, we reach the composition of *4'33"*. As we will see in Chapter 5, Cage wrote (so he later explained) *4'33"* almost as a continuation of his macro-microcosmic piano piece *Music of Changes*, simply substituting silences for the notes that were chosen from charts used in the earlier work. Thus the only difference between *Music of Changes* and *4'33"* was a change of materials. The specific three-movement division used for *4'33"*, which may seem unnecessary for a work made up of silences, has its roots in this need for structure as the socially agreed-upon aspect of music. An

unarticulated stretch of silence would presumably have seemed too amorphous.

Another idée fixe of Cage's had to do with materials: the practice of making music not merely with traditionally musical sounds, but with noises. The idea was not original with him. The percussion pieces he had already heard put nonstandard noises to use, and one of his favorite books, Luigi Russolo's *The Art of Noises* (1916, to be discussed further in the next chapter), advocated using the sounds of machines to compose with. Cage had already, in 1937, delivered to the Seattle Sonic Arts Society a lecture that outlined his new attitude toward percussion music and noises in general.[35] Printed as the opening of his 1961 book *Silence*, it would become one of his most famous manifestos. The text, in typically innovative fashion, intertwines two parallel arguments. One, in capital letters, reads:

I BELIEVE THAT THE USE OF NOISE TO MAKE MUSIC WILL CONTINUE AND INCREASE UNTIL WE REACH A MUSIC PRODUCED THROUGH THE AID OF ELECTRICAL INSTRUMENTS WHICH WILL MAKE AVAILABLE FOR MUSICAL PURPOSES ANY AND ALL SOUNDS THAT CAN BE HEARD . . . WHEREAS, IN THE PAST, THE POINT OF DISAGREEMENT HAS BEEN BETWEEN DISSONANCE AND CONSONANCE,

IT WILL BE, IN THE IMMEDIATE FUTURE, BE-
TWEEN NOISE AND SO-CALLED MUSICAL SOUNDS.

The other text opens:

Wherever we are, what we hear is mostly noise. When
we ignore it, it disturbs us. When we listen to it, we
find it fascinating. The sound of a truck at fifty miles
per hour. Static between the stations. Rain. We want
to capture and control these sounds, to use them not
as sound effects but as musical instruments. Every
film studio has a "library of sounds" recorded on film.
With a film phonograph it is now possible to con-
trol the amplitude and frequency of any one of these
sounds and to give to it rhythms within or beyond
the reach of the imagination. Given four film phono-
graphs, we can compose and perform a quartet for
explosive motor, wind, heartbeat, and landslide.[36]

True to his word, Cage began experimenting with elec-
tronic sound resources he found in the Cornish School
radio station. Using records of frequency tones on
variable-speed turntables, he made an electronic accom-
paniment for a Jean Cocteau play performed in Seattle and
recycled this material into *Imaginary Landscape No. 1*.[37] A
1942 work titled *Credo in US* is scored for tin cans, gongs,
electric buzzer, tom-tom, piano, and phonograph, the last

of which is supposed to be used to play some favorite from the orchestral repertoire. One of the work's early recordings begins with the stirring opening of the Shostakovich Fifth Symphony, into which the tin cans and piano intrude rudely—and with somewhat comic effect.

Then, in March 1940, Syvilla Fort was scheduled to perform a dance concert on a Friday night, and on the previous Tuesday she didn't yet have any music to accompany it. The dance, titled *Bacchanale*, was to be "primitive, almost barbaric" in character, and she wanted an African theme. Cage started to think in terms of percussion, but found that the hall was too small to fit a percussion orchestra onstage; he was reduced to the piano. Unable to find a piano style appropriate to the dance—given the Schoenberg-induced serial style he was accustomed to when writing for pitched instruments—Cage decided, he later said, "that what was wrong was the piano, not my efforts, because I was conscientious."[38] Remembering Cowell's forays into the inside of the piano in *The Banshee* and *Aeolian Harp*, Cage began placing objects on the strings to alter the sound. The greatest success came with screws, which could be screwed between the piano strings, and pieces of felt or weather stripping, which could be squeezed in— both could be counted on to remain in place, and both dramatically altered the sound, turning a normal piano

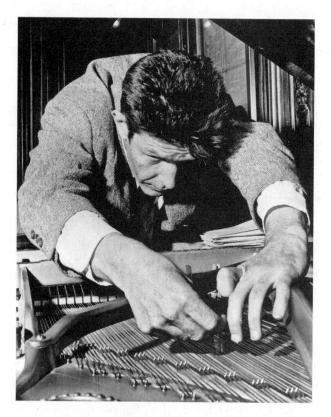

John Cage preparing a piano. Courtesy of the
John Cage Trust at Bard College.

into a one-person percussion orchestra. Cage christened
his invention the prepared piano. It would be the medium
that dominated his work through the 1940s and for which
he wrote much of his music that is still most widely appre-
ciated today.

The following September found the Cages moving
back to San Francisco, and soon afterward Cage found

employment with the Works Projects Administration, the program that Franklin Delano Roosevelt had instituted in 1935 (originally called the Works Progress Administration, but always the WPA) to give employment to millions of artists, artisans, and workers during the Great Depression. Because he wrote for percussion, the WPA wouldn't consider Cage a musician, but it hired him in the recreation project, which was defined as "employment of semi-skilled, skilled, and professional workers to provide leadership in leisure-time pursuits for children and adults as amateur participants."[39] In a 1982 interview, Cage connected this job with the origins of *4'33"*: "I had applied to be in the music section of the WPA, but they refused to admit me because they said that I was not a musician. I said, 'Well, what am I? I work with sounds and percussion instruments and so forth.' And they said, 'You could be a recreation leader.' So I was employed in the recreation department, and that may have been the birth of the silent piece, because my first assignment in the recreation department was to go to a hospital in San Francisco and entertain the children of the visitors. But I was not allowed to make any sound while I was doing it, for fear that it would disturb the patients. So I thought up games involving movement around the rooms and counting, etc., dealing with some kind of rhythm in space."[40]

In San Francisco Cage found himself part of a group

of composers who were writing unconventional music for percussion and other forces: in addition to Cowell and Lou Harrison, William Russell (1905–1992), who wrote a handful of innovative percussion works before disappearing from the music world and only reappearing decades later; Harry Partch, whose main interest at this time was microtonality, the use of more than twelve pitches per octave; and Alan Hovhaness, one of the most prolific symphonists of modern times. Cage and Harrison presented percussion concerts and collaborated on a piece called *Double Music*, for which they decided on a rhythmic structure first and then wrote their own parts independently. In July of 1941 Cage was teaching at Mills College again, where he met Virgil Thomson (1896–1989)—a Missouri composer who had lived in Paris until the outbreak of World War II, and who presumably introduced Cage to the works of Erik Satie, whom he had known personally—and met once again László Moholy-Nagy (1895–1946), the Hungarian-born painter, sculptor, and photographer who had come to America both to escape the war and to spread the Bauhaus religion in America.

The Bauhaus was a school founded in Weimar which propagated a philosophy of art heavily based in design and technology, and emphasizing simplicity and rationalized functionality. The school was closed down by the Nazis in 1933, scattering many of its illuminati to the Western

hemisphere. Moholy-Nagy ended up in Chicago in 1937 to found the New Bauhaus School, which was soon re-named the Institute of Design. Visiting San Francisco, he invited Cage to come out and teach a course in experi-mental music. So the Cages headed east. Cage's ambitious course description in the catalogue promised "exploration and use of new sound materials; investigation of manual, vocal, mechanical, electrical, and film means for the pro-duction of sound; sound in the theater, dance, drama, and the film; group improvisation; creative musical expres-sion; rehearsal and performance of experimental music; the orchestra."[41]

In Chicago, Cage had a brief stint as a music critic for the journal *Modern Music,* accompanied dance classes at the University of Chicago, produced an electronic score for a play by poet Kenneth Patchen, and met the painter Max Ernst (1891–1976), who was there on a visit. Ernst gave the Cages an open invitation to New York and ar-ranged for his companion, the millionaire art collector Peggy Guggenheim (1898–1979), to celebrate the open-ing of her new gallery with a concert of Cage's percus-sion music. Off again the Cages traveled, to New York in spring of 1942 with twenty-five cents left over after their bus fare. Living at first with Ernst and Guggenheim, they were plunged into a heady world of famous abstract expressionist artists: Arshile Gorky, Joseph Cornell,

Roberto Matta, Jackson Pollock, Piet Mondrian, Robert Motherwell. Yet Cage, on his own effort, succeeded in arranging a concert at the Museum of Modern Art, and when the imperious Guggenheim learned of this, she cancelled the planned concert at her gallery and initiated plans for the termination of the Cages' visit.[42]

They next stayed with Joseph Campbell, the great writer on world mythology, and his wife, the dancer Jean Erdman. Erdman was collaborating with Merce Cunningham, whom Cage hadn't seen much of since Cunningham had left Seattle in 1939 to dance with the Martha Graham company in New York.[43] (Later, in 1949, Erdman would introduce Cage to her accompanist, David Tudor.)[44] Cage paid his rent by writing music for Erdman's dances, and his eventual concert at the Museum of Modern Art, which took place on February 7, 1943, brought an onslaught of publicity. The program was as follows:

Cage: *Construction in Metal*
Lou Harrison: *Counterdance in the Spring*
Henry Cowell: *Ostinato Pianissimo*
Harrison: *Canticle*
Cage: *Imaginary Landscape No. 3*
Jose Ardévol: *Preludio a 11*
Cage: *Amores*
Amadeo Roldan: *Rítmicas V & VI*

The event earned a two-full-page spread in *Life* magazine, and the anonymous reviewer, if a bit condescending, was bemused and not without insight:

At the Museum of Modern Art in New York City a few Sundays ago, an orchestra of earnest, dressed-up musicians sat on the stage and began to hit things with sticks and hands. They whacked gongs, cymbals, gourds, bells, sheets of metal, ox bells, Chinese dishes, tin cans, auto brake drums, the jawbone of an ass and other objects. Sometimes instead of hitting, they rattled or rubbed. The audience, which was very highbrow, listened intently without seeming to be disturbed at the noisy results.

The occasion was a percussion concert, sponsored by the League of Composers and conducted by a patient, humorous, 30-year-old Californian named John Cage, who is the most active percussion musician in the U.S. Cage not only conducts percussion orchestras but also composes percussion music, as do other modern experimental composers. Percussion music goes back to man's primitive days when untutored savages took aesthetic delight in hitting crude drums or hollow logs. Cage believes that when people today get to understand and like his music, which is produced by banging one object with another, they

will find new beauty in everyday modern life, which
is full of noises made by objects banging against each
other.[45]

This heady attention did not at all mean that Cage's days
of struggling were over. Of this concert and its reception,
he would later remark, "I discovered that no matter how
well-known you are, it doesn't mean anything in terms
of employment or willingness to further your work or do
anything." In fact, Cage's output over the next few years
turned away from the percussion orchestra and more and
more toward the prepared piano, on which he could per-
form as a soloist.[46] He found what many composers after
him have found, that in New York City rehearsal time and
space are extremely dear, and you can only sustain a career
if you can do much of the work by yourself.

The reentry of Merce Cunningham into Cage's life
from 1942 on spelled the beginning of the end of Cage's
marriage to Xenia. The trio experimented with ménage
à trois, and in so doing Cage realized that, sexually, he
was more drawn to Cunningham. Cage and Xenia finally
divorced in 1945, while Cage became the music director
for the nascent Merce Cunningham Dance Company, a
pairing that would become one of the great music-dance
collaborations of history. During this period Cage wrote
a series of pieces for prepared piano whose very titles, as

David Revill has pointed out, seem indicative of psycho-
logical distress: *Tossed as It Is Untroubled* (1943), *The Peril-
ous Night, Root of an Unfocus, A Valentine Out of Season* (all
1944), *Daughters of the Lonesome Isle* (1945).[47]

A private man about his personal life, Cage doesn't
provide us with much information about the nature of his
crisis. In a 1992 interview with Thomas Hines, ten weeks
before his death, Cage confided that his love life had been
an ongoing trial because he didn't know how to "practice
the emotions" properly. Going on, he said,

> I'm entirely opposed to the emotions . . . I really am.
> I think of love as an opportunity to become blind and
> blind in a bad way . . . I think that seeing and hearing
> are extremely important; in my view they are what life
> is; love makes us blind to seeing and hearing.[48]

Cage revealed another intriguing hint during a talk in
Peter Gena's class at the School of the Art Institute of
Chicago in 1988:

> So when it was clear from a Rorschach test that I took
> in the '40s, at the time when my life, both as a com-
> poser and as someone married—when I saw that all of
> these things were in question—I had a Rorschach test
> and it was shown very clearly that I was in a disturbed
> state of mind.[49]

Relatedly, Cage came in the 1940s to a crisis in his conception of the purpose of music itself. In particular, he was trying to express emotion in music, and the emotions he intended were not coming through. The crisis crystallized around his prepared piano piece *The Perilous Night*, after a reviewer likened the sound of the piece to "a woodpecker in a church belfry":

> I had poured a great deal of emotion into the piece, and obviously I wasn't communicating this at all. Or else, I thought, if I *were* communicating, then all artists must be speaking a different language, and thus speaking only for themselves. The whole musical situation struck me more and more as a Tower of Babel.[50]

Concerned by Cage's apparent emotional distress over his divorce and the ongoing change in his sexual identity, his friends counseled psychoanalysis, but Cage was distrustful of the idea. As he liked to tell the story: "I was never psychoanalyzed. I'll tell you how it happened. I always had a chip on my shoulder about psychoanalysis. I knew the remark of Rilke to a friend of his who wanted him to be psychoanalyzed. Rilke said, 'I'm sure they would remove my devils, but I fear they would offend my angels.' When I went to the analyst for a kind of preliminary meeting, he said, 'I'll be able to fix you so that you'll

write much more music than you do now.' I said, 'Good heavens! I already write too much, it seems to me.' That promise of his put me off."[51]

"And then in the nick of time," the story continues, "Gita Sarabhai came from India." Sarabhai was an heiress from a wealthy Indian family who was worried about the deleterious influence that the spread of Western music was having on the classical traditions of her native country; in an attempt to understand and circumvent it, she traveled to New York in 1946 to study the European musical system. Here she met Cage, and the two agreed that he would teach her about counterpoint and modern music if she would teach him about Indian music and the philosophy and culture behind it. "We were together almost every day, often with Lou Harrison," Cage would later claim.[52] From Sarabhai, Cage learned much more than music. She introduced him to the world of Asian thought and philosophy, which he had already been edging toward in his reading. David Patterson deduces that Cage had discovered Ananda K. Coomaraswamy's book *The Transformation of Nature in Art* as early as 1942.[53] To that, Cage would soon add Aldous Huxley's *The Perennial Philosophy*, Coomaraswamy's *The Dance of Shiva*, Huang-Po's *The Doctrine of Transmission of Mind*, the sermons of Meister Eckhart, Carl Jung's *The Integration of the Personality*, R. H. Blyth's *Zen in English Literature and Oriental*

Classics, and *The Gospel of Sri Ramakrishna* (a gift from Sarabhai). In short, Cage healed his own mental state in the late 1940s through thorough study of comparative religions, with special emphasis on Zen Buddhism.

People who know Cage only by his wild reputation and from his post–*4′33″* music are generally dumbfounded when confronted with the gentle beauty of his music of the late 1940s. He later gained a dubious notoriety for being the "anything goes" composer, creator of shocking, bewildering, yet often boring works, in which any group of actions might occur simultaneously and notes bounce around forever at random. In contrast, however, his music of the late '40s, most of it for piano or prepared piano, is typically delicate, meditative, and lyrical. In the "Lecture on Nothing," he would write, "Half-intellectually and half sentimentally, when the war came along, I decided to use only quiet sounds. There seemed to be no truth, no good, in anything big in society. But quiet sounds were like loneliness, or love or friendship. Permanent, I thought, values, independent at least from Life, Time and Coca-Cola."[54] Though later in the 1950s and 1960s he ended up as a kind of one-man counterpart to the brash European serialist avant-garde, Cage started out closer to Erik Satie, Alan Hovhaness, Virgil Thomson, and Henry Cowell: music that rejected modernism to go backward in a sense, into a simpler, almost precivilized soundworld. He would be-

come the advance man for the psychedelic '60s, but first he would go through a period of almost neomedievalism.

Experiences No. 1 for two pianos (1945) and *Experiences No. 2* for solo voice (1948) are entirely modal, couched in a natural minor scale on A, with no sharps or flats. *The Seasons* (1946) is a gentle, meandering orchestra piece given to celesta solos. *Dream* (1948) is a piano solo played mostly as a single melodic line, wandering within a simple diatonic scale. The String Quartet in Four Parts (1949–50) restricts itself to a limited number of sonorities, sometimes merely rocking back and forth between a pair of them. The lyrical simplicity of the Six Melodies for violin and piano (1950) would sound almost late-nineteenth-century French were it not for the spareness of their harmonies. Much more energetic, the Three Dances for two amplified prepared pianos (1945) bristle with perpetual motion, an entertaining barn burner of a piece. And *In a Landscape* (1948) is almost impressionist, a slow rippling of arpeggios on major seventh chords, closer to the famous *Gymnopédies* of Satie than to anything twentieth century. Cage wrote a body of music in these years that could endear itself to the most reactionary antimodernist. He has often been cited as having anticipated in this music not only minimalism (and, even more, its less strict successor postminimalism) but even New Age music.

From 1946 to 1948 Cage worked on the piece that many

still consider his magnum opus: *Sonatas and Interludes* for prepared piano. Most of the sixteen sonatas are written, anachronistically enough, in a simple binary sonata form inherited from the early eighteenth century, with the piece divided in two and each half repeated. (Interestingly, his friend Lou Harrison, whose sympathies with ancient music were more overt, had used the same form for his Six Sonatas for Cembalo or Pianoforte of 1943.) The young pianist Maro Ajemian premiered *Sonatas and Interludes* on January 11, 1949. It was one of the few Cage works about which there has been almost no controversy—nearly everyone considers it a well thought-out, substantial work, even a masterpiece. Recent researches locate no fewer than seventeen full or partial recordings of the piece. Cage had summed up his life's work to date: the percussion music, the rhythmic structures, the prepared piano, the gentle explorations into different emotions—and it was time to move on to something new.

Dramatis Personae (Predecessors and Influences)

The meme that Cage was more of a music philosopher than a composer has become a commonplace, most of all, it seems, among people who don't like his music and are in need of a way to justify his celebrity. Cage was not a philosopher in any sense that the philosophy profession would recognize, but he was very much a composer who drew inspiration for his music from philosophical ideas. The list of artists, writers, and thinkers he names in justification of his musical trajectory is a long one: Meister Eckhart, Huang-Po, Kwang-Tse, Erik Satie, Henry David Thoreau, Gertrude Stein, Arnold Schoenberg, John Cage Sr., Marcel Duchamp, Sri Ramakrishna, Daisetz Suzuki, Joseph Campbell, Ananda K. Coomaraswamy, Alan Watts, Antonin Artaud, Robert Rauschenberg,

Morton Feldman, David Tudor, Norman O. Brown, Marshall McLuhan, Buckminster Fuller, Gita Sarabhai, and Christian Wolff, among others. Cage was one of the great name-droppers in twentieth-century music. Sometimes he did no more than drop them. "Need I quote Blake?" he pointedly asks in "45′ for a Speaker," and answers himself, "Certainly not."[1]

Before documenting the specific process that led to Cage's composition of *4′33″*, we will do well to highlight some of the historical figures and friends who led him in the direction of silence, meditation, and environmental sound. Some of these figures will appear again as contacts Cage cited as leading directly to the work; others are dealt with only here as relevant influences with whose work Cage was thoroughly familiar.

Erik Satie

In 1948 Cage took up a deliberate position as defender of arguably the most eccentric composer in the history of classical music, Cage himself included: Erik Satie (1866–1925). Author of mostly piano pieces with a whimsical sense of humor, and a tunesmith of pop songs who made his living as a cabaret pianist, Satie is a perennial fringe figure in classical music: scorned as a lightweight by academia and the orchestral elite, yet winning in each new

Erik Satie. Courtesy of the Archives Erik Satie, Paris.

generation countless fans for his effervescent originality and nose-thumbing irreverence. For Cage to take up the cudgel for Satie in 1948, organizing a festival of his music and lecturing on him at Black Mountain College, was a surprising move for the time, for after a period of bad-boy celebrity in Paris in the 1920s, Satie had been largely forgotten. Cage's interest would help spur a Satie renaissance in the 1960s.

Satie may remain forever best known for a trio of gentle, hypnotically repetitive piano works he wrote at

age twenty-two and gave the invented title *Gymnopédies* (1888). Declared untalented by his teachers at the Paris Conservatoire, Satie left school; later stung by criticisms of his music's eccentricities, he took the remarkable step of enrolling at the Schola Cantorum at age 39 and studying composition with Albert Roussel, a composer three years younger than himself. Satie satirized his education in works such as *Embryons desséchés* ("Dried-up embryos") and *Sonatine bureaucratique*. However, he was a close friend of the more famous Claude Debussy, and Satie did attract helpful patrons such as the Princess Edmond de Polignac, who commissioned his magnum opus, *Socrate* (1918), based on three texts from Plato's Socratic dialogues. Cage made a piano arrangement of *Socrate* for a dance by Merce Cunningham and later used chance processes to transform the piece's melody into his 1969 piano work *Cheap Imitation*.

Around 1919 Satie became connected with the Dadaist movement around Tristan Tzara, and in the 1920s he found a new celebrity as the author of such absurdist ballets as *Parade* (which features a typewriter in the orchestra) and *Relache* (which includes a Dada-flavored film segment featuring the artists Marcel Duchamp, Francis Picabia, Man Ray, and Satie himself).

Among Satie's works, two would seem to possess particular significance toward the direction of *4'33"*. One is a series of pieces written between 1917 and 1923 under

the umbrella term *musique d'ameublement*, which is usually rendered as "furniture music," or "furnishing music." One day Satie and the painter Fernand Léger were at a restaurant where the resident orchestra became too loud for comfort. Satie turned to Léger and said, "You know, there's a need to create furniture music, that is to say, music that would be a part of the surrounding noises and that would take them into account. I see it as melodious, as masking the clatter of knives and forks without drowning it completely, without imposing itself. It would fill up the awkward silences that occasionally descend on guests. It would spare them the usual banalities. Moreover, it would neutralize the street noises that indiscreetly force themselves into the picture."[2] The one experimental performance of Satie's furniture music during his lifetime took place on March 8, 1920, at the Galérie Barbazange. The selections, which used quotations from music by Camille Saint-Saëns and Ambroise Thomas over repetitive ostinato accompaniments, were scored for three clarinets, trombone, and piano duet and were played during the intermissions of a play by Max Jacob. The younger composer Darius Milhaud, who assisted Satie, captured the scene for posterity:

In order that the music might seem to come from all sides at once, we posted the clarinets in three different

corners of the theatre, the pianist in the fourth, and the trombone in a box on the first floor. A programme note warned the audience that it was not to pay any more attention to the ritornelles that would be played during the intervals than to the candelabra, the seats, or the balcony.

Contrary to our expectations, however, as soon as the music started up the audience began streaming back to their seats. It was no use for Satie to shout: "Go on talking! Walk about! Don't listen!" They listened without speaking. The whole effect was spoilt. . . . Satie had not bargained for the charm of his own music.[3]

Long hailed as the direct predecessor to both Muzak and ambient music, Satie's *musique d'ameublement* might be seen as the flip side of *4′33″*—instead of playing nothing and asking people to listen to environmental sounds, Satie played music *as* environmental sound, and begged people—in vain—not to listen to it!

The other radical gesture of Satie's was a little manuscript found in his apartment after his death, a chorale of thirty-four chords bearing the title *Vexations*. The manuscript, which scholars date to around 1893, bears the enigmatic instruction, in French, "To play this motif for oneself 840 times in a row, it will be good to prepare

oneself beforehand, and in the greatest silence, through serious immobilities." It's certainly arguable how serious Satie was—his more conventional piano pieces contained absurd and humorous expression markings such as "like a nightingale with a toothache." Nevertheless, Cage discovered the little piece (which had been known to only a few) in 1949, arranged for its publication in the magazine *Contrepoints*, and organized a performance at the Pocket Theater in New York on September 9, 1963, at which a team of twelve pianists (including David Tudor and composers Christian Wolff, James Tenney, Philip Corner, David Del Tredici, and John Cale) took turns playing through the 840 suggested repetitions, a feat which took eighteen hours and forty minutes.[4]

Called "a poor man's *Ring of the Nibelungs*" by composer Gavin Bryars, *Vexations* has since become a recurring ritual of the avant-garde: performances are surprisingly frequent (I have participated in three, in Austin, Chicago, and New York).[5] Richard Cameron-Wolfe, James Cuomo, and a few others have even succeeded in performing the piece without assistance. The thirty-four chords Satie wrote are mildly dissonant and non-directed, leading to no cadence. Descriptions of the marathon, by listeners and performers, often allude to hallucinogenic effects and a strange suspension in the passage of time. The piece

The score to Satie's *Vexations*.

seems like a test case for something that Cage would often subsequently quote: "In Zen they say: If something is boring after two minutes, try it for four. If still boring, try it for eight, sixteen, thirty-two, and so on. Eventually one discovers that it's not boring at all but very interesting."[6] In any case, playing the same inconclusive fragment of music 840 times in a row could be considered the same kind of Dadaist, anti-art gesture as playing a piece with no sounds in it at all. Cage's discovery of *Vexations* might have made the idea of a "silent sonata" far less radical by comparison. "A performance of this piece," Cage wrote in 1951, "would be a measure—accurate as a mirror—of one's 'poverty of spirit,' without which, incidentally, one loses the kingdom of heaven."[7]

Nevertheless, in the short run Cage took something from Satie's music that had more direct implications for *4′33″*. In his lecture "Defense of Satie," delivered in conjunction with his Satie festival at Black Mountain, Cage elaborated the fourfold division of music into structure, form, method, and materials, and credited Satie, along with Anton Webern (1883–1945), with producing the only new idea of structure in modern music:

> In the field of structure, the field of definition of parts and their relation to a whole, there has been only one new idea since Beethoven. And that new idea can be perceived in the work of Anton Webern and Erik Satie. With Beethoven the parts of a composition were defined by means of harmony. With Satie and Webern they are defined by means of time lengths. The question of structure is so basic, and it is so important to be in agreement about it, that one must now ask: Was Beethoven right or are Webern and Satie right?
>
> I answer immediately and unequivocally, Beethoven was in error, and his influence, which has been as extensive as it is lamentable, has been deadening to the art of music.

Cage goes on to justify his historical heresy in theoretical terms:

It is very simple. If you consider that sound is characterized by its pitch, its loudness, its timbre, and its duration, and that silence, which is the opposite and, therefore, the necessary partner of sound, is characterized only by its duration, you will be drawn to the conclusion that of the four characteristics of the material of music, duration, that is, time length, is the most fundamental. Silence cannot be heard in terms of pitch or harmony: It is heard in terms of time length. It took a Satie and a Webern to rediscover this musical truth, which, by means of musicology, we learn was evident to some musicians in our Middle Ages, and to all musicians at all times . . . in the Orient. . . .

There can be no right making of music that does not structure itself from the very roots of sound and silence — lengths of time.[8]

This is an argumentative, almost shocking lecture, in its rhetoric as well as in its attempt to pull Beethoven off his pedestal — and in front of the largely Germanic scholars present at Black Mountain yet! — and replace him with a not yet well-known French composer considered little more than a jokester in academic music circles. In addition, its historical analysis does not entirely stand up to scrutiny. Section length in the late works of Webern

tends to be determined by the time it takes to articulate each twelve-tone row or set of rows. To say that the form of Webern's music is not determined by harmony is generally true, but to imply that he worked out his musical durations in advance and then filled them in with tone rows doesn't accord well with the organic surface of Webern's music.

Applied to Satie, the argument is tenuous, but more feasible. The intercutting among unrelated materials, the sudden and unmotivated key shifts, in Satie's music do suggest that he thought of section lengths as freed from harmonic constraints (or rather, articulated by harmonic non sequiturs), and some charts among Satie's sketches seem to suggest that he attempted to structure his late ballet *Relache*, and its accompanying film sequence *Entr'acte*, according to proportionate numbers of measures. More securely, much of the intercutting and repeated phrases in a Satie work like *Socrate* has a similar effect to the works Cage was composing using macro-microcosmic form such as *In a Landscape*. To this extent, many of Cage's works of the 1940s seem closely derived from Satie's structural methods, even if Satie was not thinking of them in as mathematical or premeditated a way as Cage was. (Cage's reference to the Middle Ages was on target: the isorhythmic motet of the fourteenth and fifteenth centuries was typically built up of predetermined durations.)

More important, the assertion that music should be structured from time lengths rather than harmony, so as to provide for the ability to structure silence, was an obvious necessary step on the road to *4′33″*, however directly or indirectly Cage drew such an idea from his study of Satie's music.

Luigi Russolo

Luigi Russolo (1885–1947) was an Italian painter, inventor, and composer who around 1913 became obsessed with the idea of making music from noises. Impressed by the controversy caused by an orchestra piece called *Musica futurista* by his friend Francesco Balilla Pratella (1880–1955), Russolo wrote in 1913 a manifesto titled *L'arte dei rumori* (The Art of Noises) and in 1916 expanded it into a book—having, meanwhile, experimented with new noise-making instruments of his own invention. (Along with Filippo Tommaso Marinetti [1876–1944], these artists were known as the Italian Futurists.) Cage mentioned *The Art of Noises* in his 1948 lecture at Vassar in which he prophesied *4′33″*, and, at Wesleyan in 1960, he would list it as one of ten books that most influenced him.

A chapter from *The Art of Noises* called "The Noises of Nature and Life" anticipates *4′33″* somewhat, though with considerably more effusion, in its appreciation for

noises heard in both rural and urban environments. With considerable discrimination, Russolo apostrophizes the sounds of thunder, wind, rain, and the rustling of trees:

> The poplar makes its eternal *moto perpetuo.* The weeping willow has long and delicate tremblings, like its leaves. The cypress vibrates and sings everything with a chord. The oak and the plane tree have rough and violent motions, followed by sudden silences. . . .
>
> And here it can be demonstrated that the much poeticized silences with which the country restores nerves shaken by city life are made up of an infinity of noises, and that these noises have their own timbres, their own rhythms, and a scale that is very delicately enharmonic in its pitches. It has been neither said nor proven that these noises are not a very important part (or in many cases the most important part) of the emotions that accompany the beauty of certain panoramas, the smile of certain countrysides!
>
> But let us leave nature and the country (which would be a tomb without noises) and enter a noisy modern city. Here, with machines, life has created the most immense, the most varied sources of noise. But if the noises of the country are few, small, and pleasing, then those of the city . . . Oh! To have to listen to noises from dawn to dusk, eternal noise![9]

Russolo's painstaking description of urban noises might serve as a characterization of a performance of *4'33"* in an urban concert hall:

> A general observation that is useful in studying noises in the city is this: in places where continuous noises are produced (much-used streets, factories, etc.) there is always a low, continuous noise, independent to a certain degree of the various rhythmic noises that are present. The noise is a continuous low sound that forms a *pedal* to all the other noises. . . .
>
> The street is an infinite mine of noises: the rhythmic strides of the various trots or paces of horses, contrasting with the enharmonic scales of trams and automobiles, and the violent accelerations of their motors, while other motors have already reached a high pitch of velocity.[10]

However much it seems that Russolo analyzed his street noises as though they were themes in a sonata, one gets the impression that he must have spent long periods enjoying his own private performances of *4'33"*. Moreover, his justification that such a music of noises will increase the listener's appreciation of modern life foreshadows Cage's with remarkable specificity (or perhaps more accurately, Cage echoed the idea). Russolo writes:

The constant and attentive study of noises can reveal new pleasures and profound emotions.

I remember that the performers that I had employed for the first concert of noise instruments in Milan had to confess this truth, with deep wonder. After the fourth or fifth rehearsal, *having developed the ear* and having grown accustomed to the pitched and variable noises produced by the noise instruments, they told me that they took great pleasure in following the noises of trams, automobiles, and so on, in the traffic outside. . . . It was the noise instruments that deserved the credit for revealing these phenomena to them.[11]

Marcel Duchamp

When Peggy Guggenheim discovered Cage's arrangement of a concert at the Museum of Modern Art, canceled his performance at her gallery, and proceeded to banish him from her lodgings, Cage burst into tears. A man smoking a cigar in an adjoining room stepped in to ask what the matter was. In response to Cage's explanation, "he said virtually nothing," Cage later recalled, "but his presence was such that I felt calmer. . . . He had calmness in the face of disaster." The man was Marcel Duchamp, and he would become something of a mentor to Cage.[12]

Cage often noted Duchamp as his most profound influence. On the day after Duchamp's death, Cage was walking along 10th Street with Duchamp's widow, Teeny. "I said, needing some courage to do so: You know, Teeny, I don't understand Marcel's work. She replied: Neither do I. [Cage continues:] While he was alive I could have asked him questions, but I didn't. I preferred simply to be near him. I love him and for me more than any other artist of this century he is the one who changed my life."[13]

Born into an artistic family, Duchamp (1887–1968) developed quickly through the series of movements that enlivened painting in the early decades of the century. His painting career came to a near halt with his most famous work: *Nude Descending a Staircase, No. 2* (1912), a "portrait" of a machine-like figure whose downward motion is captured cinematically as in a multiple-exposure photograph. The Salon des Indépendants to which he submitted it refused to exhibit what seemed almost like a satire of a painting, but the piece was an instant success at the Armory Show in New York the following year. As critic Robert Lebel has written, "There was no question that as a painter Duchamp was on a footing with the most gifted. What he lacked was faith in art itself, and he sought to replace aesthetic values in his new world with an aggressive intellectualism opposed to the so-called common-sense world."[14]

Thus Duchamp's career as any kind of conventional painter was basically over at age 25. What came next, more relevant to Cage, was a series of "ready-mades," found objects reinterpreted as art. The most famous of these was *Fountain* (1917), an ordinary urinal submitted under the name R. Mutt. Perhaps even more scandalous was a photograph of Leonardo da Vinci's *Mona Lisa* with a mustache painted on her face, and the title *L.H.O.O.Q.*—which, in French, sounds like a sentence meaning "There is a fire down below," a pointed sexual reference. Although Duchamp's sexually charged world was distant from Cage's Protestant puritanism, one can see a parallel between *Fountain* and *4′33″*: in each case an artist presents before the public materials (ceramic, environmental sounds) which he did not create himself, but which become subjects of aesthetic perception merely through the act of presentation in a traditionally artistic setting. In addition, Duchamp anticipated Cage in using chance processes to make music; in 1913 (when Cage was a baby), Duchamp, with his sisters, had produced a piece of music called *Musical Erratum* in which notes of the scale were drawn at random from a hat.[15]

Cage ran into Duchamp occasionally from 1942 onwards, and in 1954 he gathered the courage to ask Duchamp to teach him to play chess, at which the artist was a master and about which he had even written a book.

Duchamp agreed, and the two afterward met twice a week whenever possible. "He spoke constantly against the retinal aspects of art," Cage said, whereas "I have insisted upon the physicality of sound and the activity of listening. . . . You could say I was saying the opposite of what he was saying, yet I felt so much in accord with everything he was doing that I developed the notion that the reverse is true of music as is true of the visual arts." Morton Feldman said something similar, but more succinct: "Duchamp freed the mind from the eye, while Cage freed one's ears from the mind."[16]

Ananda K. Coomaraswamy

Ananda K. Coomaraswamy (1877–1947) was a pioneer historian of Asian art, especially Indian, who served from 1916 until his death as curator at the Boston Museum of Fine Arts. His father was Sinhalese, his mother English, and though born in Ceylon he was raised in England from the age of two. He first trained as a geologist, but a period spent directing the newly formed Geological Survey of Ceylon formed a turning point in his life. Driven by a resentment of British imperialism, he re-formed himself as an explicator of non-Western art and a protector of traditions that Western dominance had devalued. His first major publication was a treatise on Sinhalese art of the

seventeenth through the nineteenth centuries. As his expertise deepened, he came to see both Indian and medieval European art as expressing a "higher wisdom" of which the post-Renaissance European and American art worlds had lost sight, to their extreme detriment and decreasing relevance to human life. This view didn't originate with him; he cited, for instance, the work of the nineteenth-century historian of Indian architecture James Fergusson, who became convinced that then-current Indian architectural methods shed light on those of medieval Europe.[17] It was Coomaraswamy, though, who brought the idea into public consciousness in 1940s New York. Despite his dubious view of personalized modern art, Coomaraswamy was a close friend of the photographer Alfred Stieglitz, his wife the painter Georgia O'Keeffe, and Cage's eccentric painter friend Morris Graves. A strong ascetic streak notwithstanding, Coomaraswamy and his successive wives were at home in the Bohemian circles of artistic Manhattan.

David Patterson speculates that Cage might have been introduced to Coomaraswamy's writings as early as 1942, when he came to live with the mythologist Joseph Campbell, who was a writer closely concerned with Indian aesthetics.[18] On a superficial reading, Coomaraswamy might seem like the last writer in whom an avant-garde composer like Cage would find inspiration. Much of Coomaraswamy's energy was devoted to valorizing the religious

art of Asia and medieval Europe at the expense of the more individual and idiosyncratic art of modern Europe and America. He was perennially criticized for seeming to advocate the abandonment of modernity and for quixotically willing a return to a preindustrial way of life. Coomaraswamy often echoes Plato: "New songs, yes; but never new kinds of music, for these may destroy our whole civilization."[19] He accepts rather dogmatically an ancient view that art is always a representation of something, and that it is always meant to be useful—not positions that would resonate in Cage's music of the 1940s or any other period. As his biographer Roger Lipsey puts it, Coomaraswamy believed that "beauty is always *for* something"— even the light of dawn is a call to action.[20] The contrast with Cage's emphasis on purposelessness and letting the sounds be themselves could hardly be more complete.

As Patterson points out, Cage's "creative misreading" of Coomaraswamy is not simply an adoption of ideas but a wholesale subversion of them. Patterson characterizes it as "a particular type of appropriation whereby the basic elements and unifying structure of an idea are maintained, though the intended effect is first undercut and then reversed (i.e., subverted) by a motivation contrary to the idea's original purpose."[21] Throughout his writings, Cage collects authors to buttress his views on music and life but often projects his own meanings into them, taking what

views he needs and transforming them to fit into his own context.

Coomaraswamy rejects any distinction between fine arts and applied arts and harshly criticizes the museum culture that separates works of art from daily life. For Plato, he says approvingly, "painting and agriculture, music and carpentry and pottery are all equally kinds of poetry or making." Likewise—and this will become a theme in Cage's life—Coomaraswamy rejects the modern distinction by which some people are artists and others are not. "The artist is not a special kind of man, but every man who is not an artist in some field, every man without a vocation, is an idler."[22] Self-expression plays only an incidental role, never a central one, and our culture's emphasis on the human personality in art is nothing less than a perversion:

> There is also a sense in which the man as an individual "expresses himself," whether he will or no. This is inevitable, only because nothing can be known or done except in accordance with the mode of the knower. . . . The uses and significance of works of art may remain the same for millennia, and yet we can often date and place a work at first glance. Human idiosyncrasy is thus the explanation of style. . . . Styles are the basis of our histories of art, which are written like

other histories to flatter our human vanity. But the
artist whom we have in view is innocent of history and
unaware of the existence of stylistic sequences. Styles
are the accident and by no means the essence of art;
the free man is not trying to express himself, but that
which was to be expressed. Our conception of art as
essentially the expression of a personality, our whole
view of genius, our impertinent curiosities about the
artist's private life, all these things are the products
of a perverted individualism and prevent our under-
standing of the nature of medieval and oriental art.[23]

According to Coomaraswamy's Perennial Philosophy, all
art is imitation, but not in a literal visual sense:

All the arts, without exception, are representations or
likenesses of a model; which does not mean that they
are such as to tell us what the model looks like, which
would be impossible seeing that the forms of tradi-
tional art are traditionally imitative of invisible things.
. . . Works of art are reminders; in other words, sup-
ports of contemplation.

Art is not something for the senses, but for the intellect:

In this sense art is the antithesis of what we mean by
visual education, for this has in view to tell us what
things that we do not see, but might see, look like. It

is the natural instinct of a child to work from within outwards; "First I think, then I draw my think." What wasted efforts we make to teach the child to stop thinking, and only to observe! Instead of training the child to think, and how to think and of what, we make him "correct" his drawing by what he sees.

This does sound a little like Duchamp's "freeing the mind from the eye." And in speaking of the Indian concept of mimesis, Coomaraswamy finds himself appropriating a formulation from St. Thomas Aquinas:

> Nature, for example in the statement "Art imitates nature in her manner of operation," does not refer to any visible part of our environment; and when Plato says "according to nature," he does not mean "as things behave," but as they should behave, not "sinning against nature." The traditional Nature is Mother Nature, that principle by which things are "natured," by which, for example, a horse is horsey and by which a man is human. Art is an imitation of the nature of things, not of their appearances.[24]

And thus we arrive at a phrase from St. Thomas Aquinas that would become a motto of Cage's life: *ars imitatur naturam in sua operatione*, "art imitates nature in its manner of operation."[25]

Coomaraswamy's de-emphasis on self-expression dovetails nicely with Cage's growing fears, in the 1940s, that music could not reliably communicate emotion—the Tower of Babel situation he encountered with *The Perilous Night.* Coomaraswamy's contempt for sensory appreciation, however, and his belief in art's obligation to depict intellectual archetypes seem very much at odds with the focus on physical phenomena that Cage would soon absorb from his Zen studies; perhaps the contrast reflects a difference between Indian and Japanese perspectives, or between musical and visual perspectives as Cage noted concerning Duchamp. But Cage clearly felt at home with Coomaraswamy's rejection of museum culture and its overriding idea that art should be separated from life. It is from this point that Cage begins talking about more thoroughly integrating life and art: "Art's obscured the difference between art and life. Now let life obscure the difference between life and art."[26] And in the slogan "Art imitates nature in its manner of operation"—no matter how far Cage's reading of St. Thomas may have been from Coomaraswamy's—he found a justification for turning to chance operations and for allowing the "natural" sounds of life into his music.

Along with the imitation of nature, Cage's other best-known inheritance from Coomaraswamy is the concept of the nine Indian permanent emotions, or *rasas.* The

word *rasa* most closely translates as flavor, essence, juice, or taste, and it was used in culinary writings as well as those on aesthetic philosophy.[27] Coomaraswamy calls it "the equivalent of Beauty or Aesthetic Emotion in the strict sense of the philosopher." Coomaraswamy's explanation seems particularly pertinent to the doubts Cage was having about music's ability to express emotion: "Aesthetic emotion—*rasa*—is said to result in the spectator—*rasika*—though it is not effectively caused, through the operation of determinants (*vibhava*), consequents (*anubhava*), moods (*bhava*) and involuntary emotions (*sattvabhava*)." Indian tradition divides bhava into thirty-three transient moods, such as joy, agitation, and impatience, and the nine permanent rasas: the Erotic, Heroic, Odious, Furious, Mirthful, Terrible, Pathetic, Wondrous, and Peaceful. "In order that a work may be able to evoke rasa," Coomaraswamy continues, "one of the permanent moods must form a master-motif to which all other expressions of emotion are subordinate." If a mere transient mood is made the overriding theme, "the work becomes sentimental." Perhaps more important, rasa is the emotive part of a work of art that we grasp via empathy, and a work's possession of rasa is more significant than whatever flavor the rasa might happen to be.[28]

The two works of Cage's to which the rasa concept was most important were written during the lead-up to *4′33″*.

One was *Sonatas and Interludes*, which Cage called "an at-
tempt to express in music the eight permanent emotions
. . . and their common tendency toward tranquility."[29]
(Cage distinguishes tranquility from the permanent emo-
tions here, thus counting eight instead of nine rasas.) The
correlations between the nine emotions and the sixteen
sonatas and four interludes remain speculative, however,
and Cage never indicated, in either sketches or program
notes, which movement was meant to express which rasa.
The connection is more explicit in the *Sixteen Dances*
Cage wrote for a Cunningham dance in 1950 and 1951.
The eight solo dances are correlated to rasas—the first to
anger, the second to humor, the third to sorrow, and so on.
The final quartet expresses tranquility (no correlation is
made concerning the seven non-solo dances).[30] Moreover,
Cage was explicit in intending that the emotion not arise
gradually or intensify through the music's development
(as commonly happens in Romantic and modern Euro-
pean classical music) but be present equally throughout.
In his 1946 article "The East in the West," Cage lists as
an oriental characteristic "the quality of being static in
sentiment rather than progressive," next mentioning that
in European music one can find this quality in the music
of Satie: "His *Socrate* presents a vocal line which is con-
tinuous invention, which is like an arabesque, and never
seems to move towards or away from a climax."[31] This

static affective mode—inspired by both Indian music and Satie, and otherwise absent from European music after the Baroque era—became part of the legacy that Cage's music, especially of the 1940s, bequeathed to minimalism and its offshoots.

One would assume that *4'33"* attempts no such expression of rasa, but there is an interesting passage in *Silence* that connects the rasas with the phenomena of nature: "Does not a mountain unintentionally evoke in us a sense of wonder? otters along a stream a sense of mirth? night in the woods a sense of fear? Do not rain falling and mists rising up suggest the love binding heaven and earth? Is not decaying flesh loathsome? Does not the death of someone we love bring sorrow? And is there a greater hero than the least plant that grows? What is more angry than a flash of lightning and the sound of thunder?"[32] Conceivably Cage thought of *4'33"* as the ultimate expression of tranquility but, depending on the weather and the surroundings, perhaps capable of expressing some of the other rasas as well.

"The East in the West" also marks Cage's first mention of Coomaraswamy, who, he says, "convinced me of our naiveté with regard to the orient. At the time—it was at the end of the war, or just afterward—people still said that the East and the West were absolutely foreign, separate entities. And that a Westerner did not have a right to

profess an Eastern philosophy. It was thanks to Coomaraswamy that I began to suspect that this was not true, and that Eastern thought was no less admissible for a Westerner than European thought."[33] In more general terms, perhaps Cage's most helpful inheritance from Coomaraswamy was the spiritual authority to claim that Western music and art were on the wrong track—or at least that other tracks were possible—so that he could make a radical shift away from the way music was being composed.

Meister Eckhart

One name that begins to crop up in Cage's writing from the 1940s on is Meister Eckhart, a figure whom Huxley frequently quotes, to whom Coomaraswamy devotes a chapter of *The Transformation of Nature in Art*, and whom Daisetz Suzuki also praises. Coomaraswamy considered Eckhart's thought closer to Mahayana Buddhism than to conventional Protestantism or modern philosophy, calling Eckhart's Sermons "an Upanisad of Europe" and "one consistent demonstration [of] the spiritual being of Europe at its highest tension."[34] One might be surprised at Cage taking inspiration in the 1940s from so Christian, indeed Catholic, a figure, but in the "Lecture on Something" in *Silence* he lists Eckhart among several Western

authors (with R. H. Blyth, Joseph Campbell, and Alan Watts) from whom one can learn the principles of Zen if the Zen writings themselves seem too alien. Likewise he tells a story of something Suzuki said about Eckhart: "There was a lady in Suzuki's class who said once, 'I have great difficulty reading the sermons of Meister Eckhart, because of all the Christian imagery.' Dr. Suzuki said, 'That difficulty will disappear.'"[35]

The Dominican theologian Eckhart von Hochheim was born in Erfurt, Thuringia, in 1260 and died around 1328. In 1302 he lectured at the College of Paris, which bestowed upon him the Licentiate and Master's Degree; from that point he took the name Meister Eckhart, by which he is generally known today. The overriding idea of his preaching is the unity of the human and the divine, and perhaps his best-known quotation is "The eye by which I see God is the same as the eye by which God sees me."[36] Beginning in 1325, church officials began to lodge complaints about Eckhart for allegedly preaching obscure truths to the common people, and eventually the Franciscans (who tended to frown on Dominicans anyway) charged him with heresy. In 1327 he was forced to defend himself in a now-famous document. A passage Cage quotes that was cited in the charges is Eckhart's "Dear God, I beg you to rid me of God."[37] In fuller context:

To be a proper abode for God and fit for God to act in, a man should also be free from all [his own] things and [his own] actions, both inwardly and outwardly. . . . If it is the case that a man is emptied of things, creatures, himself, and god, and if still God could find a place in him to act, then we say: as long as that [place] exists, this man is not poor with the utmost poverty. For God does not intend that man shall have a place reserved for *him* to work in, since true poverty of spirit requires that man shall be emptied of god and all his works, so that if God wants to act in the soul, he himself must be the place in which he acts. . . .

Thus we say that a man should be so poor that he is not and has not a place for God to act in. To reserve a place would be to maintain distinctions. Therefore I pray God that he may quit me of god, for [his] unconditioned being is above god and all distinctions.[38]

The aspect of Meister Eckhart's thought that shows the most affinity with Zen, and for which he was so championed by Cage and other twentieth-century Zen thinkers, is his refusal to make distinctions, his insistence that the soul of God is not separate from the actions of his creatures.

Meister Eckhart seems to have attracted quite a following, for in his defense he states, "If I were of less re-

pute among the people, and less zealous for justice, I am sure that such attempts would not have been made against me by envious men." He adds, "I must, however, bear it patiently, for 'Blessed are they that do suffer patiently for justice's sake,' and 'God scourgeth every son whom he receiveth.'"[39] It is unclear exactly what happened to Eckhart, but a bull issued by Pope John XXII in 1329 calls several of Eckhart's statements heretical and states that "the aforesaid Eckhart . . . at the end of his life . . . revoked and also deplored the twenty-six articles which he admitted that he had preached, and also many others, written and taught by him . . . insofar as they could generate in the minds of the faithful a heretical opinion."[40] Note that Eckhart did not admit that his statements were heretical, only that, in effect, their subtlety might have misled unschooled listeners into heretical beliefs. Cage tells the story a little more colorfully than the reference works do: "While Meister Eckhart was alive, several attempts were made to excommunicate him. . . . None of the trials against him was successful, for on each occasion he defended himself brilliantly. However, after his death, the attack was continued. Mute, Meister Eckhart was excommunicated."[41]

What seems to have resonated with Cage in Eckhart's sermons is the idea of emptying oneself of desires and distinctions, or, as Cage would phrase it, likes and dis-

likes. Words of counsel from Eckhart's "Talks of Instruction" anticipate similar passages that Cage would write, exhorting listeners to accept phenomena as they occur, including the unexpected sounds of *4'33"*: "People fly from this to seek that—these places, these people, these manners, those purposes, that activity—but they should not blame ways or things for thwarting them. When you are thwarted, it is your own attitude that is out of order."[42]

Daisetz Suzuki

Daisetz Teitaro Suzuki (1870–1966) was a Japanese writer and educator who, in the 1930s through the 1950s, became the leading figure in introducing the traditions and concepts of Zen into American society. In his youth, after studying at the University of Tokyo, he became a disciple of the monk and Zen master Shaku Soen (or Soyen), under whom he achieved enlightenment. Accompanying his master to the 1893 World Parliament of Religions in Chicago, Suzuki received the opportunity to work as a translator of Eastern spiritual writings as assistant to the German scholar Paul Carus, with whom he went to live in LaSalle, Illinois. He stayed in the United States until 1909 and married an American woman in 1911. The next couple of decades were spent mostly teaching in Japan,

with travel throughout Europe, Asia, and America. He was fascinated by Western writers on spirituality such as Emerson and Swedenborg, and he translated the latter into Japanese. Invited in 1950 (at the age of eighty) by the Rockefeller Foundation to lecture in America, he eventually taught at Columbia University from 1952 to 1957.[43] Admired by Jung, Cage, and many other notables, Suzuki held a hybrid position in his field: he was neither a monk nor a trained academic, but something of a lay historian and philosopher, with a reputation as a popularizer of Zen thought. He is credited as having had an unparalleled impact on the West's understanding of Buddhism.

How much exposure Cage actually had to Suzuki has been a matter of some speculation. In various writings and interviews he claimed to have attended Suzuki's classes for two years or three, ranging in date from 1945 to 1951. Yet David Patterson documents that Suzuki didn't arrive in New York until the late summer of 1950, first lectured at Columbia in March 1951, and taught no courses until the spring of 1952. Cage repeatedly said things like, "I had the good fortune to attend Daisetz Suzuki's classes in the late forties." His first written reference to Suzuki, though, comes in his "Juilliard Lecture" of 1952, when he mentions a Suzuki class of the previous winter. Nor, somewhat

frustratingly, did Cage ever directly quote any of Suzuki's published writings, as he quoted so many other thinkers and writers.[44]

Already an octogenarian at the time of his extended return to America, Suzuki lectured on Fridays in Columbia University's department of religion in a voice so quiet as to be sometimes inaudible. Cage describes the conditions the lectures were given in: "The room had windows on two sides, a large table in the middle with ash trays. There were chairs around the table and next to the walls. These were always filled with people listening, and there were generally a few people standing near the door. The two or three people who took the class for credit sat in chairs around the table. The time was four to seven. During this period most people now and then took a little nap. Suzuki never spoke loudly. When the weather was good the windows were open, and the airplanes leaving La Guardia flew directly overhead from time to time, drowning out whatever he had to say. He never repeated what had been said during the passage of the airplane."[45] "I wanted approval from him," Cage told David Revill about Suzuki. "When I didn't get it, I carried on regardless"—much as he had with Schoenberg.[46]

Suzuki put considerable emphasis on the Zen concepts of *satori* and *zazen*, concepts that Cage did not particularly engage in his writings. The impetus toward *4′33″*,

though, might have been furthered by Suzuki's talk about emptiness, or (in Sanskrit) *sunyata*. In the *Manual on Zen Buddhism* Suzuki quotes from the *Shingyo* sutra: "Form is here emptiness, emptiness is form; form is no other than emptiness, emptiness is no other than form; that which is form is emptiness, that which is emptiness is form." He comments: "'Empty' (*sunya*) or 'emptiness' (*sunyata*) is one of the most important notions in Mahayana philosophy and at the same time one of the most puzzling for non-Buddhist readers to comprehend. Emptiness does not mean 'relativity,' or 'phenomenality,' or 'nothingness,' but rather means the Absolute, or something of transcendental nature, although this rendering is also misleading as we will see later. When Buddhists declare all things to be empty, they are not advocating a nihilistic view; on the contrary, an ultimate reality is hinted at, which cannot be subsumed under the categories of logic. With them, to proclaim the conditionality of things is to point to the existence of something altogether unconditioned and transcendent of all determination."[47] On a philosophical level, such talk could have led Cage to think of the emptiness of *4′33″* not as something negative, but as the perception of ultimate reality.

Many of Cage's ideas echo, perhaps sometimes unconsciously, statements he could have heard from Suzuki. Cage sometimes spoke of his music in terms of questions

and answers, the answers coming partly from the *I Ching*. With reference to his composing method, Cage once said, "What can be analyzed in my work, or criticized, are the questions that I ask," explaining that sometimes early drafts of his music were no good because his initial question had been too superficial.[48] Suzuki said: "Zen masters tell us that the answer is in the question itself. You look into your own question, yourself. My answering only leads you farther away from your question." And in Suzuki's saying "Any position you may have, or any idea you may cherish, Zen wants to destroy it," we see perhaps the germ of the motto Cage used to sum up his entire view of life: "Get yourself out of whatever cage you find yourself in."[49]

Irwin Kremen

Cage apparently dedicated *4'33"* to Tudor at first but then dedicated the second version of the score to Black Mountain College student Irwin Kremen (b. 1925).[50] Kremen grew up in the west Chicago suburbs, went to Medill Journalism School at Northwestern University, and, at the time Cage met him, was working as a reporter. After reading an article about Black Mountain College, Kremen said, "I immediately got on the train and went down

there, and I decided that was the place for me to go."[51] He had become interested in writing as an avant-garde art form, and so he studied with M. C. Richards. After the Black Mountain experience, though, he took courses in psychology at the New School for Social Research, got a PhD in psychology at Harvard, and by 1963 had ended up on the psychology faculty at Duke University. A student describes him as "the kind of person who made a big impact on you. He's a very strong personality who has very deep scientific and artistic convictions. He had this real passion about the philosophy of science and how that could make psychology a better science."[52]

M. C. Richards encouraged Kremen to try his hand at collage, and around 1966 Kremen took another career detour and started making art, not only collage but sculpture, working with found materials such as Styrofoam, sandpaper, wasps' nests, string, and particularly paper (such as posters) that had been exposed to the elements.[53] Many years after his fateful encounter with Cage and Rauschenberg, Kremen emerged as an artist in much the same experimental vein; in 1979, he was given a solo exhibition at the Smithsonian Institution. At the time of *4′33″* he hadn't yet found his life's calling, but he is now active as an artist and as a lecturer on Cage and Black Mountain College.

Robert Rauschenberg

A remarkable facet of Cage's personality was his open-
ness to artists and writers younger than himself. As he
continued to discover important figures from the next
generation (Robert Rauschenberg, Jasper Johns, Morton
Feldman, Christian Wolff, James Tenney), he became just
as willing to quote them, cite them as influences, or even
write articles about their work as he was for masters of his
own or the previous generation.

Robert Rauschenberg (1925–2008) was an artist from
Port Arthur, Texas, whose daring collages and "combines,"
bringing together objects from everyday life (much like
Cage's music did), revolutionized the art world during the
dramatic transition from Abstract Expressionism to Pop
Art in the 1950s. As a boy, Rauschenberg partitioned his
bedroom with crates and planks, in whose compartments
he would collect and display rocks, plants, insects, jars,
boxes, and images cut out of or traced from magazines.[54]
Thus from his earliest years he exhibited a somewhat
compulsive tendency to juxtapose incongruous objects,
which would become a major component of his collage
style. Following a stint in the navy, Rauschenberg was
educated on the GI Bill at the Kansas City Art Institute
and School of Design, then studied for six months at the
Académie Julian in Paris. Starting in autumn of 1948 he

studied with Josef and Anni Albers at Black Mountain College, where he would continue returning even after moving to New York. Josef Albers, a geometrist known for his obsessive researches into the theory of color and also an authoritarian personality, was not prepared for someone as freewheeling as Rauschenberg and was not a supportive mentor.

"I consider Albers the most important teacher I've ever had," Rauschenberg would later say,

> and I'm sure he considered me one of his poorest students. . . . I must have seemed not serious to him, and I don't think he ever realized that it was his discipline that I came for. . . . When Albers showed me that one color was as good as another and that you were just expressing a personal preference if you thought a certain color would be better, I found that I couldn't decide to use *one* color instead of another, because I really wasn't interested in taste. I was so involved with the materials separately that I didn't want painting to be simply an act of employing one color to do something to another color, like using red to intensify green, because that would imply some subordination of red. . . . I didn't want color to serve me, in other words. That's why I ended up doing the all-white and all-black paintings—one of the reasons, anyway.[55]

Color for its own sake rather than subjugated to the taste of the artist: it is a supremely Cagean desideratum.

Late in the summer of 1949 Rauschenberg moved to New York City. The controversy over the Abstract Expressionism of Jackson Pollock, Clyfford Still, Willem de Kooning, Franz Kline, and others was at its height; lines were drawn over the issue of abstraction versus representation, and by using images in his collages, Rauschenberg seemed at first to be coming down on the less avant-garde side. The galleries that featured Abstract Expressionists were those of Betty Parsons, Charles Egan, and Samuel Kootz. After a couple of years of discouraging obscurity, Rauschenberg finally harangued Betty Parsons to take a look at his work and simply give him an opinion. Putting him off as long as she could, Parsons finally consented to take a look. After perusing Rauschenberg's paintings for a while, she suddenly floored him by saying, "I can't schedule a show of these until the spring." He had only wanted to hear whether she thought he was any good; little did he expect to get a major solo exhibition at the age of twenty-five.[56]

There is some uncertainty about when Cage met Rauschenberg. Walter Hopps, in his monograph on early Rauschenberg for the Menil Collection, states definitively that "Rauschenberg's first academic year at Black Mountain (1949–50) was essentially for him a period of basic

study. . . . Other important visitors to Black Mountain (such as John Cage and Merce Cunningham) he did not meet until later in New York." Further, Hopps notes that Cage "happened upon" the younger man's Betty Parsons exhibition in spring of 1951 and that "Cage, who admired it enormously, asked for and was given a painting."[57] Irwin Kremen remembers seeing Rauschenberg's White Paintings at Cage's loft in New York late in 1951. Since Cage's visits to Black Mountain College were in the spring and summer of 1948 and 1952, it would seem that Cage and Rauschenberg met in New York rather than at Black Mountain. Nevertheless, Cage in later life mentioned having met him at Black Mountain College, and several writers cite this as fact.[58]

Nothing sold from Rauschenberg's spring 1951 exhibition and reviews were tepid, but Cage came by and reacted enthusiastically.[59] Rauschenberg's openness to every possible image as artistic material was parallel to Cage's newfound openness to all sounds. For instance, Rauschenberg stated, "I feel very sorry for people who think things like soup cans or mirrors or Coke bottles are ugly, because they're surrounded by things like that all day, and it must make them miserable." Cage later added, "Almost immediately I had the feeling that it was hardly necessary for us to talk, we had so many points in com-

mon. To each of the works he showed me, I responded on the spot. No communication between us—we were born accomplices!"[60]

Rauschenberg would wait for major visibility until 1957, when the brand-new Leo Castelli Gallery picked him up, and fame wouldn't ensue until his retrospectives at the Jewish Museum in 1963 and at the Venice Biennale the following year. Meanwhile, he and Cage and Cunningham would prove simpatico accomplices in the creation of a new artistic universe.

Morton Feldman

On January 26, 1950, Cage attended a concert at Carnegie Hall at which Dimitri Mitropoulos conducted the Symphony of Anton Webern, which had been written in 1928 but was still considered avant-garde for its exploded twelve-tone textures. The piece was not yet well known in America at the time. The audience reaction was somewhat hostile, but Cage, having enjoyed the performance, did not want to stay for the conservatively Romantic Symphonic Dances of Sergei Rachmaninoff, which were to close the program. So he left, and as he was leaving, a twenty-four-year-old man with thick glasses and thick black hair—whose reactions to both Webern and Rachmaninoff were identical to Cage's—came up and said,

"Wasn't that beautiful?" He introduced himself as Morton Feldman, and the two made plans to visit.

Feldman came to Cage's apartment on Monroe Street, overlooking the East River, for a composition lesson. In Feldman's words, "At this first meeting I brought John a string quartet. He looked at it a long time and then said, 'How did you make this?' I thought of my constant quarrels with [Stefan] Wolpe and also that, just a week before, after showing a composition of mine to Milton Babbitt and answering his questions as intelligently as I could, he said to me, 'Morton, I don't understand a word you're saying.' And so, in a very weak voice, I answered John, 'I don't know how I made it.' The response to this was startling. John jumped up and down and, with a kind of high monkey squeal, screeched, 'Isn't that marvelous. Isn't that wonderful. It's so beautiful, and he doesn't know how he made it.'" The two became close friends; Feldman moved into an apartment in the same building as Cage. The two shared a close connection to the Abstract Expressionist painting of the time, and they socialized at the bar known for all the painters who hung out there. "John and I would drop in at the Cedar Bar at six in the afternoon," Feldman later recalled, "and talk until it closed and after it closed. I can say without exaggeration that we did this every day for five years of our lives."[61]

Feldman became known for an unusual and, for the time,

extremely unfashionable limitation he placed on his music (though Cage had also flirted with it in the '40s): almost all of his works were very quiet throughout, and often the only dynamic marking was one at the beginning indicating, "As soft as possible." Starting in the 1970s, Feldman's works would become longer and longer, up to two, five, even six hours in his String Quartet II. More important, in an era in which subjectivity was deemed suspect and the more progressive composers were all working in some kind of mechanical compositional system or other, Feldman was an unabashed intuitionist, someone who delicately weighed every sonority by ear and flaunted his independence from theoretical mandates. For young composers wearily emerging from the doctrinaire twelve-tone period it was an attractive position, and in the 1980s, just before and especially following his untimely death at sixty-one, Feldman's influence spread like wildfire until he became, arguably, the most influential composer of the late twentieth century, surpassing even Cage in his impact on composers born in the 1950s and 1960s. Following Feldman's death, even Cage himself switched to writing slow, sustained works that many have described as Feldmanesque.

Having met Cage only two and a half years before *4′33″*, Feldman can't be credited with having had much impact on this particular piece. However, one evening late in 1950 Cage, Tudor, and Feldman were having a long con-

versation when Feldman left the room, returning shortly with a composition he had written on graph paper.[62] The notes to be played were indicated by dots in boxes, and each system consisted of three rows on the graph paper, representing high, middle, and low registers, respectively. This was the first of two series of pieces called *Projections* and *Intersections*, which indicated only register and left the actual pitches up to the performer. Cage was impressed by Feldman's willingness to give up control over pitch and remarked soon afterward in his "Lecture on Something," "Feldman speaks of no sounds, and takes within broad limits the first ones that come along. . . . [He] has changed the responsibility of the composer from making to accepting."[63] This license given the performer was an aspect that Feldman would eventually reject for his own use, but it helped nudge Cage toward the chance-based music he would spend the rest of his life writing, and one could imagine that this acceptance of sounds played some role in the move toward *4′33″*.

Henry David Thoreau

The great author and naturalist Henry David Thoreau (1817–1862) had nothing to do with the run-up to *4′33″*, but Cage's increasing interest in the issues raised by the work eventually led him to Thoreau. At an event in Port

Royal, Kentucky, in 1967, Cage heard the novelist and essayist Wendell Berry speak about Thoreau, and afterward Berry interested Cage in Thoreau's journal. By November Cage (who before this had read only the essay "Civil Disobedience" in college) was deep into Thoreau's complete works.[64] It's surprising that "Civil Disobedience" itself wasn't enough to spur a deeper interest, for its opening words are certainly congruent with all of Cage's talk about anarchy from the 1960s: "I heartily accept the motto, 'That government is best which governs least'; and I should like to see it acted up to more rapidly and systematically. Carried out, it finally amounts to this, which also I believe, — 'That government is best which governs not at all'; and when men are prepared for it, that will be the kind of government which they will have."[65] Cage's quotations from Thoreau have to do with silence: "Music, he said, is continuous, only listening is intermittent"; "The best communion men have is in silence." Later Cage would remark, "Reading Thoreau's *Journal*, I discover any idea I've ever had worth its salt."[66]

Thirty years before *4′33″*, the great American composer Charles Ives began his essay on Thoreau in *Essays Before a Sonata:* "Thoreau was a great musician, not because he played the flute but because he did not have to go to Boston to hear 'the Symphony.'"[67] This evocation

of Thoreau listening to the sounds of Walden Pond as though they were a piece of music sounds like a prophecy of *4′33″*. Certainly Cage admired Thoreau's ability to describe nature as objectively, as selflessly, as possible; Thoreau's journal gives one the impression that he, too, was engaged in a continual performance of *4′33″*, as well as its visual and olfactory equivalents. "What is a course of history, or philosophy, or poetry, no matter how well selected," Thoreau wrote in *Walden*, "or the best society, or the most admirable routine of life, compared with the discipline of looking always at what is to be seen?"[68] It is a perfectly Cagean sentiment.

Still, as with Coomaraswamy and other writers, Cage read into Thoreau what he wanted to find. William Brooks despaired to find a quotation in the following mesostic:

<div style="text-align:center">

thoreau saiD the same

thIng

over a hundred yearS ago

i want my writing to be as Clear

as water I can see through

so that what I exPerienced

is toLd

wIthout

my beiNg in any way

in thE way[69]

</div>

On the other hand, it's difficult to imagine a more eloquently stated justification for *4′33″* than this passage from Thoreau's journal for December 27, 1857: "The commonest and cheapest sounds, as the barking of a dog, produce the same effect on fresh and healthy ears that the rarest music does. It depends on your appetite for sound. Just as a crust is sweeter to a healthy appetite than confectionery to pampered or diseased one. It is better that these cheap sounds be music to us than that we have the rarest ears for music in any other sense. I have lain awake at night many a time to think of the barking of a dog which I had heard long before, bathing my being again in those waves of sound, as a frequenter of the opera might lie awake remembering the music he had heard."[70]

Joke Precedents

Of course, it is easy to take *4′33″* as a joke, and one would expect that someone else might have come up with it before. The French humorist Alphonse Allais (1854–1905), a friend of Erik Satie's, wrote in 1897 a *Funeral March for the Obsequies of a Deaf Man* which consists entirely of blank measures, much like the first score of *4′33″*. As though that weren't enough, Allais also apparently anticipated Rauschenberg by executing paintings entirely in one color, with evocative titles like "Anaemic Young Girls

Cartoon from *Etude* magazine, 1932.
Courtesy of Theodore Presser Company.

Going to Their First Communion through a Blizzard"
(white), "Negroes Fighting in a Cave at Night" (black),
and "Apoplectic Cardinals Harvesting Tomatoes on the
Shore of the Red Sea (Study of the Aurora Borealis)"
(red). These paintings were made for an 1884–1885 exhibit

of *Expositions des arts incohérents,* organized "for people who did not know how to draw."[71]

More mysterious is a 1932 cartoon in *The Etude,* a magazine for piano enthusiasts, of a boy who gets out of practicing by composing a piece entirely of rests. What makes the coincidence uncanny is the name of the cartoonist: Hy Cage.[72]

The Path to 4′33″: 1946 to 1952

Ultimately, the genesis of 4′33″ seems overdetermined. One could imagine that another composer, having seen Rauschenberg's White Paintings, could have written 4′33″ as a response; or, having discovered in the anechoic chamber that there was no such thing as silence, might have written the piece as a demonstration of the fact. Cage, however, seems to have been urged toward 4′33″ via a redundant multiplicity of routes. It was a controversial step to take, one that might damage his reputation as a serious composer—as, indeed, for many people, it still has. Perhaps he would never have summoned the necessary courage without so many signs pointing in the same direction. We will now attempt to follow his path step by step.

Our story about the road to 4′33″ begins in 1946 with

Cage's reciprocal study with Indian classical musician Gita Sarabhai. One day Cage asked Sarabhai what her teacher had told her was the function of music. She replied: "To sober and quiet the mind, thus rendering it susceptible to divine influences." "I was tremendously struck by this," Cage would later say, "and then something really extraordinary happened. Lou Harrison, who had been doing research on early English music, came across a statement by the seventeenth-century English composer Thomas Mace expressing the same idea in almost exactly the same words. I decided then and there that this *was* the proper purpose of music. In time, I also came to see that all art before the Renaissance, both Oriental and Western, had shared this same basis, that Oriental art had continued to do so right along, and that the Renaissance idea of self-expressive art was therefore heretical."[1]

Actually it was in Coomaraswamy's writings, as we've seen, that Cage would have found the argument that medieval Europe and modern Asia represented what had once been a shared culture, from which Europe diverged in the Renaissance. The weight that Cage accords Thomas Mace's slim contribution to this argument seems hard to justify. Mace (c. 1613–c. 1706) was a singing clerk at Cambridge who, growing deaf and needing money, sat down in the 1670s to write the definitive work on lute playing in an attempt to revive an art that was then in steep decline.[2]

His result, *Musick's Monument*, is full of practical advice leavened with the occasional divine platitude. The words Harrison attributes to him do not appear literally, though they echo Mace's general tone. Amid dozens of plausible possibilities, Austin Clarkson has located the Sarabhai-Harrison purpose of music in two separate passages in Mace. In one passage he says that the "Grave Musick" of the past has been "to myself, (and many others) as Divine Raptures, Powerfully Captivating all our Unruly Faculties, and Affections, (for the time) and disposing us to Solidity, Gravity, and a Good temper; making us capable of Heavenly, and Divine Influences." Two pages later, Mace writes that modern music "is rather fit to make a Mans Ears Glow, and fill his brain full of Frisks, &c. than to Season, and *Sober his Mind*, or Elevate his Affection to Goodness."[3] This hardly seems like "expressing the same idea in almost exactly the same words," but perhaps they were words that stuck in Harrison's mind, which he then enthusiastically imparted to Cage.

From Mace's connections at Cambridge, Clarkson attributes a Neoplatonic origin to Mace's ideas, and perhaps Mace's conservatism points to a pre-Renaissance aesthetic viewpoint.[4] Still, musicologists do not universally consider Mace a reliable observer of his age; his volume's absence of classical references, as well as a lack of musical examples from any works besides Mace's own me-

diocre fare, has been noted.[5] Of course Cage had every right to adopt the traditional Indian philosophy of music's purpose as given to him by Gita Sarabhai; but it stretches credulity to imagine that any statement by the obscure Thomas Mace could have added decisive reinforcement. As he did with so many sources, Cage picked this citation for his collection because it bolstered what he was already tempted to believe. The calm of his works of the late 1940s certainly seems intended more to quiet the mind than to render it "full of frisks."

In any case, Cage's year-long association with Sarabhai initiated a new period of intellectual exploration in which he came to feel that Asian philosophies had much to offer the American intellectual and artist. Sarabhai's parting gift to Cage was a copy of *The Gospel of Sri Ramakrishna*, a body of writings about the life of an important Hindu religious leader who lived from 1836 to 1886. Cage spent the following year devouring the book.[6] He also discovered *The Perennial Philosophy* of Aldous Huxley (1894–1963), a comparison of Eastern and Western strains of religious mysticism; the title is a phrase often credited to the German philosopher Gottfried Leibniz (1646–1716), who used it to refer to an underlying stream of thought that unites all religions.

Another influential writer on Eastern topics was Reginald Horace Blyth (1898–1964), an English authority on

Japanese culture who, starting in 1949, reintroduced the English-speaking world to the body of Japanese haiku and vastly increased the popularity of the genre. In 1942 Blyth had published *Zen in English Literature and Oriental Classics*, a wonderfully erudite and entertaining tome that traces the ideas of Zen through English poetry and literature, showing that the eternal truths of Zen are inherent in human experience and not limited to the Asian worldview. Returning over and over to the Shakespearean mantra (from *Hamlet*) "There is nothing either good or bad but thinking makes it so," Blyth builds an exuberant case that couched within the metaphors of all great poetry is a Zen sense of the identity of the finite and the infinite, the underlying unity of all experience. "All beauty, all music, all religion, all poetry," Blyth writes, "is a dancing of the mind. Without this dancing of the spirit there is no true Zen."[7] Before World War II, the common opinion was that Zen was a fundamentally Japanese way of life that the Western mind could not authentically translate into its own experience; Blyth did as much as anyone to make Zen seem thoroughly congenial and universal.

The Vassar Lecture

On February 28, 1948, Cage gave a long autobiographical lecture at Vassar College called "A Composer's Con-

fessions" in which he announced some upcoming plans: "I have, for instance, several new desires (two may seem absurd, but I am serious about them): first, to compose a piece of uninterrupted silence and sell it to the Muzak Co. It will be 3 or 4½ minutes long—these being the standard lengths of 'canned' music, and its title will be 'Silent Prayer.' It will open with a single idea which I will attempt to make as seductive as the color and shape or fragrance of a flower. The ending will approach imperceptibly."[8] Here we have, four and a half years before *4′33″*, the first announcement of a plan to write a piece consisting of silence. (The other "absurd" plan was to write a piece for twelve radios, which crystallized in 1951 as *Imaginary Landscape No. 4*.) In a 1982 interview Cage referred to "A Composer's Confessions" as "a lecture which is not published, and which won't be." This is odd, for why would there be a Cage lecture in existence that he thought would never be published? (It has been, of course.)[9] Note, moreover, that *Silent Prayer* is not exactly *4′33″* and is confusingly described. "It will open," Cage says, "with a single idea which I will attempt to make as seductive as the color and shape or fragrance of a flower." How can a silent piece open with any idea at all? And again, "The ending will approach imperceptibly."

William Brooks links *Silent Prayer* to Cage's frequent use of silence in more conventional works. For instance,

Experiences No. 2 for solo voice contains long passages of silence between phrases, as much as six slow measures of rests. The piece was written for a Merce Cunningham dance, so the audience would not have been left merely listening—there was something to watch. As Brooks says, "*Silent Prayer* was problematic on two counts. First, the 'silence' would certainly not be *silent.* Noises would intrude; the experience would be imperfect; the listener would be distracted. And second, like any expressive music, it might not actually convey Cage's intentions; it might be more likely to amuse or irritate than to sober and quiet the mind. The question was: was it the first failure that gave rise to the second? If one could *truly* experience 'silence,' would the mind be quieted?"[10] Cage never performed *Silent Prayer.* The piece does not exist; its description is self-contradictory. In order to reach *4'33"* from *Silent Prayer,* Cage needed to go through experiences that would lead from attempting to listen to *nothing* to redefining silence as being not *nothing*, but *something.*

Muzak

Cage mentioned in 1948 his intention to sell his silent piece to the Muzak company. Muzak had not entirely shed its novelty at the time but was beginning to acquire the sour reputation it still has among musicians today. It

had been the creation of two-star general and tireless inventor George Owen Squier (1865–1934), who, in 1908, had become the world's first airline passenger when he hopped aboard a plane with one of the Wright brothers. In 1922 Squier developed the technology for transmitting music from a phonograph along electrical power lines. In 1934, the invention, at first called Wired Radio, was tested for the purpose of piping music into restaurants and hotels, and that same year Squier founded the Muzak corporation, taking the brand name "Kodak," which he admired, and combining it with "music." Two more years passed before the company was able to transmit its product into commercial spaces.[11]

Rather than relying on commercial recordings, Muzak made its own, standardizing its repertoire according to tempos and styles appropriate to different times of day. Muzak's clients included more than 360 businesses by 1939, and the company added more than a thousand new accounts in the next five years, expanding from New York to Boston, Detroit, and Los Angeles.[12] Muzak was broadcast from 78 rpm vinyl records; a ten-inch disc held about three minutes of music and a twelve-inch disc about four and a half, thus accounting for the potential timings of the *Silent Prayer* Cage wanted to write. The length 4′33″ itself owes something to the technology of the twelve-inch 78 rpm record.

Despite the stigma that Muzak carries today in educated circles—the term is now often generically applied to any bland, characterless music meant to be soothing and nothing else—it was at first considered a tremendous boon for the working class. In 1937, according to Muzak's corporate history, "a study conducted at the Stevens Institute of Technology in New Jersey showed that 'functional music' in the workplace reduced absenteeism by 88 percent and early departures by 53 percent."[13] Further studies claimed that background music reduced fatigue among workers doing repetitive tasks, and mitigated boredom. Use of Muzak in the armed forces made it a booming industry during wartime, as well as spreading it across Europe. A 1946 *Forbes* magazine article titled "Have You Tried Working to Music?" announced that "music is now being piped into banks, insurance companies, publishing houses, and other offices, where brain workers find that it lessens tension and keeps everyone in a happier frame of mind." The next year, a study on the use of Muzak in the army found it responsible for a 44.5 percent boost in production efficiency and claimed that 88.7 percent of employees found it helpful.[14]

One of the conductors of that survey, Richard Cardinell, described Muzak's essential features: "Factors that distract attention—change of tempo, loud brasses,

vocals—are eliminated. Orchestras of strings and wood-winds predominate, the tones blending with the sur-roundings as do proper colors in a room. The worker should be no more aware of the music than of good light-ing. The rhythms, reaching him subconsciously, create a feeling of well-being and eliminate strain."[15] Of course, many musicians objected to what seemed a demeaning use of music, stripping it of all personal features to create a background wash. Even among nonmusicians, a suspicion began to grow in the late 1940s that Muzak was a kind of brainwashing mechanism, a subliminal use of music to keep workers and customers in line.

The first formal protest against Muzak came in 1949, in response to the installation of a "Music as You Ride" program on public buses and trains in Washington, D.C. Some 92 percent of the riders supposedly had no objec-tion to the program, but there were sufficient complaints that the D.C. Public Utilities Commission investigated and started hearings that July. The complainants initially lost their case when the commission ruled that "the trans-mission of radio programs through receivers and loud-speakers in passenger vehicles . . . does not violate the free speech guaranty of the First Amendment."[16] The case went to the United States District Court, and the brief filed June 1, 1951, states that

transit passengers commonly have to hear the broadcasts whether they want to or not. . . . These broadcasts make it difficult for petitioners to read and converse. . . . The passengers are known in the industry as a "captive audience." Formerly they were free to read, talk, meditate, or relax. The broadcasts have replaced freedom of attention with forced listening. . . .

No occasion had arisen until now to give effect to freedom from forced listening as a constitutional right. Short of imprisonment, the only way to compel a man's attention for many minutes is to bombard him with sound that he cannot ignore in a place where he must be. The law of nuisance protects him at home. At home or at work, the constitutional question has not arisen because the government has taken no part in forcing people to listen. Until radio was developed and someone realized that the passengers of a transportation monopoly are a captive audience, there was no profitable way of forcing people to listen while they travel between home and work or on necessary errands. Exploitation of this audience through assault on the unavertible sense of hearing is a new phenomenon. . . .

The Supreme Court has said that the constitutional guarantee of liberty "embraces not only the right of a

person to be free from physical restraint, but the right to be free in the enjoyment of all his faculties. One who is subjected to forced listening is not free in the enjoyment of all his faculties.[17]

Nevertheless, the court reversed only the part of the commission's finding that applied to public service announcements, ruling that the playing of music alone was unobjectionable.

Ultimately the case went to the Supreme Court, which, on May 26, 1952, ruled against the complainants. Justice Harold Burton wrote for the majority that broadcasting music was "not inconsistent with public convenience, comfort and safety and 'tends to improve the conditions under which the public ride.'" Joseph Lanza reports, though, that Justice Felix Frankfurter was apparently such an inveterate Muzak hater that he felt it necessary to recuse himself, and that Justice William O. Douglas, in his minority opinion, stated that "the right to be let alone is indeed the beginning of all freedom."[18]

I once interviewed the reclusive composer Conlon Nancarrow, and the subject of Cage's anarchist sympathies came up; Nancarrow said good-humoredly, "Cage isn't an anarchist, he just wants to be left alone." It is intriguing that Cage first mentioned the idea of *Silent Prayer* in early 1948, just at the time that some public up-

roar against Muzak was beginning to take shape, and that he completed $4'33"$ in 1952, just as the courts were ruling that forced listening to music was not a violation of the First Amendment. Perhaps Cage felt strongly enough about the right to be left alone that he conceived his *Silent Prayer* as something that might be programmed on Muzak stations to provide listeners with a blessed four-and-a-half-minute respite from forced listening. One can imagine many musicians who resented Muzak coming up with such a rueful idea.

In fact, Cage apparently noticed that his proposed campaign for freedom from Muzak found a parallel in another entrepreneur's assault on the jukebox. Among Cage's personal papers is an article he saved from the *New York Post* from January 16, 1952, which proposed a strikingly similar use of silence:

"Darling," said a frosh to a coed, "they're playing our song." For the first time since a juke box has been installed in the Student Union of the University of Detroit, she heard him. The place was swinging way out to one of those new sides called "Three minutes of Silence." That's it—silence. The student puts his dime in and he takes his choice, either the 104 jump records on the big flashy juke box or on one of the three that play absolutely nothing, nothing but

silence. It's a new idea developed by Dick McCann, president of the Student Council, for the comfort of the silent types who'd just as soon not be blasted off their chairs by the rocking records. He's refining it. "The new model," he said, "will have a beep tone which will sound ever so gently every 15 seconds so that people will know the machine is playing." . . . Besieged by other students around the country for copies of the silent records, McCann is quietly contemplating two new projects: Stereophonic silence and blank home movies.[19]

One wonders if this item sparked a fear in Cage that someone else would get to the idea of a silent piece before he did—and with more commercial purposes in mind.

Cage habitually worked to overcome his likes and dislikes, and speaking to Roger Reynolds in 1961 he said, "If I liked Muzak, which I also don't like, the world would be more open to me. I intend to work on it." Later, he suggested that the Muzak company should consider using Erik Satie's musique d'ameublement.[20]

Zen

Why, given Cage's newfound enthusiasm for Asian aesthetics, would he come up with so Christian-sounding a

title as *Silent Prayer*? Douglas Kahn argues that Huxley's *The Perennial Philosophy* was the impetus here: the book's fifteenth chapter is entitled "Silence," and the next is entitled "Prayer." Among the quotes from "Silence" is one from St. John of the Cross:

> The Father uttered one Word; that Word is His Son, and he utters Him forever in everlasting silence; and in silence the soul has to hear it.

And further:

> For whereas speaking distracts, silence and work collect the thoughts and strengthen the spirit. As soon therefore as a person understands what has been said to him for his good, there is no further need to hear or to discuss; but to set himself in earnest to practice what he has learnt with silence and attention, in humility, charity, and contempt of self.

From the eighteenth-century English theologian William Law:

> The spiritual life is nothing else but the working of the Spirit of God within us, and therefore our own silence must be a great part of our preparation for it, and much speaking or delight in it will be often no small hindrance of that good which we can only have

from hearing what the Spirit and voice of God speak-
eth within us.

And, from a more easterly direction, words of Lao Tzu:

> He who knows does not speak;
> He who speaks does not know.[21]

(But a later commentator once asked, with humorous in-
sight, "If he who knows does not speak, why did Lao Tzu
write five thousand words?"[22] There has been a parallel
question about Cage: if he loved listening to the environ-
ment, why did he write so much music?)

Perhaps most relevant to Cage's train of thought, Hux-
ley adds his own commentary:

The twentieth century is, among other things, the
Age of Noise. Physical noise, mental noise and noise
of desire—we hold history's record for all of them.
And no wonder; for all the resources of our almost
miraculous technology have been thrown into the
current assault against silence. That most popular and
influential of all recent inventions, the radio, is noth-
ing but a conduit through which pre-fabricated din
can flow into our homes. And this din goes far deeper,
of course, than the ear-drums. It penetrates the mind,
filling it with a babel of distractions—news items,
mutually irrelevant bits of information, blasts of

corybantic or sentimental music, continually repeated doses of drama that bring no catharsis, but merely create a craving for daily or even hourly emotional enemas. And where, as in most countries, the broad-casting stations support themselves by selling time to advertisers, the noise is carried from the ears, through the realms of phantasy, knowledge and feeling to the ego's central core of wish and desire.[23]

Cage had strikingly similar feelings about the evils of modern society during the mid-1940s, his years of mental distress. In fact, Kahn insightfully links the thought to the paper on Pan-American relations Cage had delivered at age fifteen in which he opined that the United States "should be hushed and silent, and we should have the opportunity to learn what other people think." Clearly, Cage spent his life yearning for the condition of silence, with more and more urgency in the 1940s. Huxley helped focus that yearning.

As Cage would later tell Peter Gena, it was through *The Perennial Philosophy* that he discovered Zen: "Just at that time, when I knew that I needed help, and needed it in terms of my mind, Daisetz Suzuki came from Japan to teach the philosophy of Zen Buddhism. And I had already studied a book called *The Perennial Philosophy* of Aldous Huxley, which brought together remarks by teachers in

various religions, cultures, and times. And I had chosen from that anthology Zen Buddhism as the flavor [rasa?] that tasted best to me."[24] The Japanese word *Zen* corresponds to *Ch'an* in Chinese and *Dhyana* in Sanskrit, and means "meditation." The movement grew from a combination of Indian Buddhism and Taoism but is considered a specifically Chinese innovation, dating to the time of the legendary figure Bodhidharma, who flourished from A.D. 460 to 534.[25] In later centuries Zen achieved its most pervasive expression in Japanese culture. The most distinguishing feature of Zen is the practice of zazen, or sitting meditation, during which one attempts a clear perception of phenomena, untroubled by the usual mental chattering that arises from the ego. Cage, however, decided not to practice zazen. As he later put it, in response to Suzuki he "decided not to give up the writing of music and discipline my ego by sitting cross-legged but to find a means of writing music as strict with respect to my ego as sitting cross-legged."[26] Thus, ultimately, came the chance processes with which he would compose from 1951 on, with their interminable and repetitive tossing of coins.

Also characteristic of Zen is a belief in satori, or sudden enlightenment. For Western readers, Zen is most famously known for the paradoxical, seemingly capricious devices used in its teaching, such as *koans* and *mondos*. As Alan Watts puts it, "One of the beginning *koans* is Chao-

chao's answer '*Wu*' or 'No' to the question as to whether a dog has Buddha nature. The student is expected to show that he has experienced the meaning of the *koan* by a specific and usually nonverbal demonstration which he has to discover intuitively."[27] Perhaps the most famous koan is "Two hands clap and there is a sound; what is the sound of one hand clapping?" Koans are traditional, handed down from sayings by the great Zen masters; there are alleged to be about 1,700 of them in the official canon.[28] The purpose of the koan is to defeat the intellect and egotism of the student, to break down rational thinking and release intuition and direct observation of experience. A similar device is the mondo, an often nonsensical question that the student must answer immediately, without thinking.

Related, and with a similar Zen flavor, is the haiku, well known by now as a brief, unrhymed poem consisting of three lines, usually in a pattern of 5, 7, and 5 syllables. As examples I give three from the famous haiku poet Matsuo Basho (1644–1694), translated by R. H. Blyth, starting with what is perhaps his most famous (and one quoted by Cage); note that these, being translations, do not follow the 5-7-5 syllable scheme in English.

> The old pond,
> A frog jumps in:
> Plop!

The melons look cool,
 Flecked with mud
 From the morning dew.

On the mushroom
 Is stuck the leaf
 Of some unknown tree.[29]

An anthology of Japanese haiku published by Blyth in 1949 reintroduced the genre to the Western world. It quickly became so popular that haiku in English became common. Even more central to the haiku than the syllabic structure is the focus on concrete reality, on sensory experience and vivid imagery rather than abstraction, emotion, or cogitation. The aim of a traditional haiku is to render some physical phenomenon vivid or magical by making it present to the mind in words. As Blyth, not afraid to criticize his mentor Suzuki, points out about the frog's leap into the water: "Suzuki says 'This leap is just as weighty a matter as the fall of Adam from Eden.' This is true enough, but this is mysticism. If we say, The fall of Adam from Eden is just as weighty a matter as the leap of the frog, this is Zen. Mysticism and Zen overlap, but are distinct. Mysticism sees the infinite meaning in the (apparently) trivial thing; Zen sees the thing."[30]

However different in effect, haiku's insistence on physical immediacy and 4'33"'s focus on the actual sounds in

one's personal space share a perceptible link—though one could argue in this case that it is the listener, not the artist (Cage), who completes the identification with the physical phenomena. In *4'33"*—and in all of Cage's music after 1952—one hears the thing itself ("the ding-a-ling-an-sich," in Douglas Kahn's clever bilingual philosophy pun based on Kant's "thing in itself"), and the thing is sufficient.[31] The sensed phenomenon, no matter how small or ephemeral, is not trivial, because the meaning, or meaninglessness if you prefer, of all existence is encapsulated within it. Substitute for the "Plop!" of that frog any sound that one might hear during *4'33"*—the rain pattering on the roof of the Maverick Concert Hall, for instance—and the connection between Cage's "silent" piece and Zen starts to emerge.

The basis of Zen is that the real world, as we capture it and divide it up in our thoughts, is an illusion. There is actually no difference between life and death, good and evil, happiness and misery; "there is nothing either good or bad but thinking makes it so." The First Noble Truth of Buddhism is that life is suffering—or, to use Alan Watts's preferred translation of *duhkha*, life is frustration. The Second Noble Truth is that all suffering or frustration results from desire, clinging, or grasping. Desire is based in ignorance, because, as Watts puts it, "to one who has self-knowledge, there is no duality between himself

and the external world."[32] The Third Noble Truth states that the end of frustration, *nirvana*, can only be achieved by the cessation of desire, and the Fourth details the eightfold path to achieve this. We are not born with an ego, but we invent it, invent a sense of self;[33] and we divide this self from the world, divide what we own and what we want from what we don't own and don't want, divide good from bad. If we could short-circuit this false sense of division, through the sitting meditation of zazen or the sudden insight of koans, we could return to the truth that all existence is one.

In fact, unlike moralizing religions that demand a conversion experience, Zen tells us that each of us is already enlightened, as in a story that Cage liked to tell: "When the sixth patriarch of Zen Buddhism was being chosen the sixth one [*sic*] arranged a poetry contest and each one had to tell his understanding of enlightenment. The oldest monk in the monastery said, the mind is like a mirror. It collects dust, and the problem is to remove the dust. There was a young fellow in the kitchen, Hui-neng, who couldn't read and couldn't write, but had this poem read to him, and said . . . Oh, I could write a much better poem. And so they asked him to say it and he did and they wrote it and it was: Where is the mirror and where is the dust?"[34] Each of us, however subconsciously, is already one with the vast universe of nature, and so all is right

with the world. (Cage delighted in telling the story of the Zen monk who cried, "Now that I'm enlightened, I'm just as miserable as ever.")[35] Of course, to break out of the cycle of desire and frustration, it is necessary to *realize* that all is right with the world and live accordingly. If I can truly internalize the fact that there is no difference between myself and the rest of creation, then why do I still want money for some new clothes? Why do I still hope that publication of this book will increase my fame? Why am I still angry with the man who did me an injury? He and I are the same, and so I did myself an injury. To achieve this suprapersonal level of consciousness is the point of zazen.

In zazen, the person sits cross-legged and attempts to free his or her mind of irrelevant thoughts. What thoughts are irrelevant? Any that aren't necessary to the exigencies of the moment, which means all of the ego-based chattering that normally runs through our heads. The zazen sitter is asked to focus on breathing, slowly in and out, and to register only the sensory impressions that are immediately present—which, if the eyes are closed, means primarily whatever sounds may occur in the environment. As the ninth-century Zen master Huang-Po said, "The ignorant eschew phenomena but not thought; the wise eschew thought but not phenomena." And as R. H. Blyth wrote, "The object of our lives is to look at, listen to,

touch, taste things. Without them,—these sticks, stones, feathers, shells—there is no Deity."[36] Eschewing thought, but paying close attention to sensory phenomena, even treating these as the Deity—this attitude explains much about *4'33"*, and about Cage's music from 1952 onward.

And thus we arrive at perhaps the simplest understanding of *4'33"*: that it is an invitation to (or, if you weren't aware of what was coming, an imposition of) zazen. If you desire certain things to happen in music, you will often be frustrated by it, and you must let go of desires and preferences. The attention to sonic phenomena, the understanding of them as the Deity, quiets the mind and renders it susceptible to divine influences. And what else is music supposed to do? If you are able to appreciate, at least on an intellectual level, that from a Zen standpoint there is no difference between playing a note and not playing a note, that a chord on the piano and a cough from an audience member behind you and the patter of rain on the Maverick Concert Hall roof are not different, but the same thing—then you may be able to think of *4'33"* as something more profound than a joke, a hoax, or a deliberately provocative and nihilistic act of Dada. If you can turn toward the whir of the wind in the oak trees or the pulse of the ceiling fan the same attention you were about to turn to the melodies of the pianist, you may have a few moments of realizing that the division you

habitually maintain between art and life, between beautiful things and commonplace ones, is artificial, and that making it separates you off from life and deadens you to the magic around you.

Many people scoff at *4′33″*. But I once performed it for a class of new freshmen, and a young woman exclaimed afterward with surprised delight, "I never realized there was so much to listen to!" Perhaps that's exactly the kind of musical satori Cage hoped to bring about.

The bulk of the lectures and writings in Cage's contagiously whimsical 1961 book *Silence*—which vastly increased his fame and had a tremendous impact on all art forms in the following decades—dated from 1952 to 1961, with two articles from the 1930s and two from the 1940s. Thus by the time he came to widespread public attention outside the music and art community, he was well into his Zen period, and the fingerprints of his studies with Suzuki are everywhere. His essays begin to delight in the koan-derived quality of paradox, such as in the most oft-quoted words from the "Lecture on Nothing": "I have nothing to say and I am saying it and that is poetry as I need it." He begins the third of his Darmstadt lectures on "Composition as Process" (1958) with the Japanese Zen saying "Nichi nichi kore ko nichi"—"Every day is a beautiful day"—and ends it with a long story from the 4th-century-B.C. Zen

master Zhuangzi, or, in 1950s transliteration, Kwang-Tse (also Chuang Tsu, Chuang Tzu, Zhuang Tze, Chouang-Dsi, or Chuang Tse). He tells a story of Dr. Suzuki closing an argument about metaphysics by commenting, "That's why I love philosophy: no one wins." He comments on European harmony with a quotation from Sri Rama-krishna: "When asked why, God being good, there was evil in the world, Sri Ramakrishna said: To thicken the plot." Beginning a "History of Experimental Music in the United States," he starts with Suzuki:

> Once when Daisetz Teitaro Suzuki was giving a talk at Columbia University, he mentioned the name of a Chinese monk who had figured in the history of Chinese Buddhism. Suzuki said, "He lived in the ninth or the tenth century." He added, after a pause, "Or the eleventh century, or the twelfth or thirteenth century or the fourteenth."

And this leads to thoughts about the omni-interpenetration of history, and de Kooning's comment "The past does not influence me; I influence it." And another Suzuki saying:

> Before studying Zen, men are men and mountains are mountains. While studying Zen, things become con-fused. After studying Zen, men are men and moun-tains are mountains. After telling this, Dr. Suzuki was

asked, "What is the difference between before and after?" He said, "No difference, only the feet are a little bit off the ground.

In the introduction to *Silence*, however, Cage cautions,

What I do, I do not wish blamed on Zen, though without my engagement with Zen (attendance at lectures by Alan Watts and D. T. Suzuki, reading of the literature) I doubt whether I would have done what I have done. I am told that Alan Watts has questioned the relation between my work and Zen. I mention this in order to free Zen of any responsibility for my actions. I shall continue making them, however.[37]

Reportedly, Watts retracted his concerns after reading Cage's writings, but he was not the only one who thought that Cage did not quite get the point. I remember, at the first June in Buffalo festival in 1975, Cage drawing on the blackboard a diagram that Suzuki used to draw: a circle (or oval) crossed by two small parallel lines near the top. The circle was the self, in the widest sense, and the two lines represented the comparatively tiny boundaries of the ego. Cage, quoting Suzuki, talked about how the point was to get past the ego to the entire self, and (not quoting Suzuki) how chance processes were his way of doing

that. The following week, however, Cage's composer friend Earle Brown referred again to that diagram and said that he thought the idea was to charm the ego into flowing into the self and becoming more spontaneous, not simply to use the mechanics of chance to bypass the ego. Thus, Cage's experience of Zen consciousness did not necessarily have to result in the gesture of 4′33″. As R. H. Blyth's innumerable poetic examples make clear, the spontaneity, the unconscious selflessness of great art is also full of Zen.

Cage was not a monk or a Zen master or a scholar, but a composer, an artist. Zen, with its concepts and literature, was one of his inspirations.

The *I Ching*

In 1950 Cage received a remarkable new student: Christian Wolff, the precocious sixteen-year-old son of publishers Kurt and Helen Wolff. "I believe I learned more from him," Cage would later say, "than he did from me."[38] Kurt Wolff, born in Bonn, was a giant on the literary scene, the first to publish Franz Kafka and Franz Werfel. His son Christian would enter the circle around Cage, Feldman, and Tudor, becoming a composer of chance tendencies. Wolff also developed a political streak and,

along with associates like Frederic Rzewski and Cornelius Cardew, would form a movement of political music in the 1970s. Music was not Wolff's only talent; from 1971 to 1999 he taught classics and comparative literature (the Greek tragedian Euripides was his early specialty), as well as music, at Dartmouth College.

Wolff's primary significance for *4′33″*, however, is a book he introduced Cage to. Since Cage (in memory of Schoenberg's similar generosity) charged Wolff no money for lessons, Wolff would sometimes bring him books published by Bollingen Press, his father's company, including, one day, the first English translation of the *I Ching*, the ancient Chinese *Book of Changes*, in a translation from the German of Richard Wilhelm. The *I Ching* is a Chinese document of incalculable antiquity, a book that both encapsulates an ancient Chinese philosophical system and serves as an oracle of divination. The book comprises sixty-four images and their interpretations. Legend has it that fortunes used to be told by casting a turtle shell on the fire and drawing inferences from the cracks that appeared. The same tradition has it that the patterns of cracks were eventually schematized into sixty-four possibilities, based on a binary system of straight and broken lines. The divination evolved into a practice of drawing yarrow sticks to build up a hexagram of straight or broken lines; today, it

is more common to toss a set of three coins six times. In any case, the result is six lines each with two possibilities, giving a total of sixty-four possible hexagrams.

According to the thinking behind the *I Ching*, a synchronicity in the universe ensures that whatever hexagram comes up will be in accord with the state of the universe at that moment, and thus relevant. For instance, at the point of writing this description, I flipped three coins six times to come up with hexagram 55, "Feng/Abundance." The interpretation says, in part:

> The hexagram pictures a period of advanced civilization. However, the fact that development has reached a peak suggests that this extraordinary condition of abundance cannot be maintained permanently.
>
> THE JUDGMENT
>
> ABUNDANCE has success.
> The king attains abundance.
> Be not sad.
> Be like the sun at midday.

It is not given to every mortal to bring about a time of outstanding greatness and abundance. Only a born ruler of men is able to do it, because his will is directed to what is great. Such a time of abundance is

usually brief. Therefore a sage might well feel sad in view of the decline that must follow. But such sadness does not befit him. . . . He must be like the sun at midday, illuminating and gladdening everything under heaven.[39]

This is, admittedly, a little vague to me, perhaps because I had no real question or quandary about how I was going to write about Cage and the *I Ching*. On the other hand, I am certainly writing at a time of abundance in Cage scholarship—so many of the excellent secondary sources I've drawn from have appeared only in the past few years—and I am not adding to that abundance, only organizing it and shining a light onto it by collecting it into a single volume. I could be sad that I am not generating new insights or research about Cage or the *I Ching*, but instead I should be happy to be doing such work in a time of abundance. (On the other hand, soon after I first wrote those words in August 2008, the stock market plummeted, and another time of abundance was certainly over.)

Cage seems to have often consulted the *I Ching* for advice in the traditional manner—he used it, he said, "every time I had a problem. I used it very often for practical matters, to write my articles and my music—for everything."[40] Eventually, though, it came to serve more often as a kind of random number generator. Cage would as-

sign durations, dynamic markings, pitch complexes, and so on to the numbers 1 through 64, then use the *I Ching* (or rather, its coin-based deliberation technique) to make decisions as to what would come next and what elements and characteristics would go together. His first thorough-going experiment in this method was *Music of Changes*. Working from February to December 1951, during one of the poorest stretches of his life, he would toss coins continuously on the street and in the subway, painstakingly adding to the piece chord by chord. He asked friends and passersby to buy shares in the work, promising to pay back a percentage of whatever money he made from it—the "stock" he sold brought in about $250. (Interestingly, Cage's father had financed some of his inventions through a similar scheme.)[41]

For the rest of his life Cage would be closely associated with the *I Ching*, using it to compose most of his later works—though he eventually replaced the coin tossing with a computer printout of random numbers from 1 through 64, which he carried around with him. The process of *Music of Changes*, however, was particularly complex. Not only were the coin tosses applied to three charts determining sonority, duration, and dynamics, and also to randomized tempo changes, the musical texture was made up of anywhere from one to eight layers at a given moment. To write *4′33″*, Cage would use pretty much the

same process—except that, having no sounds, he simply omitted the tables for sonority and dynamics and retained those for duration.

Black Mountain College

Nestled near Asheville, North Carolina, and owned and operated by its faculty, Black Mountain College represented for its brief duration (1933–1957) a radical approach to education. Following the progressive principles of John Dewey, the school treated the arts as central to education, and all members shared in farm work and construction projects. Black Mountain also benefited from the influx of Europeans escaping the growing Nazi menace, particularly in the arrival of its first art teacher, Josef Albers. Cage had unsuccessfully applied for a job at Black Mountain in 1939, and in April 1948 he and Cunningham came and gave concerts, without receiving a fee. Enthusiasm for their work brought a return invitation for the July session;[42] this is the one at which Cage lectured on Satie and performed his music, irritating some of the German immigrants with his dismissal of Beethoven. However, Albers seems to have liked him, and Cage became a close friend of Albers's wife, Anni. By 1952, Lou Harrison was working in the music department, and he invited Cage back for a residency in August. Tudor also taught at Black

Mountain from 1951 to 1953 and kept Cage's music alive on campus.

During his 1952 residency, Cage orchestrated a multimedia theater piece, later variously called *Theater Piece No. 1* or *Black Mountain Piece*, which has gone down in history as the first "happening"—a genre of free-form, often spontaneous theatrical event that would become popular in the 1960s, generally associated with Bohemian society. M. C. Richards had written a translation of Antonin Artaud's *The Theater and Its Double*, and as Cage later said, "We got the idea from Artaud that theater could take place free of a text, that if a text were in it, that it needn't determine the other actions, that sounds, that activities, and so forth, could all be free rather than tied together . . . so that the audience was not focused in one particular direction."[43] Descriptions of the event vary widely, but one thing that's clear is that Cage seated the audience in four triangles all facing the center. He then stood on a ladder delivering a lecture (one memory was that it was about Meister Eckhart), Rauschenberg played an old-fashioned phonograph (Edith Piaf records, apparently), Cunningham and his dancers moved through the audience, and Tudor played a piano, with Rauschenberg's White Paintings hung at various angles as backdrops. The chaotic success of this piece led Cage further in the direction of theater, most immediately in the composition

David Tudor and John Cage. Courtesy of the
John Cage Trust at Bard College.

of *Water Music*, which would become the lead piece on
David Tudor's August 29 concert at Maverick.[44]

The White Paintings

It was at Black Mountain in the summer of 1951 that
Rauschenberg created his famous White Paintings. One

of them was simply a white square canvas; another was made of two attached vertical rectangles, one of three, one of five, and one of seven; another was of four squares arranged in a square. As an exhibition catalogue for the Guggenheim Museum put it,

> At a time when Abstract Expressionism was ascendant in New York, Rauschenberg's uninflected all-white surfaces eliminated gesture and denied all possibility of narrative or external reference. In his radical reduction of content as well as in his conception of the works as a series of modular shaped geometric canvases, Rauschenberg can be seen as presaging Minimalism by a decade.
>
> The *White Paintings* shocked the artistic community at Black Mountain, and word of the "scandal" spread to the New York art world long before they were first exhibited at the Stable Gallery in October 1953.[45]

Rauschenberg's impetus for the White Paintings had both similarities to and differences from Cage's push toward *4′33″*. Neither was trying to shock anyone; both felt compelled by necessity. Like Cage, Rauschenberg was motivated partly by feelings of religious mysticism, though his were more conventionally Christian. In Rauschenberg's abstract paintings of 1950–1951, the color

white was used to suggest the divine. His painting *Cruci-fixion and Reflection* is almost all white, comprising a cross and its reflection outlined with thin dark lines and differences in the paint thickness. Another painting, *Mother of God*, imposes a large white circle on a collage of city maps, the circle's whiteness dominating the image.

Likewise, the White Paintings at first held a religious significance for the artist. On October 18, 1951, Rauschenberg wrote to Betty Parsons begging (unsuccessfully) for a second exhibition, due to what he saw as the urgency of this new phase in his output. Of the White Paintings, he enthused: "They are large white (1 white as 1 GOD) canvases organized and selected with the experience of time and presented with the innocence of a virgin. Dealing with the suspense, excitement, and body of an organic silence, the restriction and freedom of absence, the plastic fullness of nothing, the point a circle begins and ends. they are a natural response to the current pressures of the faithless and a promoter of intuitional optimism. It is completely irrelevant that I am making them—*Today* is their creater [*sic*]." Although Rauschenberg started out more or less continuing the work of the Abstract Expressionists, the White and the later Black Paintings, daubed with thick swirls of monochrome paint, advanced the logic of abstraction to a point that revolted against expressionism.

As in their reactions to Cage, critics were indignant. After the paintings finally had their first New York exhibition in 1953, Hubert Crehan in *Art Digest* denounced their "dada shenanigans," and added, "White canvas, conceived as a work of art, is beyond the artistic pale. If anything, it is a *tour de force* in the domain of personality gesture."[46]

Cage, however, as he had done with Coomaraswamy and Suzuki, integrated Rauschenberg's new development in his own way. For Cage, the whiteness wasn't a divine presence but an absence that refused to dominate the viewer, in a way analogous to the "silent" piece he'd been contemplating. The lack of focus turned the White Paintings into objects not separated from their environment (as art is) but contiguous with it. A phrase that Cage came up with in his 1961 article "On Robert Rauschenberg, Artist, and His Work" has come to pervade the literature about the White Paintings: "The white paintings were airports for the lights, shadows, and particles." Cage saw an emptiness in which the shadow of the viewer, or of another viewer, could become part and parcel of the painting, just as unintended sounds would become part of *4′33″*. Each of Cage's references to the White Paintings drives this point home:

> Is it true that anything can be changed, seen in any light, and is not destroyed by the action of shadows?

Before such emptiness, you just wait to see what you will see. Is Rauschenberg's mind then empty, the way the white canvases are?

The white paintings caught whatever fell on them; why did I not look at them with my magnifying glass?[47]

In his 1954 lecture "45′ for a Speaker," Cage fused the significance of the white paintings and 4′33″ into a manifesto that separated the new, "modern" music and painting from the old stuff:

> The way to test a modern painting is this: If
> it is not destroyed by the action of
> shadows it is a genuine oil painting.
> A cough or a baby crying will not
> ruin a good piece of modern music.[48]

Now, no museum today would allow enough dust to fall on one of these celebrated paintings to visibly become part of it, but Rauschenberg took the hint, and he later made paintings or combines with dirt, movable objects, or other impermanent materials that changed or disintegrated over time. A painting may not want to separate itself from life any more than 4′33″ wants to separate itself from the sounds of our lives, but in museum culture,

an original object made by a famous artist is going to be set off by curatorial fiat. Nevertheless, what concerns us here is that Cage saw in the white paintings a visual analogue of the "silent" piece he'd been yearning to create. As he said later, "Actually what pushed me into [writing *4′33″*] was not guts but the example of Robert Rauschenberg. His white paintings . . . When I saw those, I said, 'Oh yes, I must; otherwise I'm lagging, otherwise music is lagging.'"[49] And he generously added an epigraph at the beginning of his Rauschenberg lecture:

> To Whom It May Concern:
> The white paintings came
> first; my silent piece
> came later.[50]

The Anechoic Chamber

Even with his growing interest in Zen, the impetus of the White Paintings, and the threat of silent jukebox records, it took one more insight for Cage to take the dramatic step toward a "silent" piece. The inspiration he most often mentioned was his realization that there is no such thing as silence. This came about sometime in 1951 or 1952 when he had a chance to visit an anechoic chamber at Harvard University. An acoustic anechoic chamber

is a room built to absorb and block sound reflections so as to approach conditions of absolute silence; the room is covered with sound-absorbent material, and usually insulated on the outside as well to prevent sound from coming in. Such rooms can be used to test electronic sound equipment in pristine conditions, or for acoustic or psychoacoustic research. The Harvard University catalogue for 1949–59 boasted that "in this remarkable room, 99.8 or more per cent of the energy in a sound wave is absorbed during a single reflection over a frequency range of 60 to 20,000 or more cycles per second."[51] Since there were at the time two anechoic chambers at Harvard, one in the applied engineering department and a smaller one in the psychoacoustic laboratory at Memorial Hall, it is uncertain which Cage visited.

Cage's visit to the anechoic chamber was one of the formative experiences for his late aesthetic, and it can only be related in his own words:

It was after I got to Boston that I went into the anechoic chamber at Harvard University. Anybody who knows me knows this story. I am constantly telling it. Anyway, in that silent room, I heard two sounds, one high and one low. Afterward I asked the engineer in charge why, if the room was so silent, I had heard two sounds. He said, "Describe them." I did. He said,

"The high one was your nervous system in operation. The low one was your blood in circulation."[52]

In a 1957 lecture titled "Experimental Music," Cage amplified the ramifications:

There is no such thing as an empty space or an empty time. There is always something to see, something to hear. In fact, try as we may to make a silence, we cannot. . . . Until I die there will be sounds. And they will continue following my death. One need not fear about the future of music.

But this fearlessness only follows if, at the parting of the ways, where it is realized that sounds occur whether intended or not, one turns in the direction of those he does not intend. This turning is psychological and seems at first to be a giving up of everything that belongs to humanity—for a musician, the giving up of music. This psychological turning leads to the world of nature, where, gradually or suddenly, one sees that humanity and nature, not separate, are in this world together; that nothing was lost when everything was given away. In fact, everything is gained.[53]

Notice that the first of these paragraphs refers to the physical facts learned in the anechoic chamber; the second is the Zen-conditioned response to those facts.

Though perhaps it was already changing, the concept of *Silent Prayer* definitely changed in 1952, through Cage's realization that strict theoretical "silence" was unavailable to human experience. To compose silence was not only a paradox or a provocation, but an impossibility. Cage had been used to thinking of sound and silence as opposites; he now understood them as merely aspects of the same continuum, in keeping with the Zen tendency to dissolve dualities. It is in this sense that he says in his "Lecture on Nothing," "What we require is silence; but what silence requires is that I go on talking."[54] The idea that had begun as negation—a respite from the forced listening of Muzak—now became affirmation, an acceptance of those sounds over which one has no control, and which one did not intend. The anechoic chamber revealed the futility of the negation, while Zen offered the alternative, affirmative attitude. Without both these sides of the equation, *4'33"* might not have happened. To have retained "Silent" as part of the title would have been misleading, implying the opposite of what Cage now understood. *4'33"* is often mischaracterized as Cage's "Silent Sonata," but the point is that it is *not* silent, that there is no such thing as silence; "Unintended Noise Sonata" would come closer to the truth.

There is some questioning, by the way, of the facts so confidently given to Cage by the anechoic chamber tech-

nician. Peter Gena, a composer who has based much of his music on data drawn from medical research, has confirmed with several doctors that no one can hear the operation of his or her own nervous system, which is merely a series of electrical impulses. It is possible that Cage had tinnitus, a persistent ringing in the ears, which many musicians develop and which often remains masked until the afflicted person is in an extremely quiet environment. Gena also reports the suggestion that the circulation of one's blood remains inaudible unless there is some incipient cardio-vascular blockage. He often takes students into anechoic chambers, and reports that the healthy ones—at least, those who haven't already developed tinnitus—report hearing no sound whatever. For some, virtual silence may indeed exist, at least momentarily. The accuracy of the engineer's account, though, isn't really the issue. If the complete absence of auditory stimuli is something that can only be experienced by very healthy people in an anechoic chamber, then it is little more than a theoretical potential in human life, something most people will never experience. Medical fact leaves Cage's basic point unscathed: our bodies do produce sounds of their own, and in the vast continuum of human experience true silence is virtually unknown.

Determining the exact date of the anechoic chamber experience is a maddening puzzle. In one place Cage at-

tributes the experience to the late 1940s, but then in *Silence* he describes the chamber as being "as silent as technologically possible in 1951." [55] Some, including William Fetterman and Larry J. Solomon, have accepted this later date. Patterson and Brooks, though, venture another chronology, more strongly implied by Cage's "An Autobiographical Statement." Cage describes the 1952 happening at Black Mountain College with its unusual audience arrangement and then says, "It was later that summer that I was delighted to find in America's first synagogue in Newport, Rhode Island, that the congregation was seated in the same way, facing itself." "From Rhode Island," he continues in the next paragraph, "I went on to Cambridge and in the anechoic chamber at Harvard University heard that silence was not the absence of sound." [56]

If the progression from the happening to the synagogue at Newport to the anechoic chamber at Harvard is correct (and unlike the other accounts it attaches the incident to datable events), then the anechoic chamber incident would seem to follow the 1952 Black Mountain residency. Cage participated in a performance of *Sonatas and Interludes* at Black Mountain College on August 16, 1952. [57] If he next went to Rhode Island and then Harvard, then less than two weeks was available to experience the anechoic chamber and write *4′33″* — a very immediate response indeed. And even so, Cage was still deliberating

the sanity of going public with the piece, and he was only moved to do so by David Tudor's persuasion and his offer to include it on his August 29 Woodstock program.[58] If all these elements are in place, it seems that after a four-and-a-half-year gestation period, Cage—and who would be surprised by this?—wrote *4′33″* very quickly.

And then headed to Woodstock and braced for the response.

The Piece and Its Notations

It may seem silly to embark on an analysis of a piece of music containing no intentional sounds. But in fact the exact form of *4′33″* is riddled with ambiguity: its notation changed twice, and the latitude of its performance directions, as described by its composer, has expanded over the decades. To simply describe what *4′33″* is, at this point, requires almost a philosophical treatise.

Given the radicalness of the gesture, the division of the piece into three movements is a curiously "classicizing" feature, unmistakably suggesting a sonata. As we've seen, music without structure was anathema to Cage, and an uninterrupted stretch of silence might have seemed (in the more usual sense of the word) too formless, lacking any objective feature that would convince the audience

to recognize it as a work. But is the audience expected to *quit* listening to environmental sounds during the brief breaks between movements? (Interestingly, at the BBC Orchestra performance in 2004 the audience saved their coughs for between movements.) Are these two slight intermissions chances to hit the refresh button? Are they like the breaks that occur in Zen meditation when one signals the monk to hit one on the shoulders with a bundle of sticks, to refocus the attention? Is the purpose to call attention to the work's status as a *performance*, whereas a one-movement form might have seemed more of a philo- sophical statement? Or do the breaks merely pay homage to the conventions of the classical-music listening format? Certainly for Cage to have written the piece in two move- ments, or five, would have altered the connotations. The movement breaks seem anachronistic in a way similar to the binary format Cage used for the sonatas in *Sonatas and Interludes;* it is odd that Cage reverted to an eighteenth- century format for something as futuristic as a prepared piano piece, and even more so for something as uncon- ventional as *4′33″*. And yet, without those movement breaks, the framing gesture would seem less emphatic, its appropriation into the world of concert-hall performance less complete.

The process used to compose *4′33″* was an outgrowth of that which Cage had used to write *Music of Changes*.

Cage had been working with what he called a "gamut" technique, in which he would compose a group of unrelated sonorities and then limit himself, while composing, to those sonorities. This technique had its roots in his work with percussion and the prepared piano. Unlike, say, a string orchestra, which offers a vast and continuous range of harmonic and textural possibilities, an ensemble of unpitched percussion tends to comprise a fixed group of sounds, or noises; one can strike a gong, or hit one of five variously sized brake drums, but neither instrument offers a variety of harmonic progressions. The sounds available are what they are. This principle transferred well to the prepared piano: once the preparations were made, the pianist was no longer working along a scaled pitch continuum, but rather was presented with a number of different sounds related to each other more or less unsystematically. On an unprepared piano, one can play a melody or chord progression at one pitch level and then transpose it up a half step, down an octave, or anywhere else and still preserve the identity of the musical entity; on the prepared piano, this is impossible. Transposition results in an unpredictable change of timbre and pitch.

Transferring this gamut concept to more traditional musical ensembles took some thinking. A particular challenge was Cage's first orchestra work, *The Seasons* (1947). It was his first work for conventionally pitched instru-

ments in some years, and in order to avoid having to deal with harmony in any ordinary sense he composed individual sonorities and figures, then placed them into a nonlinear continuity.[1] One of the most successful of his gamut works, and one in which the technique is clearly audible, is the String Quartet of 1950. All four movements of the piece are composed from preset sonorities in which all four instruments play a part. For instance, as one can see on the first page of the score, every instance of the F-sharp above middle C in the viola is accompanied by B-flat and B in the second violin. Every C above middle C in the first violin is accompanied by a pizzicato D in the same part and a pizzicato A in the cello. The sonority in measure 8—C, D-flat, A-sharp, F-sharp—is one that recurs throughout the piece. And so on.

It is in *Sixteen Dances* that Cage began to use chance techniques to determine which elements in his gamut to use. In some of the movements, Cage would compose a gamut of sixty-four sounds and gestures in an eight-by-eight square, then use systematic moves to follow a course around the square, unable to predict exactly what progression would occur.[2] The Concerto for Prepared Piano and Orchestra (1950–1951) is a particularly transitional work, characterized by Cage as "a drama between the piano, which remains romantic, expressive, and the orchestra, which itself follows the principles of oriental

John Cage, String Quartet in Four Parts, 1950, page 1.
Published by Henmar Press, Inc. Used by permission of C.F. Peters
Corporation. All Rights Reserved.

philosophy."[3] Both piano and orchestra follow the macro-microcosmic structure, but the piano part is freely written, as in Cage's works of the 1940s; the orchestra follows the chart technique based on precomposed gamuts, as in *Sixteen Dances*. In the third movement, piano and orchestra resolve their dualism and come together; and here, for the first time, Cage began specifically to use the *I Ching* not only to order the progression of sounds but to compose the gamut charts as well. Significantly, and also for the first time, sounds and silences are now treated as equals on the chart.[4]

In *Music of Changes*, Cage aimed for maximum randomness and maximum variety, applying chance processes separately for pitch, duration, and dynamics.[5] This separation is a clear response to the kind of serialist twelve-tone thinking that his friend Boulez was pursuing in Europe. Boulez and Stockhausen had adopted Arnold Schoenberg's twelve-tone system, but Boulez was dissatisfied; in a provocative 1952 article titled "Schoenberg Is Dead," he asserted that the twelve-tone method offered a new pitch universe but maintained the same old intuitive world of rhythms and dynamics.[6] By separating out pitch, rhythm, duration, and timbre as different "parameters" of music (a word taken from mathematics and slightly misapplied), Boulez and the other serialist composers treated

each aspect of music independently, so that a note might be C-sharp because of its place in the pitch row, pianissimo because of its place in the dynamics row, a dotted quarter in length because of its place in the duration row, and so on. The extreme, most rigorous tendency of this style was called total serialism and was mostly a product of the 1950s and early 1960s.

By applying separate chance charts to pitch, duration, and dynamics, Cage showed that he was allying himself with new ways of structuring music that were arising in Europe. (Although not without misgivings; in a 1963 article in *A Year from Monday* he writes, "Musicians need now some way to work that doesn't deal with parameters; otherwise, like convicts, musicians'll be obliged come good weather, to stay indoors."[7] Meaning, one supposes, that the reliance on parameters removes some of the spontaneity and playfulness from the act of composing, which is certainly the case.) As James Pritchett describes it, "Every event in *Music of Changes* was the combination of one element of each of three charts individually referring to sonority, duration, and dynamics."[8] Thus a group of pitches or chords occurring at one point in the piece with a certain rhythmic profile might recur later with a different rhythm and dynamic attached. *Music of Changes* seems like the ultimate rigorous chance composition. Actually,

however, if you listen closely or peruse the score, you do notice certain figures recurring amid the chaos, as a result of the self-limitations of Cage's gamut technique.

The rather complex details of the compositional process of *Music of Changes*—including the varying number of layers that Cage compressed to thicken the texture—do not really concern us here. All we need to know is what carried over into *4′33″*. Cage retained the *I Ching*-determined gamut method, but as his new piece was to contain no composed sounds, he no longer needed charts for pitches or dynamics—merely durations. As he explained in the question-and-answer sessions accompanying the Harvard lectures he delivered in 1988 and 1989 (printed in *I–VI* all in lower case and without punctuation),

> when i wrote *4′33″* i was in the process of writing the *music of changes* that was done in an elaborate way there are many tables for pitches for durations for amplitudes all the work was done with chance operations in the case of *4′33″* i actually used the same method of working and i built up the silence of each movement and the three movements add up to *4′33″* i built up each movement by means of short silences put together it seems idiotic but that's what i did i didn't have to bother with the pitch tables or the amplitude tables all i had to do was work with the durations

[question from the audience:] *then it was a very
spontaneous creation*

i don't think that in this kind of work that sponta-
neous is the word i didn't know i was writing *4′33″* i
built it up very gradually and it came out to be *4′33″* i
just might have made a mistake in addition[9]

Although the construction of *Music of Changes* is often
discussed only in terms of the *I Ching*, David Revill, Larry J.
Solomon, and William Fetterman note Cage's use of Tarot
cards as well. In 1990 Cage explained that the durations of
4′33″ were written on a homemade deck of cards and inter-
preted somehow according to a Tarot-card spread:

I wrote it note by note, just like the *Music of Changes*.
That's how I knew how long it was when I added the
notes up.

It was done like a piece of music, except there were
no sounds—but there were durations. It was dealing
these [cards]—shuffling them, on which there were
durations, and then dealing them—and using the
Tarot to know how to use them. The card-spread was
a complicated one, something big.

Question: Why did you use the Tarot rather than
the *I Ching*?

Probably to balance East with West. I didn't use
the [actual] Tarot cards, I was just using those ideas;

and I was using the Tarot because it was Western, it was the most well-known chance thing known in the West of that oracular nature.

As Fetterman notes with pensive understatement, "the actual working process is not directly documentable in exact detail."[10]

In order to allow its rhythmic structure to be chance-determined, *4′33″* was built up from the addition of chance-determined lengths of silence. "Idiotic" might be a strong word for it (or perhaps the reader agrees), but it was certainly not the most direct route. The durations, as given in the program at the premiere, were:

30″
2′23″
1′40″

Thus the total of 4′33″. And we think back, now—in 1948 at Vassar College, Cage had threatened to write a silent piece four and a half minutes long, because that was the length of sections that Muzak was marketed in. What a happy coincidence! In 1948 he wanted a four-and-a-half-minute piece, and the *I Ching* gave him, by chance, a four-and-a-half-minute piece! Thank you, universe. But wait— "i just might have made a mistake in addition"? What does *that* mean? If he still recalls, thirty-six years later, that he

might have made a mistake in addition, then why didn't he go back and fix it at the time? Isn't the use of the *I Ching* based on a faith that whatever answers it gives will be those in accord with the universe at that moment? If so, how can one countenance a mistake in addition? As Solomon speculates, perhaps "Cage simply ended the piece when he came to a total length (the small parts of which were determined by chance operations) that approximated the 4.5 minutes that he already had in mind."[11]

This is the conundrum at the center of the composition of *4′33″*. The riddle will not be solved in this book, perhaps never. Someone suspicious in nature might conclude that the "mistake in addition" served to bring the piece as close as possible to that predetermined four and a half minutes. Who knows? And there's another quandary, because when the score to *4′33″* was published by C.F. Peters (which had taken over Cage's output in 1960), Cage's performance direction states that the lengths of the three movements, at the premiere, were

33″
2′40″
1′20″

All the digits are the same, but how did twenty seconds from the final movement get shifted to the second movement, and three seconds from the second end up added to

the first? Weren't those *I Ching*-mandated time lengths theoretically sacrosanct? Solomon speculates (with a statement by David Tudor in partial support) that, when it came time to publish a different score (see below), Cage recalculated the movement timings via *I Ching* but using the same overall structure.[12] The numbers are so similar, though, that to write off the discrepancy as a memory glitch is very tempting.

To add to the confusion, Cage issued three scores of *4′33″*, all quite different from each other. The original 1952 score from which Tudor performed the work is now lost, but around 1989 Tudor reconstructed it from memory twice—and came up with slightly different versions. According to David Tudor scholar John Holzaepfel, the first contained a single staff partitioned in measures 7½ inches long, with one half-inch equated to a metronome marking of 60. The second reconstruction employed a grand staff (treble and bass clefs), a time signature of 4/4, a measure 10 centimeters long, and a metronome marking of 60 to a quarter note. Holzaepfel notes that this system of measurement duplicates that of *Music of Changes*, and that since *4′33″* grew out of work on that piece, it is more likely to accurately reflect the original score.[13] Tudor performed the piece almost conventionally, by watching the music go by on the page—with the exception of closing the keyboard lid at the beginning of each movement and

opening it at the end.[14] Years later, he would say, "It's important that you read the score as you're performing it, so there are these pages you use. So you wait, and then turn the page. I know it sounds very straight, but in the end it makes a difference."[15]

In 1953, for Irwin Kremen, Cage made another score. As prelude to its published version, Kremen writes, "After David Tudor gave the first performance of 4′33″ at Woodstock in 1952, John made a copy 'in proportional notation' which he gave to me as a gift for my twenty-eighth birthday (June 5, 1953). A noteworthy feature of this score is its manner of indicating time, here made a function of continuous space with the direction '1 PAGE = 7 INCHES = 56″.'" Kremen then goes on to note that in 1967 this version of the score was published in *Source*, the leading magazine for avant-garde music in the 1960s, but that because the score was reduced in size for printing, the relationship of space to time was falsified.[16] After Cage's death, Kremen prevailed upon C.F. Peters to publish this version of the score at the correct size, in 1993. This score does away with the treble and bass staves as unnecessary, and also as too piano-specific; a note at the beginning of the score states, "For any instrument or combination of instruments." The score comprises six horizontal pages, and the horizontal time-space of each movement is marked off by vertical lines appearing at intervals proportionate to the

David Tudor's 1989 reconstruction of the original 1952 *4′33″* score in 4/4 time, page 1. Courtesy of the David Tudor Trust.

passage of time. If 7 inches equals 56 seconds, then ⅛ of an inch equals 1 second, which Cage seems to refer to by marking a tempo of 60 at the top; thus the first two vertical lines mark off a space 3¾ inches wide, or ³⁰⁄₈, to denote 30 seconds. The second movement, 143 seconds long and so 17⅞ inches wide, has its opening line on page 2, a blank page 3 (denoting the second 7 inches), and the closing line in the middle of the next page; and so on. It is difficult to resist the suspicion that these white spaces marked off by vertical lines were an attempt to make the score look a little more like Rauschenberg's White Paintings.

The *Source* issue includes, along with the score, some correspondence the editors had with Cage, Tudor, and Kremen prior to publication. Kremen writes from Durham, North Carolina, "John Cage and David Tudor were here a few weeks ago, and John asked me to arrange with you for the publication in *Source* of the original manuscript of his 'silent piece,' as I have it, for it was dedicated to me. Apparently, this version of *4′33″*, which differs from the one subsequently published, is of some considerable historical significance, as it marked a transition from one form of musical notation to another."[17] In a subsequent letter, Kremen notes that there are eight "lith" negatives for the pages of the score, except for the blank third page.[18]

Cage's 1953 proportional-notation score of *4′33″*, page 1.
Published by Henmar Press, Inc. Used by permission of
C.F. Peters Corporation. All Rights Reserved.

The 1961 score issued by C.F. Peters (which has a 1960
copyright date) does not use proportional notation. (My
copy of this score, bought in the early 1970s, still bears
its 50-cent price tag.) This version contains only roman
numerals indicating the three movements and the word
TACET after each one, *tacet* being the word used in an

orchestral part to indicate that a particular instrument does not play during a movement. To have the word *tacet* appear in a solo composition was certainly odd, and against standard usage. Even odder, though, is that the piece was published without a title. An explanatory note, typed by Cage, states:

> NOTE: the title of this work is the total length in minutes and seconds of its performance. At Woodstock, N.Y., August 29, 1952, the title was 4′33″ and the three parts were 33″, 2′40″, and 1′20″. It was performed by David Tudor, pianist, who indicated the beginnings of parts by closing, the endings by opening, the keyboard lid. However, the work may be performed by any instrumentalist or combination of instrumentalists and last any length of time.[19]

This is a redefinition of the work indeed. It is no longer *4′33″*: if you'd like a performance lasting just over two hours it could be retitled *122′45″*, or you could make it as little as *0′23″*. A division into three movements still seems to be in place, but the fact that the durations were arrived at by chance seems to suggest that any other chance-determined durations would do as well. Allowing the piece to have its title changed depending on circumstances is in the tradition of *Water Music*, whose title originally changed to reflect the date or address of each new per-

I

TACET

II

TACET

III

TACET

NOTE: The title of this work is the total length in minutes and seconds of its performance. At Woodstock, N.Y., August 29, 1952, the title was 4' 33" and the three parts were 33", 2' 40", and 1' 20". It was performed by David Tudor, pianist, who indicated the beginnings of parts by closing, the endings by opening, the keyboard lid. However, the work may be performed by any instrumentalist or combination of instrumentalists and last any length of time.

FOR IRWIN KREMEN JOHN CAGE

formance. The inference is that each performance of the piece is a new piece.

One gathers that, between 1952 and 1960, Cage did some rethinking of *4′33″*. And yet art historian Liz Kotz notes that a typewritten copy of this score, almost identical to the Peters 1961 score, can be found among David Tudor's papers, bearing a date of 1953! But even this evidence is inconclusive: like other scores in this collection, it is marked "copyright 195_" with the final digit filled in by hand, and the final number does not appear to be in Cage's handwriting; so there is no guarantee that 1953 is the correct date. Further, Fluxus artist George Brecht took Cage's course in experimental composition at the New School for Social Research in New York and referred in his notes for July 17, 1958, to *4′33″* as "Silence. Tacet"—which seems to indicate that, by 1958, Cage was already using the word "tacet" in connection with the piece.[20] Ultimately, we can only guess that Cage changed his way of thinking about the piece possibly as early as 1953 and no later than 1958. That he found a way to notate the work entirely in words, without musical symbols or time-oriented layout, had significant ramifications for the following generation.

Meanwhile, *4′33″* is no longer a piano piece of a set duration (though performers seem to like that duration for historical or sentimental reasons, declining to avail

themselves of the freedom Cage allows). Cage specifies the theatrical gesture with which Tudor marked the beginning and end of each movement, but what is, say, a bassoonist who wants to perform it to do? Or an orchestra? Each nonpianist performer or ensemble has to creatively figure out their own means of clarifying the temporal frame.

Cage's subsequent remarks make it clear, in fact, that he learned to think of *4′33″* as not needing a performer. He often characterized it as simply an act of listening. In 1982 he told William Duckworth, "Well, I use it constantly in my life experience. No day goes by without my making use of that piece in my life and in my work. I listen to it every day . . . I don't sit down to do it; I turn my attention toward it. I realize that it's going on continuously. So, more and more, my attention, as now, is on it. More than anything else, it's the source of my enjoyment of life."[21] This conception throws the nature of the piece even more into question. It is one thing to sit in an audience watching a quiescent performer onstage; it is quite another to sit somewhere by oneself—in the woods, at a bus stop, near a construction site—and pay disinterested attention to the environmental sounds for an unspecified time. To Cage, clearly the essence of the piece remained the same, but what a vast difference in self-consciousness and communal experience!

Ultimately, we are left with the conundrum that *4′33″* has expanded into an infinite river of a piece into which any of us can dip at any time we please. Someone can frame it, in performance or on recording, to draw attention to it. But for those who have an affinity for Cage's appreciation for the physicality of sound, even that is no longer necessary.

The Legacy

Cage didn't believe in recordings and wouldn't listen to them, and he doubtless preferred his *4′33″* live and in situ. Nevertheless, as of this writing the John Cage Trust documents about two dozen commercial recordings of *4′33″* (see Appendix). To record the piece forces one to choose an aspect from which to consider it. One can issue a recording of total digital silence and allow the listener to enjoy the sonic phenomena of his or her own home; this most treats the work as a philosophical idea. More common, one can perform the piece in front of a microphone, permitting just enough ambient or accidental sound to document that one actually made the gesture; this approach acknowledges the piece's theatrical nature, the mutual awareness between performer and listener. Or

one can record four and a half minutes in an intentionally nonsilent environment, allowing the listener to vicariously experience a space other than the one he or she is actually in; this emphasizes the sensuousness of Cage's appreciation of environmental sound. All three strategies have their exemplars.

Many of the recordings are on minor or ephemeral labels. In Gianni-Emilio Simonetti's 1974 recording on Cramps, the beginnings and ends of movements are marked by closings and openings of what sounds like an instrument case, though in the album art the performer is pictured at a piano. In Julie Steinberg's recording on the Music & Arts disc *Non-Stop Flight*, audience applause is heard at the beginning and end, with the silence punctuated by restless shufflings of feet, a few coughs, and a distant clock striking. Frank Zappa's recording on the 1993 two-disc memorial set *A Chance Operation — The John Cage Tribute* (Koch International) gives no hint of human presence save for a thump at the end, as though Zappa has risen from a seated position to signal the end to the recording engineer. Listening to it one summer day, I heard the quiet burbling of the water pump in my fish tank, a steady, sibilant pulsation from the ceiling fan overhead, the hum of my refrigerator, and occasional, irregularly spaced but identical bird chirps from outside. It was quite lovely, surely more sustained and repetitive than

Tudor's performance at Maverick—a minimalist version. The movement separations were inaudible.

One disc on the almost unobtainably obscure Korm Plastics label of Amsterdam is titled *45'18"* and contains nine versions of *4'33"* by various performers—or rather, some versions plus some homages to the piece. Performances by Keith Rowe (guitarist for the improvising group AMM) and Pauline Oliveros's Deep Listening Band are as silent as humanly possible, though a human presence is discernible. Sonic Youth guitarist Thurston Moore took *4'33"* as liberating whatever sounds he and other musicians wanted to make, in a "crude setting of instantaneous and improvised music."[1] Jio Shimizu records the vinyl noise of a "silent" record, while the Swiss electronic duo Voice Crack provides faint and distant machine noises. Perhaps most creatively, the electronic duo Alignment (Radboud Mens and Mark Poysden) comes up with electronic metaphors for silence: in three movements they produce steady rasps, echoing clicks, and harsh vibrations that are actually artifacts of various digital recording processes amplified to the max. Never, perhaps, has the audibility of silence been more deafeningly demonstrated.

Tudor gave *4'33"* its New York City premiere on April 14, 1954, at the Carl Fischer Concert Hall. Cage's mother, then living in Upper Montclair, New Jersey, came up to

Earle Brown afterward ("John's mother and father always thought I was much more sensible than John," Brown later explained) and said, "Now Earle, don't you think that John has gone too far this time?"[2] Christian Wolff's mother, Helen (who was, after all, no mere amateur but a successful publisher), wrote Cage a letter begging him not to jeopardize his reputation as a serious composer with such pranks. Cage responded, waxing almost mystical,

> The piece is not actually silent (there will never be silence until death comes which never comes); it is full of sound, but sounds which I did not think of beforehand, which I hear for the first time the same time others hear. What we hear is determined by our own emptiness, our own receptivity; we receive to the extent we are empty to do so. If one is full, or in the course of its performance becomes full of an idea, for example, that this piece is [quoting her letter] a trick for shock and bewilderment then it is just that. However, nothing is single or unidimensional. This is an action among the ten thousand: it moves in all directions and will be received in unpredictable ways. These will vary from shock and bewilderment to quietness of mind and enlightenment.
>
> If one imagines that I have intended any one of these responses he will have to imagine that I have

intended all of them. Something like faith must take over in order that we live affirmatively in the totality we do live in. . . .

Another friend of mine was disturbed about 4′33″ and said with some heat that I apparently thought him stupid and incapable of hearing the sounds of everyday life which he informed me he could and with pleasure. I asked him why, if in private he could hear, he was disturbed to foresee doing so in public. To this he had to say, "You have a point."[3]

Cage further offered, in response to Helen Wolff's stated embarrassment, to personally warn her friends before a performance about what they were going to experience. Press reactions, meanwhile, were varied. While a review in the *New York Post* was bemused, the *New York Times* was vicious, referring to Tudor's whole program as "hollow, sham, pretentious Greenwich Village exhibitionism."[4]

Aside from his public concerts (including a 1954 tour with David Tudor of Donaueschingen, Cologne, Paris, Brussels, Stockholm, Zurich, Milan, and London), several activities in the mid- to late 1950s enabled Cage to rapidly expand his influence among younger composers.[5] One was a series of courses taught at the New School for Social Research (where Cage had once assisted Cowell), starting in fall of 1956. Several of the composers, poets,

and artists who took Cage's course titled "The Composition of Experimental Music"—George Brecht, Dick Higgins, Jackson MacLow, Al Hansen, and Allan Kaprow among them—would in the '60s become central to the Fluxus movement, a neo-Dada group whose conceptual art ran roughshod over the barriers between poetry, music, visual art, theater, and happenings. Japanese composer Toshi Ichiyanagi took the course upon its repetition in 1959–60.[6]

In September 1958, Cage and Tudor undertook a residency in Darmstadt, where since 1946 the annual Darmstadt International Summer Courses for New Music had been held as a meeting place for ambitious young composers. As a cultural event, the Darmstadt courses were infamous for their rigorous advocacy of the kind of serial music written and theorized about by Boulez and Stockhausen. Here Cage presented the three lectures later published in *Silence* as "Composition as Process," which offered a startlingly different viewpoint from the one the Darmstadters were used to. He also met and had a strong influence on the young Korean composer Nam June Paik (1932–2006), another soon-to-be-major Fluxus figure. The following year, a young saxophonist from Idaho named La Monte Young would attend Darmstadt, meet David Tudor there, and take up Cage's ideas with considerable, if temporary, fanaticism.

Perhaps most fertile of all Cage's activities was his 1961 appointment at Wesleyan University as a fellow in the Center for Advanced Studies. Cage was sponsored there by composer Richard K. Winslow, who, despite his personal musical conservatism, convinced Wesleyan University Press to publish a volume of Cage's writings. This was *Silence*, which would spread Cage's ideas and his sense of humor far beyond the usual circles of modern music. With *Silence* as the new bible of the younger generation of artists and the Fluxus group as an audacious proselytizing army, Cage's notions began flowing into the culture at a greatly accelerated rate.

The influence of an artist as Promethean, as prolific, and as long-lived as Cage is difficult to fully assess, given the disparate phases of his career and his own myriad connections and indebtedness to other artists, past and present. It is even more difficult to isolate the influence of one specific piece, even one as unique as *4′33″*. A line can be drawn from it to almost any subsequent piece designated by anything other than conventional musical notation, or to any musical work that uses sounds made by objects other than musical instruments. The use of recording tape to capture sounds for musical use preceded *4′33″* by only a couple of years; in the history of music that employs ambient sound, the influence of *4′33″* cannot be disentangled from that of the vast potential offered

by recording technology. Ambient sound and everyday noises were destined to become part of late twentieth-century music even if Cage had never lived, though he had some pull on the direction of aesthetic exploration. Many composers took inspiration from Cage's activities in general, not distinguishing 4′33″ from the larger flow of his ideas. It might be possible to divide the legacy of 4′33″ into three broad areas:

1. the chain of musical events that began with 4′33″, much of it conditioned by "creative misreadings" of Cage and flowing in directions he would never have envisioned, culminating in minimalism;
2. the more esoteric body of music that deals with environmental sound, some of it with 4′33″ as a direct philosophical impetus, but also a result of advances in technology; and
3. the homages, many of them from pop musicians, which attest to the status of 4′33″ as an iconic work that transcended the avant-garde milieu in which it originated.

The popularization of 4′33″ dissolved the traditionally self-evident boundaries of a piece of music or work of art: the "frame" could now be shifted to any part of life itself, and all phenomena, even the most mundane or rarefied, would be considered materials of art. Liz Kotz has

theorized that one of the main significances of *4'33"* was that, in the third, "Tacet" version of the score published by C.F. Peters, it defined a musical composition without using notes or musical notations, only words.[7] This is even more true of the piece Cage wrote in 1962 titled *4'33" (No. 2)*, with the alternate title *0'00"*, which simply instructs the performer to perform a disciplined action, with the caveats that the action cannot be the performance of a "musical" composition and that no two performances can involve the same action.[8] Cage dedicated this piece to his student Toshi Ichiyanagi and his wife, Yoko Ono. Ono was a young Japanese woman who had survived wartime deprivations in her native country to move to Scarsdale and attend Sarah Lawrence College. Soon she would become active in the Fluxus conceptual art community; a few years later she would meet and marry John Lennon.

Around 1960, the composition of musical pieces defined by words alone started to become rather common in New York and San Francisco avant-garde circles, particularly within the later-so-named Fluxus group; such an instruction was rather jocularly called "the short form." For instance, La Monte Young wrote pieces in which the audience was advised that the performance would last for such-and-such a duration, and that they could do anything they wanted during that duration; in which butterflies were released into the performance area; and, more

surrealistically, in which a piano was offered a bale of hay and a bucket of water to eat and drink.[9]

Thus from *4'33"* evolved outward the idea of framing any stretch of time, any experience, even any concept as a work for aesthetic contemplation. Yoko Ono published similar pieces in her 1964 book of concept art *Grapefruit*, directing the reader to play any one note accompanied by the sound of the woods from 5 to 8 AM in summer, to listen to the sound of the earth turning, or to ride a bicycle in a concert hall without making any noise.[10]

In 1969 Ono and Lennon released a record of experimental music, *Unfinished Music No. 2: Life with the Lions*, including a track called "Two Minutes Silence," which was exactly that. Clearly the couple were aware of *4'33"* as a predecessor, though Ono had just suffered a miscarriage (of the baby whose heartbeat was captured in the track "Baby's Heartbeat," another Fluxus-style gesture), and the silence can be read as mourning as well. Not so "Toilet Piece/Unknown" on the 1971 Ono album *Fly*, which is a thirty-second recording of a toilet flushing—something that might possibly be heard during an indoor performance of *4'33"*.

Asked if there might be anything that is not music, Young replied, "There are probably very still things that do not make any sound. 'Music' might also be defined as anything one listens to."[11] Cage was aware of Young's

musical activities and took them seriously. According to an interview with Young in *EAR* magazine, Cage had told Young that their approaches were "opposite sides of the coin. . . . I'm interested in control and precision and the Yogic approach to concentration, but Cage has . . . the Zen approach . . . to clear the mind."[12]

Certainly composers' responses to *4′33″* widened the range of sounds considered musical, as every sound they heard during performances was reimagined as a potential musical phenomenon. The wind and rain at the Maverick Concert Hall were marked by the randomness we associate with nature; but within urban buildings where performances might also take place, many environmental sounds are more repetitive. Listening to or merely thinking about *4′33″* led composers to listen to phenomena that would have formerly been considered nonmusical, including:

- steady, unchanging sounds (such as Young's B and F-sharp "to be held for a long time")
- repetitive processes (fans, motors, and other machinery)
- minute variations appearing in sounds initially heard as static

All of these began to be experimented with by the composers of the 1960s who started out as conceptualist art-

ists and whose work would evolve into a style known as minimalism. *4′33″* has sometimes been referred to as the first, or ultimate, minimalist work.

For instance, a young Steve Reich (b. 1936), whose day job for a while was driving a cab, would surreptitiously record conversations with his riders to get material for sound pieces. In 1965 and 1966 Reich made two pieces, *It's Gonna Rain* and *Come Out*, based on a tape of a spoken phrase going slowly out of phase with itself. What came to fascinate him was the idea of listening to a gradual process, and he wrote of this as an inheritance from Cage, even as he distanced what he was doing from Cage:

> John Cage has used processes and has certainly ac-
> cepted their results, but the processes he used were
> compositional ones that could not be heard when the
> piece was performed. The process of using the *I Ching*
> or imperfections in a sheet of paper [which Cage ex-
> perimented with in the '50s] to determine musical
> parameters can't be heard when listening to music
> composed that way. The compositional processes and
> the sounding music have no audible connection. . . .
>
> What I'm interested in is a compositional process
> and a sounding music that are one and the same thing.[13]

At the beginning of *Silence*, Cage had stated as a motto: "Composing's one thing, performing's another, listening's

a third. What can they have to do with one another?"[14] Reich, Philip Glass, and other minimalists rejected this separation, opting for works in which the composed process was the listening focus. But they did pick up from Cage that a piece could be the result of an impersonal process, that it could result from an action in ways that might not be forseeable. This was as true of $4'33''$ as of any of Cage's other works: the chance procedure that determined the movement lengths was an impersonal process, and the composer couldn't anticipate what would actually be heard. Such characteristics typified the early, experimental phase of minimalism as well. Perhaps the most direct influence on subsequent experimental music was that $4'33''$ (as well as Cage's other works from *Music of Changes* on) encouraged composers to forget about conventional expressivity and submit themselves to objective processes, such as the two pianists playing the same short motif slowly going out of phase with itself in Reich's *Piano Phase* (1967). In time, the process-oriented minimalism of Reich, Young, Terry Riley, and Glass would balloon into an international movement, take on more intuitive and symphonic characteristics, and become arguably—in the works of John Adams, Arvo Pärt, Henryk Górecki, Meredith Monk, and dozens of other composers—the most publicly recognized classical music style of the late twentieth century. For all that Cage did not himself find

the idiom congenial, *4′33″* occupies a special place in its historical origins.[15]

Within the field of environmental sounds, *4′33″* was a landmark within an ongoing revolution brought about by the availability of recording techniques. Audio-quality electronic tape had appeared in 1947, and French composer Pierre Schaeffer produced the first piece of musique concrète (music consisting of acoustic sounds recorded on tape and manipulated) in 1948: *Etude aux chemins de fer,* recorded from the sounds of trains. In America, Vladimir Ussachevsky and Otto Luening quickly caught up. Other pieces made from recordings of environmental sound would have eventually appeared even without *4′33″*, but the piece did inspire a certain approach, most noticeable in the musique concrète classic *Presque rien no. 1* (1970) by French composer Luc Ferrari, who explicitly credits Cage with having exploded his ideas about music.[16] The work— a recorded landscape of a seaside with voices, boat motors, and so on—could seem like a realization of *4′33″*, though in actuality there is some manipulation in the layering of sounds.

From musique concrète evolved a body of electronic composition known loosely as *acousmatic* music, especially associated with the composing scene in Montreal and including composers such as Francis Dhomont (b. 1926), Denis Smalley (b. 1946), Simon Emmerson (b. 1950), and

(depending on how loosely the term is defined) many, many others. The term *acousmatic*, coined by Schaeffer in 1966, is taken from Pythagoras's practice of having students listen to him from behind a screen without being able to see him and refers to using sound separated from its source.[17] According to Jonty Harrison, acousmatic music "admits any sound as potential compositional material, it frequently refers to acoustic phenomena and situations from everyday life and, most fundamentally of all, it relies on perceptual realities rather than conceptual speculation to unlock the potential for musical discourse and musical structure from the inherent properties of the sound objects themselves—and the arbiter of this process is the ear. Because of this, it is unnecessary to have a visual stimulus connected to what is heard—in fact, it is positively detrimental to be encumbered by the visual sense for, without it, the listener's imagination is liberated from the constraints of the physical presence of the sound-producing body."[18] Harrison goes on to say that Pierre Schaeffer "was critical of his own early works, such as the *Etude aux chemins de fer* (1948), precisely because the sound material was too recognisable, too reminiscent of the physical objects which produced them, and he felt that this 'referential' quality interfered with a truly 'musical' appreciation of the material." One might say, then, that the acousmatic composers, rather than sharing Luigi

Russolo's delight in composing for the identifiable noises of everyday machines, took the more abstract approach of *4'33"* in appreciating sound for its own phenomenological qualities.

Opposed to acousmatics are the soundscape composers who value sounds as evocative of a particular time and place, the leading exponent of this being Canada's best-known experimentalist, R. Murray Schafer (b. 1933). (The idea of environmental sound as art seems to particularly appeal to the Canadian sensibility.) The so-called father of acoustic ecology, Schafer has made the soundscape, the totality of an environment's sound, the central idea of his career. He founded the World Soundscape Project (later the World Forum for Acoustic Ecology), whose affiliates monitor the state of the world's sound environments. Schafer wrote some of his music for specific environments and times of day, starting with his *Music for Wilderness Lake* for twelve trombones of 1979, to be performed on the shore of a specific isolated lake at sunrise or sunset. One of the effects of his massive outdoor operatic cycle *Patria* (1966–) is a soprano singing from across a lake, a kilometer away from the audience, with other performers seated in canoes. "The big revolutions of musical history," Shafer has said, "are changes of context more than changes of style." Unlike Cage, however, Schafer does not practice a Zen acceptance of whatever he hears; on

the contrary, he fights for urban noise reduction statutes and warns, "The world soundscape has reached an apex of vulgarity in our time, and many experts have predicted universal deafness as the ultimate consequence unless the problem can be brought quickly under control." As David Toop has charged, Shafer's aesthetic "seems shot through with a personal aversion to urbanism."[19] Other composers along this line include Barry Truax (b. 1947) and Hildegard Westercamp (b. 1946).

More recent composers like Jonty Harrison (b. 1952) and Paul Rudy (b. 1962) have bridged the gap between the acousmaticians and soundscapers by using the varying recognizability of recorded sounds as a structural component of their works. While it may be tempting to see all of this concern for listening to or recording ambient environments as having been triggered by *4'33"*, it is probably more accurate to say that the desire to incorporate industrial and environmental sounds that first surfaced in the writings and experiments of the Italian Futurists was fed and augmented by the development of recording technology and musique concrète—and that *4'33"* served as a rallying cry, a manifesto, a locus classicus that justified and inspired further experimentation in this direction.

Perhaps more revealing as a legacy, if less profound, are the references to *4'33"* that have spread throughout pop music culture. It seems to have become hip for pop

bands to include silent tracks on their albums in homage
to Cage. As examples one can name the band Covenant
(a 4:33 track on their 2000 disc *United States of Mind*),
Ciccone Youth (a one-minute silent track on *The Whitey
Album* of 1990), and the Magnetic Fields (a version of
4′33″ on their 1995 album *The Wayward Bus / Distant Plas-
tic Trees;* the Magnetic Fields have also sometimes played
4′33″ live at concerts.)[20] There is additionally a rock band
from Birmingham, England, called 4Minutes33.

A strange episode in Cage's posthumous reputation
came in 2002 when composer Mike Batt put out a disc
called *The Planets: Classical Graffiti* on EMI and included
a track titled "A Minute's Silence" with "Batt/Cage" listed
as the composer. Cage's estate sued over this disrespect-
ful gesture, and Batt settled out of court. More interest-
ing, early in 2007 a San Francisco conceptual artist named
Jonathon Keats—quite in the spirit of Cage's own Muzak
threats—advertised that he was making *4′33″* available as
a ringtone for cell phones. The press release, with its hu-
morously deliberate misinterpretation of Cage's "imper-
fect" silence, ran, in part, as follows:

JANUARY 5, 2007—Since the beginning of time, pure
silence has been available only in the vacuum of space.
Now conceptual artist Jonathon Keats has digitally
generated a span of silence, four minutes and thirty-

three seconds in length, portable enough to be carried on a cellphone. His silent ringtone, freely distributed through special arrangement with Start Mobile, is expected to bring quiet to the lives of millions of cellphone users, as well as those close to them.

"When major artists such as 50 Cent and Chamillionaire started making ringtones, I realized that anything was possible in this new medium," says Mr. Keats, whose previous art projects include attempting to genetically engineer God. "I also knew that another artist, John Cage, had formerly tried, and failed, to create a silent interlude."

Mr. Cage once famously composed four minutes and thirty-three seconds of silence, which was performed on a piano, in front of a live audience, back in 1952. By all accounts, though, his silence was imperfect, owing to the limitations of the technology available at the time. "John Cage can't be blamed," says Mr. Keats. "He lived in an analog age."[21]

Clearly 4′33″ is one of those pieces that has transcended the esoteric realm of the avant-garde to become famous among people who know almost nothing of its context, an emblem of Zen, of Dada, of American contrariness, of Cage's gentle humor. Musicians and nonmusicians joke about it, steal it, invoke it, "cover" it, pay homage to it,

listen to it, and—unlike many classical musicians who feel a vested interest in the prestige of their art—generally get a kick out of it.

Following the publication of *Silence* in 1961, Cage's fame continued to spread with the appearance of other books (*A Year from Monday, X, M, Empty Words, I-VI: The Harvard Lectures*) and also with his music for the Merce Cunningham Dance Company. In his writings of the '60s Cage became increasingly involved in social philosophy, writing about social critics Buckminster Fuller and Marshall McLuhan, social services, and world organization, to the point that music almost seemed to cease to occupy him. At the same time, however, he was more and more in demand for commissions, and he was able to write fiendishly difficult works for virtuosi, such as *The Freeman Etudes* for violinist Paul Zukofsky. An American bicentennial commission resulted in *Renga with Apartment House 1776*, a chaotically multicultural piece that incited rebellion among some of the orchestras asked to play it. Perhaps the climax of Cage's late work was a series of five amazingly inventive operas called *Europeras*, comprising dozens of arias from the European literature combined at random. Singers crossed the stage within giant wheels and rose into the air via invisible wires; the orchestra pit was

raised and lowered to bring the orchestra momentarily in front of the singers; and a radio-controlled blimp flew from the stage and around the balcony. The sense of unpredictable theater was fantastic.

Cage's old friend Morton Feldman died prematurely in 1987, and afterward Cage embarked on a series of works that veered curiously close to Feldman's soft, sustained, quiescent style. As a group they are called the "time bracket" or "number" pieces, because they indicate by clock timings ranges within which events (often just single notes) begin and end, and they are named for the number of instruments in the ensemble. An orchestra piece called 74 consists of just two parts which are played by individuals in a random double canon, with the same notes echoing around the orchestra.

During these years, Cage became an international celebrity. In 1988 he was asked to give the Charles Eliot Norton Lectures at Harvard, which had previously been given by (to name only the composers) Bernstein, Hindemith, Copland, and Stravinsky. The text was chance-determined and nonlinear; "If a lecture is informative," Cage explained, "people can easily think that something is being done to them, and that they don't need to do anything about it except receive. Whereas, if I give a lecture in such a way that it is not clear what is being given, then people have to do something about it."[22] Festivals were

devoted to Cage's music in Boston, Los Angeles, The Hague, Salzburg, and Zurich, and he was composer-in-residence at many others. When he died unexpectedly, he was preparing to leave for a series of eightieth-birthday celebrations in Germany.

Cage passed away just short of age 80 on August 12, 1992, falling with a stroke in his apartment at 18th Street and 6th Avenue in New York. (The premiere of *4′33″* came at almost the exact midpoint of his life.) In my obituary for him in the *Village Voice*, I urged, "Please, reader, observe four minutes and 33 seconds of silence."[23] A little more than half of the obituaries mentioned *4′33″*. With remarkable frequency, *4′33″* is tagged in the literature as "John Cage's most misunderstood piece." And yet look at how the work was described by music critics across the United States and in England:

> A work that embodies his musical philosophy most effectively is also probably his most famous and should have a special kind of immortality. It is called *4′30″* [*sic*], and it consists of 4½ minutes of silence. It can be "played" on any instrument or none at all, so long as there is someone to listen to the silence and realize that it is full of sound.
>
> —Joseph McLellan, *Washington Post*, August 13, 1992

Typical of the kinds of compositions that set the musical world on its ear are [*sic*] "4 Minutes, 33 Seconds," a 1952 piece that consisted of musicians sitting silently on stage, with the only noises coming from the audience and sounds seeping into the auditorium from outside.

—Audrey Farolino, *New York Post*, August 13, 1992

His most famous composition—*4′33″* (1952)—required no instruments whatsoever. The performer was instructed to sit silently on stage for the duration of the piece—appropriately, four minutes and 33 seconds—while the audience listened to whatever sounds took place around it.

—Tim Page, *New York Newsday*, August 13, 1992

Mr. Cage came to believe that it should not be an artist's goal to shape the world around him to his own tastes and desires, but, rather, to surrender to the disorder he regarded as the natural state of life.

Perhaps the most famous expression of this attitude is his *4′33″* (4 minutes, 33 seconds), which may be performed by any instrument or combination of instruments, though no instrument is actually played. At the 1952 premiere, pianist David Tudor sat silently at the keyboard, stopwatch in hand, then retired to

the wings at the appointed moment, leaving the mys-
tified audience to their own conclusions.

—John von Rhein, *Chicago Tribune*, August 13,
1992

Not only did Cage grant anarchic freedoms to the
composer and necessarily also to the performer, he
even extended them to listeners, who, in the notori-
ous silent piece *4'33"* (1952), are invited to discover
music wherever they may within the ambience of the
"performance"—in coughs, grunts, rustles, natural
sounds, which acquire new meanings when the con-
text of an "art-work" is added to them.

—Paul Driver, *The Independent* (London), August
14, 1992

Like so much of Cage's artwork . . . *4'33"* had a philo-
sophical agenda. It was to call attention in a formal
context to the richness of ambient sound: to tune an
audience's ears to ever present sonic wonders, and
hence to enrich lives through meditative awareness.
Instant Zen, if you will. And for all those who dis-
missed the piece without ever hearing it, there were
others who found their lives altered.

—John Rockwell, "Cage Merely an Inventor? Not a
Chance," *New York Times*, August 23, 1992

Arm (with tattoo) of composer Jim Altieri.
Photo: Emma Lloyd.

4′33″ is often misunderstood—by people who've never heard it, who know nothing about Cage and have no interest in modern music. But imagine any other important avant-garde work from the mid-twentieth century—Olivier Messiaen's *Turangalîla*, Boulez's *Le Marteau sans maître*, Stockhausen's *Gruppen*, Wolpe's *Enactments*, Babbitt's *Philomel*, Glass's *Einstein on the Beach*—and imagine how many of these critics would have described it sympatheti-

cally and with understanding. *4′33″* is commonly derided as a joke, a provocation, yet by the time Cage died most critics fully understood that the listener was supposed to appreciate the sounds of the environment in which the piece was performed—and if even the critics got it, the interested public was probably even better informed. It seems to me that *4′33″* is one of the best-understood pieces in avant-garde twentieth-century music. Cage got his point across. Who—aside from Thoreau, perhaps— realized there was so much to listen to?

Appendix: 4'33" Discography

Performer (if known); Recording title; Release date; Label and number. Compact disc unless otherwise indicated.

Ex Novo Ensemble di Venezia: Aldo Orvieto, pianist. *Da Capo*. 1989. IB Office 3 (cassette).

Wayne Marshall. *Cage*. 1991. Floating Earth FCD 004.

The Cassandra Complex. *Sex & Death*. 1993. Play It Again Sam (PIAS) BIAS 255 CD.

Kazuo Sawai Koto Ensemble. *Kazuo Sawai Koto Ensemble live at da capo Bremen '93*. 1993. d'c records—d'c1.

Frank Zappa. *A Chance Operation—The John Cage Tribute*. 1993. Koch International Classics 7238.

Amadinda Percussion Group. *4'33"*. 1994. Hungaroton HCD 12991 (previously on LP and cassette, SLPD 12991 and MK 12991).

Colin Stone. *Music of the 20th Century*. 1995. Cala Records 88088.

CM von Hausswolff. *CM von Hausswolff Plays John Cage*. 1996. Povertech Industries PAT 38.

Deep Listening Band (Pauline Oliveros, David Gamper, Stuart Dempster). *Non Stop Flight.* 1998. Music & Arts 1030.

George Wolfe, saxophone, with the New Millennium Ensemble. *Lifting the Veil.* 1998. Arizona University Recordings 3066.

Boole. *Boole.* 2000. Dancing Bull Productions DBP05.

Mimetic Mute. *Negative.* April 2000. Prikosnovénie PRIK036.

Keith Rowe; Slavek Kwi; Thurston Moore, Steve Malkmus, Wharton Tiers, Dez Cadena, Mike Watt, Dave Markey; Pauline Oliveros, Deep Listening Band, Abel-Steinberg-Winant Trio, the Hub, with thirteen guest artists; Jio Shimizu; Voice Crack (Norbert Möslang, Andy Guhl); Clive Graham; Toshiya Tsunoda; Alignment (Radboud Mens, Mark Poysden). *48'15".* 2001. Korm Plastics KP 3005.

Northwestern University Percussion Ensemble, Michael Burritt, conductor. Noncommercial recording. 2001. Northwestern University Music Library.

Dietmar Bonnen. *John Cage — Into Silence.* 2002. Obst CD P 330.14.

Stephanie McCallum. *The Classic 100 Piano.* 2005. ABC Classics 476 720-2. (First movement only.)

Gianni-Emilio Simonetti. *nova musicha n.1: John Cage.* [2005/2006]. Edel 0136582CRA. Also available on Get Back GET 5201 (LP); previously on Cramps Records CRSLP 6101 N.1 (LP) and later on CRSCD 101 (CD).

Susanne Kessel. *Californian Concert: Music of European Immigrants and their American Contemporaries.* February 2006. Oehms Classics OC 534.

Ensemble 0 (Maitane Sebastián, Joël Merah, Stéphane Garin, Sylvain Chauveau). *John Cage/0.* June 2006. Onement #0 (limited edition CD-R).

Susanne Kessel. *. . . es wehet ein Schatten darin . . .* August 2006. Obst CD P 330.23.

The Revenge of the Dead Indians: In Memoriam John Cage. June 2008. Mode Records Mode 197 (DVD).

Margaret Leng Tan. *Margaret Leng Tan: Sorceress of the New Piano.* April 2008. Mode Records Mode 194 (DVD, excerpt).

Stephanie McCallum. *Wagner's Rinse Cycle.* [Compilation disc, date unknown]. ABC Classics 465 260-2.

Notes

CHAPTER 1. *4′33″ at First Listening*

1. Actually, by 2008 the hemlock trees had succumbed to disease and had to be cut down. The remaining stumps are several feet in diameter.
2. Interviews with John Kobler, Ellsworth Snyder, and Michael John White, all quoted in Kostelanetz, *Conversing with Cage*, pp. 65–66.
3. Revill, *The Roaring Silence*, p. 165.
4. Gentry, "Cultural Politics of *4′33″*," p. 8.
5. As remembered by Earle Brown, quoted in Revill, *The Roaring Silence*, pp. 165–66.
6. *The New Grove Dictionary of Music and Musicians*, Second Edition, s.v. "Tudor, David."
7. John Holzaepfel, "Cage and Tudor," in Nicholls, *Cambridge Companion to John Cage*, pp. 170–71.
8. David Tudor, "From Piano to Electronics," in *Music and Musicians*, Vol. 20 (1972), p. 24; quoted in Holzaepfel, "Cage and Tudor," p. 170.
9. Holzaepfel, "Cage and Tudor," p. 174.
10. Revill, *The Roaring Silence*, pp. 179–80.
11. "Radio 3 Plays Silent Symphony," *BBC News*, January 19, 2004,

http://news.bbc.co.uk/2/hi/entertainment/3401901.stm (accessed April 9, 2009).

12. Donal Henahan, "Who Throws Dice, Reads I Ching, and Composes?" *New York Times*, September 3, 1972; quoted in Revill, *The Roaring Silence*, p. 12.

13. Interview with Alan Gillmor and Roger Shattuck, quoted in Kostelanetz, *Conversing with Cage*, p. 67.

14. Jeff Goldberg, "John Cage Interview," *Soho Weekly News*, September 12, 1974.

15. Edward Rothstein, "Cage Played His Anarchy by the Rules," *New York Times*, September 20, 1992.

16. Kahn, "John Cage: Silence and Silencing," p. 7.

17. Interview with Robin White, quoted in Kostelanetz, *Conversing with Cage*, pp. 211–12.

18. Philip Gentry has theorized that 4′33″ might have represented for Cage, or for some of the audience, an appropriation or expression of the silence that gay men were forced to maintain (even more than usual) during the repression of the McCarthy era, when gays were being fired from government and institutional jobs—and that the audience's anger may have had to do with the inherent homosexuality of the gesture, given Cage's persona. However this may be, the anger does seem disproportionate in a way that begs for further explanation. See Gentry, "Cultural Politics of 4′33″."

19. Block, "Dvořák, Beach, and American Music," p. 260.

20. Arnold Jay Smith, "Reaching for the Cosmos: A Composer's Colloquium," *Downbeat*, October 27, 1977, quoted in Kostelanetz, *Conversing with Cage*, p. 207.

CHAPTER 2. *The Man*

1. Revill, *The Roaring Silence*, p. 195. Facts from this chapter, except where noted, are generally from Revill's book, the only full-length biography of Cage.

2. Feldman, "H.C.E. (Here Comes Everybody)," p. 141.

3. Cage, "Indeterminacy," in *Silence*, p. 261.

4. David W. Patterson, "Words and Writings," in Nicholls, *Cambridge Companion to John Cage*, p. 94.

5. Hazel Johnson, quoted in Revill, *The Roaring Silence*, p. 138.

6. Peter Yates, *Twentieth Century Music* (London: George Allen & Unwin, 1968); quoted in Kostelanetz, *John Cage*, p. 59.
7. Thomas Hines, "'Then Not Yet "Cage"'": The Los Angeles Years, 1912–1938," in Perloff and Junkerman, *John Cage: Composed in America*, p. 67; Revill, *The Roaring Silence*, p. 17; Kostelanetz, *Conversing with Cage*, p. 1.
8. Hines, "'Then Not Yet "Cage,"'" p. 67.
9. Cage, *X*, p. 160.
10. Revill, *The Roaring Silence*, p. 19.
11. Hines, "'Then Not Yet "Cage,"'" pp. 67, 71; Revill, *The Roaring Silence*, pp. 20, 22, 71.
12. Hines, "'Then Not Yet "Cage,"'" p. 67; Revill, *The Roaring Silence*, p. 74.
13. Quoted in Hines, "'Then Not Yet "Cage,"'" p. 67; Revill, *The Roaring Silence*, pp. 74–75.
14. Hines, "'Then Not Yet "Cage,"'" pp. 67, 76; Revill, *The Roaring Silence*, pp. 28, 29, 75, 76–77.
15. Revill, *The Roaring Silence*, p. 30; Kahn, "John Cage: Silence and Silencing," p. 570. Cage quoted in Kostelanetz, *John Cage*, p. 48 (ellipsis in original).
16. Hines, "'Then Not Yet "Cage,"'" p. 67; Revill, *The Roaring Silence*, pp. 31–32, 78.
17. Revill, *The Roaring Silence*, pp. 33, 79; Hines, "'Then Not Yet "Cage,"'" p. 67.
18. Revill, *The Roaring Silence*, p. 34.
19. Hines, "'Then Not Yet "Cage,"'" p. 67; Revill, *The Roaring Silence*, p. 79.
20. Warburton, *Ernö Goldfinger*, pp. xiii, 1–3.
21. Hines, "'Then Not Yet "Cage,"'" p. 67; Revill, *The Roaring Silence*, p. 80.
22. Revill, *The Roaring Silence*, p. 37.
23. Hines, "'Then Not Yet "Cage,"'" p. 67; Revill, *The Roaring Silence*, p. 81.
24. Revill, *The Roaring Silence*, pp. 39, 41, 43, 54; Cage quoted in Hines, "'Then Not Yet "Cage,"'" p. 90.
25. Ellsworth Snyder, "Chronological Table of John Cage's Life," in Kostelanetz, *John Cage*, p. 36; Hines, "'Then Not Yet "Cage,"'" p. 92.

26. Hines, "'Then Not Yet "Cage,"'" pp. 92–93.

27. Hicks, "John Cage's Studies with Schoenberg," pp. 133–34.

28. Hines, "'Then Not Yet "Cage,"'" p. 86.

29. *The New Grove Dictionary of Music and Musicians*, s.v. "Harrison, Lou (Silver)" (by Leta Miller and Charles Hanson), http://www .grovemusic.com (accessed April 14, 2009).

30. Revill, *The Roaring Silence*, pp. 55–56.

31. Duckworth, *Talking Music*, p. 10.

32. Cecil Smith in the *Chicago Daily Tribune*, March 2, 1942, quoted in Revill, *The Roaring Silence*, p. 76.

33. Pritchett, *Music of John Cage*, pp. 14–15.

34. Cage, "Defense of Satie," in Kostelanetz, *John Cage*, p. 80.

35. Revill, *The Roaring Silence*, p. 64.

36. Cage, "The Future of Music: Credo," in *Silence*, pp. 3–4.

37. Revill, *The Roaring Silence*, p. 65.

38. Revill, *The Roaring Silence*, p. 69.

39. Revill, *The Roaring Silence*, p. 72.

40. Cage, "After Antiquity," pp. 169–70.

41. Revill, *The Roaring Silence*, p. 75.

42. Revill, *The Roaring Silence*, pp. 78, 80.

43. Revill, *The Roaring Silence*, p. 66.

44. John Holzaepfel, "Cage and Tudor," in Nicholls, *Cambridge Companion to John Cage*, p. 169.

45. "Percussion Concert: Band Bangs Things to Make Music," in *Life*, March 15, 1943, p. 42.

46. Revill, *The Roaring Silence*, pp. 83–84 (including Cage's remark, quoted from a 1974 interview with Paul Cummings); Duckworth, *Talking Music*, p. 11.

47. Hines, "'Then Not Yet "Cage,"'" p. 99; Revill, *The Roaring Silence*, p. 84. The date of Cage's divorce from Xenia is given by Ellsworth Snyder in Kostelanetz, *John Cage*, p. 37.

48. Hines, "'Then Not Yet "Cage,"'" p. 98, n. 43.

49. E-mail from Peter Gena to the author, June 23, 2008, transcribed from the talk.

50. Revill, *The Roaring Silence*, pp. 88–89; Tomkins, *The Bride and the Bachelors*, p. 97.

51. Cage, *Silence*, p. 127.

52. Revill, *The Roaring Silence*, p. 89.

53. Patterson, "The Picture That Is Not in the Colors: Cage, Coomaraswamy, and the Impact of India," in *John Cage: Music, Philosophy, and Intention*, p. 177.

54. Cage, "Lecture on Nothing," in *Silence*, p. 117.

CHAPTER 3. *Dramatis Personae (Predecessors and Influences)*

1. Cage, "45' for a Speaker," in *Silence*, p. 161. I wish now that I had asked him what he would have quoted if he *had* quoted Blake.

2. Gillmor, *Erik Satie*, p. 232.

3. Orledge, *Satie Remembered*, p. 154.

4. Bryars, "Vexations and Its Performers."

5. Bryars is quoted in Gillmor, *Erik Satie*, p. 103.

6. Cage, *Silence*, p. 93.

7. Cage, "Satie Controversy," in Kostelanetz, *John Cage*, p. 90.

8. Cage, "Defense of Satie," in Kostelanetz, *John Cage*, pp. 81–82.

9. Russolo, *Art of Noises*, p. 43.

10. Russolo, *Art of Noises*, pp. 44–45. Russolo uses *enharmonic* to mean containing pitches outside the familiar twelve-pitch scale.

11. Russolo, *Art of Noises*, p. 48 (emphasis in original).

12. Interview with Jeff Goldberg, quoted in Kostelanetz, *Conversing with Cage*, p. 11.

13. Cage, *X*, p. 53.

14. *Encyclopædia Britannica Online*, s.v. "Duchamp, Marcel," http://search.eb.com/eb/article-1922 (accessed Aug. 20, 2008).

15. Revill, *The Roaring Silence*, p. 213.

16. Revill, *The Roaring Silence*, pp. 214–15; Feldman, "H.C.E. (Here Comes Everybody)," p. 126.

17. *Grove Art Online*, s.v. "Coomaraswamy, Ananda Kentish" (by Tapati Guha-Thakurta), in *Oxford Art Online*, http://www.oxfordartonline.com/subscriber/article/grove/art/T019287 (accessed Apr. 21, 2009); Lipsey, *Coomaraswamy*, p. 35.

18. David W. Patterson, "Cage and Asia: History and Sources," in Nicholls, *Cambridge Companion to John Cage*, p. 44.

19. Coomaraswamy, "Why Exhibit Works of Art?" *Journal of Aesthetics and Art Criticism*, p. 31.

20. Lipsey, *Coomaraswamy*, p. 207n.

21. Patterson, "The Picture That Is Not in the Colors: Cage, Coo-

maraswamy, and the Impact of India," in *John Cage: Music, Philosophy, and Intention*, p. 185.

22. Coomaraswamy, "Why Exhibit Works of Art?" in *Christian and Oriental Philosophy*, p. 9; Coomaraswamy, *Christian and Oriental Philosophy*, p. 24.

23. Coomaraswamy, *Christian and Oriental Philosophy*, p. 39.

24. Coomaraswamy, "Why Exhibit Works of Art?" *Journal of Aesthetics and Art Criticism*, pp. 30, 31, 38.

25. Aquinas, *Summa theologica*, Part I, Question 117, Article 1 (Vol. 5, p. 177).

26. Cage, *A Year from Monday*, p. 19.

27. Katz, "Music and Aesthetics," p. 415.

28. Coomaraswamy, "Hindu View of Art: Theoretical," in *Dance of Shiva*, pp. 52–54. Somehow Coomaraswamy omits "Mirthful" in his first statement of the rasas in *The Dance of Shiva*, although he refers to there being nine emotions.

29. Pritchett, *Music of John Cage*, p. 30.

30. Brooks, liner notes to *Sixteen Dances*.

31. Cage, "The East in the West," in *John Cage, Writer*, p. 24.

32. Cage, "Experimental Music," in *Silence*, p. 10.

33. Quoted in Cage, *For the Birds*, p. 105. See also Patterson, "The Picture That Is Not in the Colors," p. 184.

34. Coomaraswamy, *Transformation of Nature in Art*, p. 62.

35. Cage, *Silence*, p. 266.

36. Eckhart, *Meister Eckhart: A Modern Translation*, p. xix; Eckhart, "Distinctions Are Lost in God," in *Meister Eckhart: A Modern Translation*, p. 206.

37. Cage, *Silence*, p. 193.

38. Eckhart, "Blessed are the Poor," in *Meister Eckhart: A Modern Translation*, pp. 230–31.

39. Eckhart, "The Defense," in *Meister Eckhart: A Modern Translation*, p. 258.

40. Eckhart, *Meister Eckhart: The Essential Sermons*, pp. 14–15.

41. Cage, *Silence*, p. 193. Medievalist scholar Edmund Colledge paints quite a different picture. Noting that one of Eckhart's "heresies" was a direct echo of St. Thomas Aquinas that the inquisitors should have recognized as such, he brings up "the problem of why

Eckhart himself did not put up a better defense. . . . The years . . . of paradox-spinning for the scandalized delight of larger but less critical and instructed audiences do not seem to have sharpened his wits. . . . We can perhaps detect signs of the apathetic fatigue experienced by an aging man, aware that he has not fulfilled his early promise and has exhausted his powers in his efforts to woo popular acclaim." In *Meister Eckhart: The Essential Sermons*, p. 14.

42. Eckhart, "The Talks of Instruction," in *Meister Eckhart: A Modern Translation*, p. 5.

43. Kitagawa, "Daisetz Teitaro Suzuki," p. 268.

44. Cage, "An Autobiographical Statement," in *John Cage, Writer*, p. 241 (here Cage also mentions visiting Suzuki twice in Japan); Revill, *The Roaring Silence*, p. 108; Patterson, "Cage and Asia," pp. 53–54.

45. Cage, *Silence*, p. 262.

46. Revill, *The Roaring Silence*, p. 124.

47. Suzuki, *Manual of Zen Buddhism*, p. 29.

48. Cage, interview with David Cope, in *Composer Magazine*, 1980, pp. 10–11; quoted in Kostelanetz, *Conversing with Cage*, p. 85.

49. Suzuki quoted in Goldberg, *A Zen Life—D. T. Suzuki*; Cage quoted in interview with Ellsworth Snyder, in Kostelanetz, *Conversing with Cage*, p. 284.

50. On the initial dedication to Tudor, see Solomon, *Sounds of Silence*.

51. Quoted in Patterson, "Life as Collage."

52. Patterson, "Life as Collage."

53. Patterson, "Life as Collage."

54. Hopps, *Robert Rauschenberg*, p. 13.

55. "Rauschenberg on Albers," manuscript from Cage's personal library, John Cage Trust.

56. Hopps, *Robert Rauschenberg*, pp. 13, 27.

57. Hopps, *Robert Rauschenberg*, pp. 22, 28.

58. Kremen's recollection is cited in Fetterman, *John Cage's Theater Pieces*, p. 71. Cage mentioned meeting Rauschenberg at Black Mountain College in an interview with Irving Sandler, recorded 1967.

59. Hopps, *Robert Rauschenberg*, p. 28.

60. Revill, *The Roaring Silence*, p. 96; Cage, *For the Birds*, p. 157.

61. Feldman, "Liner Notes," in *Give My Regards to Eighth Street*, pp. 4–5.

62. Revill, *The Roaring Silence*, p. 103.

63. Pritchett, *Music of John Cage*, p. 103.

64. Revill, *The Roaring Silence*, pp. 220–21.

65. Thoreau, "Civil Disobedience," in *Portable Thoreau*, p. 109.

66. Cage, "Preface to 'Lecture on the Weather,'" in *Empty Words*, pp. 3, 5; Cage, "Diary: How to Improve the World," in *M*, p. 18.

67. Ives, *Essays Before a Sonata*, p. 51.

68. Thoreau, "Sounds," in *Walden*, p. 411.

69. William Brooks, "About Cage about Thoreau," in Fleming and Duckworth, *Cage at 75*, p. 66.

70. Thoreau, *Journal*, December 27, 1857, vol. 10, p. 1239.

71. Solomon, "The Sounds of Silence."

72. From American Public Media's American Mavericks web site: http://musicmavericks.publicradio.org/features/slideshows/slide show_cage1.html.

CHAPTER 4. *The Path to* 4′33″

1. Revill, *The Roaring Silence*, pp. 89–90; Tomkins, *The Bride and the Bachelors*, p. 99.

2. Kinkeldy, "Thomas Mace and His *Musick's Monument*," p. 21.

3. Mace, *Musick's Monument*, pp. 234, 236. Composer William Alves, in an e-mail to me, also proposed the following passage on page 118: "Those Influences, which come along with [music], may aptly be compar'd, to Emanations, Communications, or Distillations, of some Sweet, and Heavenly Genius, or Spirit; Mystically, and Unapprehensibly (yet Effectually) Dispossessing the Soul, and Mind, of All Irregular Disturbing, and Unquiet Motions; and Stills, and Fills It, with Quietness, Joy, and Peace; Absolute Tranquility, and Unexpressible Satisfaction."

4. Clarkson, "The Intent of the Musical Moment," p. 79.

5. Brett, untitled review, pp. 110–12.

6. Cage, *Silence*, p. 127.

7. Blyth, *Zen in English Literature*, p. 35.

8. Cage, "A Composer's Confessions," in *John Cage, Writer*, p. 43.

9. Montague, "John Cage at Seventy," 213. The lecture is published in Cage, *John Cage, Writer*, pp. 27–44.

10. Brooks, "Pragmatics of Silence," p. 110.

11. Lanza, *Elevator Music*, pp. 23, 41; Grant and Pederson, "Muzak, Inc.," p. 353. Squier's birth year is given as 1863 in some sources.

12. Lanza, *Elevator Music*, pp. 40–41, 42; Grant and Pederson, "Muzak, Inc."

13. Grant and Pederson, "Muzak, Inc."; also Lanza, *Elevator Music*, p. 43.

14. Lanza, *Elevator Music*, pp. 47, 48.

15. Lanza, *Elevator Music*, p. 48.

16. Lanza, *Elevator Music*, p. 50.

17. *Pollak et al. vs. Public Utilities Commission.*

18. Lanza, *Elevator Music*, pp. 51–52.

19. "The Flip Side: Spin It and Get Acquainted," *New York Post*, January 16, 1952; quoted in Gentry, "Cultural Politics of *4'33"*." I am grateful to Mr. Gentry for sending the article.

20. Cage, interview with Roger Reynolds, in Kostelanetz, *John Cage*, p. 46; Cage, Shattuck, and Gillmor, "Erik Satie," p. 22.

21. All quotes are from Huxley, *The Perennial Philosophy*, pp. 216–18.

22. Hakokyo-I (Hakurakuten), quoted by Blyth in *Zen in English Literature*, p. 141.

23. Huxley, *Perennial Philosophy*, pp. 218–19.

24. Personal communication from Peter Gena, from his transcript of a recording of the class.

25. Chan, *Source Book in Chinese Philosophy*, p. 425.

26. Cage, "Tokyo Lecture and Three Mesostics," p. 7.

27. Watts, *Way of Zen*, p. 105.

28. *Encyclopædia Britannica Online*, s.v. "koan," http://search.eb.com/eb/article-9045827 (accessed June 28, 2008).

29. Blyth, *Zen in English Literature*, pp. 49, 50, 217.

30. Blyth, *Zen in English Literature*, pp. 223–24.

31. Kahn, "John Cage: Silence and Silencing," p. 559.

32. Watts, *Way of Zen*, pp. 46, 48.

33. Goldberg, *A Zen Life—D.T. Suzuki.*

34. Cage, "Questions," pp. 65–71.

35. Cage, *Silence*, p. 193.

36. Huang, *Zen Teaching of Huang Po*, p. 48; Blyth, *Zen in English Literature*, p. 144.

37. All quotations are from Cage, *Silence*. See "Lecture on Nothing," p. 109; untitled story, p. 40; "Forerunners of Modern Music," p. 63; "History of Experimental Music in the United States," p. 67; untitled story, p. 88; "Foreword," p. xi.

38. Revill, *The Roaring Silence*, p. 129.

39. Wilhelm, *I Ching*, p. 213.

40. Cage, *For the Birds*, p. 43.

41. Revill, *The Roaring Silence*, p. 142; Thomas Hines, "'Then Not Yet "Cage"': The Los Angeles Years, 1912-1938," in Perloff and Junkerman, *John Cage: Composed in America*, p. 72.

42. Katz, "Black Mountain College," p. 134.

43. Cage in interview with Mary Emma Harris, 1974, quoted in Kostelanetz, *Conversing with Cage*, p. 104.

44. Cage in interview with Michael Kirby and Richard Schechner, 1966, quoted in Kostelanetz, *Conversing with Cage*, p. 103; Katz, "Black Mountain College," p. 139.

45. Guggenheim Museum, "Robert Rauschenberg."

46. Joseph, *Random Order*, pp. 26, 29, 31.

47. Cage, "On Robert Rauschenberg, Artist, and His Work," in *Silence*, pp. 102, 104-8.

48. Cage, "45′ for a Speaker," in *Silence*, p. 161.

49. Cage, Shattuck, and Gillmor, "Erik Satie," p. 22.

50. Cage, "On Robert Rauschenberg, Artist, and His Work," p. 98.

51. Revill, *The Roaring Silence*, pp. 162-63.

52. Cage, *A Year from Monday*, p. 134.

53. Cage, "Experimental Music: Doctrine," in *Silence*, p. 8.

54. Cage, "Lecture on Nothing," in *Silence*, p. 109.

55. The late 1940s attribution comes in Cage, "An Autobiographical Statement," in *John Cage, Writer*, p. 241. The 1951 implication is in Cage, "Experimental Music: Doctrine," p. 13.

56. Fetterman, *John Cage's Theater Pieces*, p. 71; Solomon, *The Sounds of Silence*; Cage, "An Autobiographical Statement," p. 243. This is the same article in which Cage dates the anechoic chamber to the late '40s, and he clearly links it to a Black Mountain College residency,

but he then proceeds to conflate his 1948 and 1952 Black Mountain experiences as though they were the same.

57. Brooks, "Pragmatics of Silence," p. 125.

58. John Holzaepfel, "Cage and Tudor," in Nicholls, *Cambridge Companion to John Cage*, p. 174.

CHAPTER 5. *The Piece and Its Notations*

1. Some of these sonorities and figures are identified in James Pritchett's *The Music of John Cage*, pp. 43–44.

2. Brooks, untitled liner notes to *Sixteen Dances*.

3. Cage, *For the Birds*, p. 41.

4. Pritchett, *Music of John Cage*, pp. 62–71.

5. Pritchett, *Music of John Cage*, p. 79.

6. Boulez, "Schoenberg Is Dead," pp. 268–76.

7. Cage, "Where Do We Go from Here?" in *A Year from Monday*, p. 93.

8. Pritchett, *Music of John Cage*, p. 79.

9. Cage, *I–VI*, pp. 20–21.

10. Fetterman, *John Cage's Theater Pieces*, p. 72.

11. Solomon, *The Sounds of Silence*.

12. Solomon, *The Sounds of Silence*; Tudor says in an interview with Reinhart Oehlschägel, "It is clear that he had composed the piece again with the same rhythmic structure, but with different durations." "Über John Cage," translated by Daniel Wolf, *MusikTexte*, Vol. 69/70 (April 1997), pp. 69–72.

13. John Holzaepfel, "Cage and Tudor," in Nicholls, *Cambridge Companion to John Cage*, p. 175.

14. A surprising number of people, including some who were there, have stated the opposite, that Tudor raised the piano lid to open each movement and closed it at the end (see, for instance, Brown, *Chance and Circumstance*, p. 26). But Cage states specifically in the 1961 Peters score that Tudor "indicated the beginnings of parts by closing, the endings by opening, the keyboard lid." And why, in the middle of a concert, would the keyboard lid have been already closed when Tudor walked onstage? In the 1990 documentary on Cage's music *I Have Nothing to Say and I Am Saying It*, Tudor ap-

pears re-creating his 1952 performance: he closes the keyboard lid at the beginning, and opens it at the end, of movements.

15. Fetterman, *John Cage's Theater Pieces*, p. 75.
16. Cage, *4′33″*, in *Source: Music of the Avant-Garde*.
17. Irwin Kremen, letter of May 18, 1967, in *Source: Music of the Avant-Garde*, Vol. 1, No. 2 (July 1967), p. 55.
18. Irwin Kremen, letter of May 18, 1967, p. 55.
19. John Cage, [*4′33″*], (New York: C.F. Peters, 1961).
20. Kotz, *Words to Be Looked At*, p. 24.
21. William Duckworth, "An Interview with Cage," in Fleming and Duckworth, *Cage at 75*, pp. 21–22.

CHAPTER 6. *The Legacy*

1. Thurston Moore, quoted in liner notes to *45′18″*, Korm Plàstics KP 3005.
2. Revill, *The Roaring Silence*, p. 179.
3. Helen Wolff to John Cage, undated [1954], provided to me by Christian Wolff.
4. J.B., "Look, No Hands! And It's 'Music,'" Amusements, *New York Times*, April 15, 1954.
5. Ellsworth Snyder, "Chronological Table of John Cage's Life," in Kostelanetz, *John Cage*, p. 39.
6. Revill, *The Roaring Silence*, p. 197.
7. Kotz, *Words to Be Looked At*, p. 26.
8. John Cage, *4′33″ (No. 2) (0′00″)* (New York: C.F. Peters, 1962).
9. Young, *Anthology* (unpaged).
10. Ono, *Grapefruit* (unpaged).
11. Strickland, *Minimalism: Origins*, p. 138.
12. Strickland, *Minimalism: Origins*, p. 162; Ljerka Vidic, "La Monte Young and Marian Zazeela," *EAR*, May 1987, p. 25.
13. Reich, "Music as a Gradual Process," p. 35.
14. Cage, "Experimental Music: Doctrine," in *Silence*, p. 15.
15. Gann, "The Last Barbarian," in *Music Downtown*, p. 130.
16. Ferrari, interview with Dan Warburton.
17. Schaeffer, *Traité des objets musicaux*.
18. Harrison, "Dilemmas, Dichotomies and Definitions."

19. McIntire, "A Sense of Community," p. 7; *The New Grove Dictionary of Music and Musicians*, Second Edition, s.v. "Schafer, R(aymond) Murray"; Schafer, *Soundscape*, p. 3; Toop, *Haunted Weather*, p. 62, quoted in McIntire, "Sense of Community."

20. Gross, "Rock/avant convergences."

21. The press release was posted on *Wired*, among other web sites: http://blog.wired.com/sterling/2007/01/post.html (accessed Sept. 26, 2008).

22. Revill, *The Roaring Silence*, p. 289.

23. Kyle Gann, "Philosopher No More," *Village Voice*, August 25, 1992.

Bibliography

Aquinas, Thomas. *The Summa Theologica of St. Thomas Aquinas*, Part I, QQ. CIII–CXIX. Literally translated by Fathers of the English Dominican Province. London: Burns, Oates, and Washburne, 1922.

Block, Adrienne Fried. "Dvořák, Beach, and American Music." In Richard Crawford, R. Allen Lott, and Carol J. Oja, eds., *A Celebration of American Music: Words and Music in Honor of H. Wiley Hitchcock*. Ann Arbor: University of Michigan Press, 1990.

Blyth, R. H. *Zen in English Literature and Oriental Classics*. Tokyo: Hokuseido Press, 1942.

Boulez, Pierre. "Schoenberg Is Dead." In *Notes from an Apprenticeship*. New York, Alfred A. Knopf, 1968.

Brett, Philip. Untitled review of *Musick's Monument* by Thomas Mace. Paris: Editions du Centre National de la Recherche Scientifique, 1966. *Journal of the American Musicological Society*, Vol. 21, No. 1 (Spring 1968), pp. 110–12.

Brooks, William. "Pragmatics of Silence." In Nicky Losseff and Jenny Doctor, eds., *Silence, Music, Silent Music.* Aldershot, Hampshire, England; Burlington, VT: Ashgate, 2007.

———. Untitled liner notes to *Sixteen Dances* (compact disc). CP2 Records, 2002.

Brown, Carolyn. *Chance and Circumstance.* New York: Alfred A. Knopf, 2007.

Bryars, Gavin. "*Vexations* and Its Performers." *Contact*, No. 26 (Spring 1983). Available in *JEMS: An Online Journal of Experimental Music Studies*, http://www.users.waitrose.com/~chobbs/Bryars.html (accessed April 14, 2009).

Cage, John. *4′33″*. In *Source: Music of the Avant-Garde*, Vol. 1, No. 2 (July 1967), pp. 46–55.

———. *I–VI.* Cambridge, MA, and London: Harvard University Press, 1990.

———. "After Antiquity." Interview with Peter Gena. In Gena and Jonathan Brent, eds., *A John Cage Reader.* New York: C.F. Peters Corporation, 1982.

———. *Empty Words.* Middletown, CT: Wesleyan University Press, 1981.

———. *For the Birds.* With Daniel Charles. Boston and London: Marion Boyers, 1981.

———. Interview with Irving Sandler, recorded 1967. Archived at John Cage Trust.

———. *John Cage, Writer: Previously Uncollected Pieces.* Edited by Richard Kostelanetz. New York: Limelight Editions, 1993.

———. *M.* Middletown, CT: Wesleyan University Press, 1973.

———. "Questions." *Perspecta*, Vol. 11 (1967).

———. *Silence.* Middletown, CT: Wesleyan University Press, 1973.

———. "Tokyo Lecture and Three Mesostics." *Perspectives of New Music*, Vol. 26, No. 1 (Winter 1988).

———. *X: Writings '79–'82*. Middletown, CT: Wesleyan University Press, 1990.

———. *A Year from Monday*. Middletown, CT: Wesleyan University Press, 1969.

———, Roger Shattuck, and Alan Gillmor. "Erik Satie: A Conversation." *Contact*, No. 25 (Autumn 1982).

Chan, Wing-Tsit, translator and compiler. *A Source Book in Chinese Philosophy*. Princeton: Princeton University Press, 1963.

Clarkson, Austin. "The Intent of the Musical Moment: Cage and the Transpersonal." In David W. Bernstein and Christopher Hatch, eds., *Writings Through John Cage's Music, Poetry, and Art*. Chicago: University of Chicago Press, 2001.

Coomaraswamy, Ananda K. *The Christian and Oriental Philosophy of Art*. New York: Dover Publications, 1956.

———. *The Dance of Shiva*. Bombay: Asia Publishing House, 1948.

———. *The Transformation of Nature in Art*. 1934. Reprint, New Delhi: Munshiram Manoharlal Publishers Pvt. Ltd., 1994.

———. "Why Exhibit Works of Art?" *Journal of Aesthetics and Art Criticism*, Vol. 1, No. 2/3 (Autumn 1941).

Duckworth, William. *Talking Music: Conversations with John Cage, Philip Glass, Laurie Anderson, and Five Generations of American Experimental Composers*. New York: Da Capo, 1999.

Eckhart, Meister. *Meister Eckhart: The Essential Sermons, Commentaries, Treatises, and Defense*. Translated by Edmund Colledge and Bernard McGinn. Mahwah, NJ: Paulist Press, 1981.

———. *Meister Eckhart: A Modern Translation.* Translated by Raymond B. Blakney. New York, Hagerstown, San Francisco, and London: Harper Torchbooks, 1941.

Feldman, Morton. *Give My Regards to Eighth Street: Collected Writings of Morton Feldman.* Cambridge, MA: Exact Change, 2000.

———. "H.C.E. (Here Comes Everybody)." Interview with Peter Gena. *TriQuarterly,* Vol. 54 (Spring 1982).

Ferrari, Luc. Interview with Dan Warburton. *ParisTransatlantic.com,* July 22, 1998, http://www.paristransatlantic.com/ magazine/interviews/ferrari.html (accessed Sept. 7, 2008).

Fetterman, William. *John Cage's Theater Pieces.* Amsterdam: Harwood Academic Publishers, 1996.

Fleming, Richard, and William Duckworth, eds. *Cage at 75.* Lewisburg, PA: Bucknell University Press, 1989.

Gann, Kyle. *Music Downtown.* Berkeley, Los Angeles, and London: University of California Press, 2006.

Gentry, Philip. "The Cultural Politics of 4′33″." In "The Age of Anxiety: Music, Politics, and McCarthyism, 1948–1954." PhD diss., UCLA, 2008.

Gillmor, Alan M. *Erik Satie.* New York and London: W. W. Norton, 1988.

Goldberg, Michael, producer. *A Zen Life—D.T. Suzuki.* DVD. Japan Inter-Culture Foundation, 2006.

Grant, Tina, and Jay P. Pederson, eds. "Muzak, Inc." In *International Directory of Company Histories,* pp. 353–56. Detroit: St. James Press, 1988.

Gross, Jason. "Rock/avant convergences of the '90s and beyond." *Perfect Sound Forever,* http://www.furious.com/ perfect/rockexp/rockavantproject.html (accessed April 14, 2009).

Guggenheim Museum. "Robert Rauschenberg." *Singular Forms*

(Sometimes Repeated): Highlights, http://pastexhibitions
.guggenheim.org/singular_forms/highlights_1a.html
(accessed April 14, 2009).

Harrison, Jonty. "Dilemmas, Dichotomies and Definitions:
Acousmatic Music and Its Precarious Situation in the Arts."
Paper presented at *SoundAsArt: Blurring of the Boundaries,*
University of Aberdeen, Nov. 26, 2006, http://www
.urbannovember.org/conference/viewpaper.php?id=31&cf=2
(accessed April 14, 2009).

Hicks, Michael. "John Cage's Studies with Schoenberg."
American Music, Vol. 8, No. 2 (Summer 1990).

Hopps, Walter. *Robert Rauschenberg: The Early 1950s.* Houston:
Fine Art Press, 1991.

Huang Po. *The Zen Teaching of Huang Po on the Transmission of
Mind.* Translated by John Blofeld. New York: Grove, 1958.

Huxley, Aldous. *The Perennial Philosophy.* New York: Harper,
1945.

Ives, Charles. *Essays Before a Sonata, and Other Writings.* New
York: Norton, 1962.

Joseph, Branden W. *Random Order: Robert Rauschenberg and
the Neo-Avant-Garde.* Cambridge, MA, and London: MIT
Press, 2003.

Kahn, Douglas. "John Cage: Silence and Silencing." *Musical
Quarterly,* Vol. 81, No. 4 (Winter 1997).

Katz, Jonathan. "Music and Aesthetics: An Early Indian Per-
spective." *Early Music,* Vol. 24, No. 3 (August 1996).

Katz, Vincent. "Black Mountain College: Experiment in Art."
In *Black Mountain College: Experiment in Art.* Cambridge,
MA, and London: MIT Press, 2002.

Kinkeldy, Otto, "Thomas Mace and His *Musick's Monument.*"
Bulletin of the American Musicological Society, No. 2 (June
1937).

Kitagawa, Joseph M. "Daisetz Teitaro Suzuki (1870–1966)." *History of Religions*, Vol. 6, No. 3 (February 1967).

Kostelanetz, Richard, ed. *Conversing with Cage*. New York: Limelight Editions, 1988.

———. *John Cage*. New York and Washington, D.C.: Prager, 1970.

Kotz, Liz. *Words to Be Looked At: Language in 1960s Art*. Cambridge, MA, and London: MIT Press, 2007.

Lanza, Joseph. *Elevator Music: A Surreal History of Muzak, Easy-Listening, and Other Moodsong*. New York: St. Martin's, 1994.

Lipsey, Roger. *Coomaraswamy*. Vol. 3, *His Life and Work*. Princeton: Princeton University Press, 1977.

Mace, Thomas. *Musick's Monument*. 1676. Paris: Editions du Centre National de la Recherche Scientifique, 1958.

McIntire, David. "A Sense of Community: Social Dimensions of the World Soundscape Project—The Music of R. Murray Schafer, Barry Truax and Hildegard Westerkamp." Unpublished paper, 2006.

Miller, Allan, director, and Vivian Perlis, writer. *"I Have Nothing to Say and I Am Saying It": A Film Biography of John Cage*. DVD. American Masters and The Music Project for Television, 1990.

Montague, Stephen. "John Cage at Seventy: An Interview," *American Music*, Vol. 3 (1985), p. 213.

Nicholls, David, ed. *The Cambridge Companion to John Cage*. Cambridge and New York: Cambridge University Press, 2002.

Ono, Yoko. *Grapefruit*. New York: Simon and Schuster, 1971.

Orledge, Robert. *Satie Remembered*. Portland, OR: Amadeus Press, 1995.

Patterson, David W., ed. *John Cage: Music, Philosophy, and Intention, 1933–1950*. New York and London: Routledge, 2002.

Patterson, Tom. "Life as Collage." *Duke University Alumni Magazine*, Vol. 86, No. 5 (Sept.–Oct. 2000), http://www.dukemagazine.duke.edu/alumni/dm30/collage.html (accessed April 14, 2009).

Perloff, Marjorie, and Charles Junkerman, eds. *John Cage: Composed in America*. Chicago: University of Chicago Press, 1994.

Pollak et al. v. Public Utilities Commission of the District of Columbia et al., 1951. Available at http://www.altlaw.org/v1/cases/773124.

Pritchett, James. *The Music of John Cage*. Cambridge: Cambridge University Press, 1993.

Ramakrishna, Sri. *The Gospel of Sri Ramakrishna*. Translated by Swami Nikhilananda. New York: Ramakrishna-Vivekananda Center, 1942.

Reich, Steve. "Music as a Gradual Process." In *Writings on Music, 1965–2000*. New York: Oxford University Press, 2002.

Revill, David. *The Roaring Silence: John Cage; A Life*. New York: Arcade, 1992.

Russolo, Luigi. *The Art of Noises*. New York: Pendragon, 1986.

Schaeffer, Pierre. *Traité des objets musicaux*. Paris: Editions du Seuil, 1966.

Schafer, R. Murray. *The Soundscape: Our Sonic Environment and the Tuning of the World*. Rochester, VT: Destiny Books, 1994.

Solomon, Larry J. "The Sounds of Silence: John Cage and 4′33″," http://solomonsmusic.net/4min33se.htm (accessed Apr. 14, 2009).

Strickland, Edward. *Minimalism: Origins.* Bloomington: Indiana University Press, 1993.

Suzuki, Daisetz. *Manual of Zen Buddhism.* New York: Grove, 1960.

Thoreau, Henry David. *The Journal of Henry D. Thoreau.* New York: Dover, 1962.

————. *The Portable Thoreau.* Ed. Carl Bode. New York: Viking, 1947.

————. *Walden.* In *The Portable Thoreau.* Ed. Carl Bode. New York: Viking, 1947.

Tomkins, Calvin. *The Bride and the Bachelors: Five Masters of the Avant-Garde.* Harmondsworth, England, and New York: Penguin, 1976.

Toop, David. *Haunted Weather: Music, Silence and Memory.* London: Serpent's Tail, 2004.

Warburton, Nigel. *Ernö Goldfinger: The Life of an Architect.* New York: Routledge, 2004.

Watts, Alan. *The Way of Zen.* New York: Vintage, 1957.

Wilhelm, Richard, trans. *The I Ching or Book of Changes.* Princeton: Princeton University Press, 1950.

Wright, Richard. *Haiku: This Other World.* New York: Arcade, 1998.

Young, La Monte, ed. *An Anthology of chance operations concept art anti-art indeterminacy improvisation meaningless work natural disasters plans of action stories diagrams Music poetry essays dance constructions mathematics compositions.* New York: La Monte Young and Jackson MacLow, 1963.

Index

Page references in italic type refer to illustrations.

Absolute, 105
Abstract Expressionism, 61–62,
 108, 110, 113, 156, 157
acousmatic music, 201–3, 204
acoustic ecology, 203
Adams, John, 200
Aeschylus, *The Persians*, 43
Aesthetic Emotion, 95
affective athleticism, 8
Ajemian, Maro, 70
Albers, Anni, 109, 153
Albers, Josef, 109, 153
Alignment (electronic duo), 190
Allais, Alphonse: "Anaemic
 Young Girls Going to Their
 First Communion through a
 Blizzard," 118–19; "Apoplectic
 Cardinals Harvesting Toma-
 toes on the Shore of the Red

Sea (Study of the Aurora
 Borealis)," 119; *Funeral March
 for the Obsequies of a Deaf
 Man*, 118; "Negroes Fighting
 in a Cave at Night," 119
Altieri, Jim, tattoo of, *212*
ambient sounds: accidental, 4;
 and acousmatic music, 201–3,
 204; in anechoic chambers,
 161–62; as the Deity, 144;
 during *4′33″* performance,
 3–4, 16, 28, 141, 144–45, 168,
 186, 188, 191, 194–95, 201, 211,
 213; environmental, 27–28;
 Huxley on, 136–37; industrial,
 204; as music, 11; of nature,
 82–83, 116–17; sensed phe-
 nomenon of, 141, 143–44; in
 Silent Prayer, 127; and tech-

Index

ambient sounds (continued)
nological developments, 201;
in twentieth-century music,
195; urban, 84, 204; *see also*
sound
AMM group, 190
anechoic chamber, 160–66
Antheil, George, 26, 27; *Ballet
mécanique*, 50
Aquinas, St. Thomas, 93, 94,
224–25n41
Ardévol, Jose, *Preludio a II*, 62
Armory Show (1913), New
York, 86
Arp, Hans, 16
art: color in, 109–10, 156–57;
conceptual, 193, 198–99; dif-
fering concepts of, 15, 20;
framing of, 20, 195; Hud-
son River School, 22–23, 28;
human personality in, 91–92;
for the intellect, 92–93, 94;
and nature, 93, 94; non-art
vs., 20; and perception, 20,
87; representational, 90, 92,
110; self-expression in, 91–92,
94; as separate from life,
94; sound as, 20, 203–4; and
style, 91–92; Zen in, 148
Artaud, Antonin, 71; *Le théâtre
et son double* (The Theater
and Its Double), 8, 154
Art Digest, 158
Artists Welfare Fund, 5
Asian philosophy: Buddhism,
29, 98, 105, 141–42; *see also*
Zen; and Coomaraswamy,
67, 94, 98; mysticism, 29,

140; *rasas* in, 94–97; and
religious mysticism, 124; and
Sarabhai, 67, 124

Babbitt, Milton, 21, 113; *Philo-
mel*, 212
Bach, Johann Sebastian, 42
Balilla Pratella, Francesco,
Musica futurista, 82
Ball, Hugo, 16
Bartók, Béla, 46
Basho, Matsuo, 139
Batt, Mike: "A Minute's
Silence" (Batt/Cage), 205;
The Planets: Classical Graffiti,
205
Bauhaus school, 60–61
BBC Symphony Orchestra,
14–15, 168
Beach, Amy, 25
Beethoven, Ludwig van, 37, 79,
80, 153
Bernstein, Leonard, 208
Berry, Wendell, 116
Billings, William, "Jargon," 23
Bird, Bonnie, 49
Black Mountain College:
Cage's "Defense of Satie"
lecture at, 53–54, 72, 73, 79–
80, 153; Cage's visits to, 111,
153–55, 165; Rauschenberg at,
109, 110–11, 154, 155; Tudor
on faculty of, 9, 153–54
Blyth, Reginald Horace, 99,
124–25; haiku translated by,
29, 125, 139–40; on sensory
phenomena, 143–44; on
spontaneity, 148; *Zen in En-*

glish Literature and Oriental Classics, 67–68, 125
Bodhidharma, 138
Bollingen Press, 149
Boston Museum of Fine Arts, 88
Boulez, Pierre, 21; First Piano Sonata, 7; *Le Marteau sans maître*, 212; "Schoenberg Is Dead," 172; Second Sonata, 8, 9–10; and total serialism, 172–73, 193
Boy Scouts of America, 39
Brahms, Johannes, 44
Brecht, George, 185, 193
Bristow, George Frederick, 24
Brooks, William, 117, 126–27, 165
Brown, Earle, 5, 148, 191
Brown, Norman O., 72
Bryars, Gavin, 77
Buddhism, 29; First Noble Truth of, 141; Fourth Noble Truth of, 142; Mahayana, 98, 105; Second Noble Truth of, 141–42; Third Noble Truth of, 142; *see also* Zen
Buhlig, Richard, 45
Burton, Harold, 132
butterflies, release of, 196

Cage, Gustavus Adolphus, 36
Cage, Hy, 120
Cage, John, *155*; on art as imitation of nature, 93; awards and honors to, 5, 39; birth of, 37; celebrity of, 208–9; chance methods used by, 5,

10, 21, 115, 138, 147–48, 170, 173, 199–200; childhood of, 37–39; as composer-in-residence, 209; composition methods of, 152–53, 169–70, 172, 174–76; compositions by, *see* Cage, John, works of; death and eulogies, 17, 209–11; early musical interest of, 38–39, 43; emotional crisis of, 65–67, 137; European travel of, 41–43; family background of, 36–37; festivals devoted to music of, 209; finances of, 13–14; influence of, 10–11, 33, 69, 97, 107, 108, 192, 193, 194–95; influences on, 27, 29, 42, 71–72, 82, 85–86, 97–99; jobs held by, 43, 47, 49, 59, 61; lectures by, *see* Cage, John, lectures of; lifelong output of, 14; marriage to Xenia, 48–49, 64; mathematical techniques of, 44–45, 52; personal traits of, 32–33, 35, 36, 108; prepared piano devised by, 7, 9, 50, 57–58, *58*, 64, 169; reputation of, 9, 10, 68, 71, 191, 205, 207; on social philosophy, 207; teen years of, 39–41; tinnitus of, 164
Cage, John, lectures of, 35, 65; "A Composer's Confessions" (Vassar lecture), 82, 125–27, 176; "Composition as Process" (Darmstadt lectures), 145, 193; "Defense of Satie,"

Cage, John (continued)
53–54, 72, 73, 79–80, 153;
"Experimental Music," 162;
"45' for a Speaker," 72, 159;
"History of Experimental
Music in the United States,"
146; *I–VI: The Harvard Lec-
tures*, 174–75, 207, 208; at
Juilliard, 103; "Lecture on
Nothing," 68, 145, 163; "Lec-
ture on Something," 98, 115;
on Pan American relations
(1928), 39–40, 137
Cage, John, works of: *Amores*,
62; "An Autobiographical
Statement," 165; *Aug. 29,
1952*, 4; *Cheap Imitation*, 74;
Concerto for Prepared Piano
and Orchestra, 170, 172; *Con-
struction in Metal*, 62; *Credo
in US*, 56–57; *Daughters of
the Lonesome Isle*, 65; *Double
Music* (with Harrison), 60;
Dream, 69; "The East in the
West," 96, 97–98; *Empty
Words* (book), 207; *Etcetera*,
27; in eulogies, 209–11; *Eur-
operas*, 207–8; *Experiences
No. 1*, 69; *Experiences No. 2*,
69, 127; *First Construction in
Metal*, 52–54; *4'33"*; see *4'33"*;
The Freeman Etudes, 207;
Imaginary Landscape No. 1,
52, 56–57; *Imaginary Land-
scape No. 3*, 62; *Imaginary
Landscape No. 4*, 126; "The
Immaculate Medawewing"
(short story), 40–41; *In a

Landscape*, 69, 81; legacy of,
97, 206–7; *M* (book), 207;
Music of Changes, 10, 13, 14,
54, 152, 168, 172, 173–75, 178,
200; "On Robert Rauschen-
berg," 158–60; percussion
in, 10, 50–52, 55, 56–57, 59,
60, 169; *The Perilous Night*,
65, 66, 94; *Renga with Apart-
ment House 1776*, 207; *Root
of an Unfocus*, 65; *Score*, 27;
The Seasons, 69, 169–70; 74,
208; *Silence* (book), 17, 55,
97, 98–99, 115, 145, 147, 165,
193, 194, 199, 207; silence in,
126–27; *Silent Prayer*, 126–27,
128, 132–33, 135, 163; "Silent
Sonata," 163; Six Melodies
for violin and piano, 69;
Sixteen Dances, 96, 170, 172;
Sonata for Clarinet, 45;
Sonatas and Interludes, 70,
96, 165, 168; String Quar-
tet in Four Parts, 69, 170,
171; *Theater Piece No. 1/Black
Mountain Piece*, 154; Three
Dances for two amplified
prepared pianos, 69; "time
bracket" or "number" pieces,
208; *Tossed as It Is Untroubled*,
65; *A Valentine Out of Season*,
65; *Water Music*, 4–5, 155,
183, 185; *Works of Calder* (film
score), 5; *X* (book), 207;
A Year from Monday article/
book, 173, 207
Cage, John Milton (father),
36–37, 71

Cage, Lucretia "Crete" Harvey (mother), 36–37, 38, 190–91

Cage, William, 36

Cale, John, 77

Cameron-Wolfe, Richard, 77

Campbell, Joseph, 62, 71, 89, 99

Cardew, Cornelius, 149

Cardinell, Richard, 129–30

Carl Fischer Concert Hall, New York, 190–91

Carpenter, John Alden: *Krazy Kat*, 26; *Skyscrapers*, 26

Carus, Paul, 102

Castelli, Leo, Gallery, New York, 112

Chamillionaire, 206

chance methods: Cage's use of, 5, 10, 21, 115, 138, 147–48, 170, 173, 199–200; gamut technique, 169–70, 172, 174; and the *I Ching*, 151–53, 199; imperfections in a sheet of paper, 199; as impersonal process, 200; randomness, 198, 200; and Tarot cards, 175–76

Chao-chao, 138–39

chaos: of Dada movement, 16; in music, 21

Chicago Tribune, 210–11

Chopin, Frederic, 24

Church, Frederic E., 23, 28

Ciccone Youth, *The Whitey Album*, 205

Clarkson, Austin, 123

Cocteau, Jean, 56

Cole, Thomas, 22

Contrepoints magazine, 77

Converse, Frederick Shepherd, *Flivver Ten Million*, 26

Coomaraswamy, Ananda K., 71, 88–98; Cage's "creative misreading" of, 90–91, 94; *The Dance of Shiva*, 67; family background and early years of, 88–89; on Indian art, 29; influence of, 97–98, 122; on mimesis, 93; Perennial Philosophy of, 92; on *rasas*, 94–97; on representational art, 90, 92; *The Transformation of Nature in Art*, 67, 98

Cooper, James Fenimore, *The Last of the Mohicans*, 23

Copland, Aaron, 27, 208

Cornell, Joseph, 61

Corner, Philip, 77

Cornish School, Seattle, 49–50

Covenant (band), *United States of Mind*, 205

Cowell, Henry, 28, 68; *Aeolian Harp*, 57; *The Banshee*, 7–8, 45–46, 57; Cage as student of, 26, 27, 46–47, 49, 192; *New Musical Resources*, 25–26; New Music Editions, 45, 46; *Ostinato Pianissimo*, 62; *The Tides of Mananaun*, 45; and tone clusters, 45, 46; unconventional piano pieces by, 45–46, 60

Cramps label, 189

Crawford, Ruth, 46

Crehan, Hubert, 158

Cropsey, Jasper, 23, 28

Cunningham, Mercier (Merce), 50, 62, 112; at Black Mountain, 111, 153; dance company of, 64, 74, 127, 154, 207; friendship with Cage, 64
Cuomo, James, 77

Dada, 5, 16–17, 144, 206; and Fluxus, 193; and Satie, 16, 74, 78
Darmstadt International Summer Courses for New Music, 193
Darmstadt lectures, 145, 193
Debussy, Claude, 74
Deep Listening Band, 190
Del Tredici, David, 77
Dennison, Doris, 50
Dewey, John, 153
Dhomont, Francis, 201
Dillon, Fannie Charles, 38
Douglas, William O., 132
Driver, Paul, 211
Duchamp, Marcel, 71, 85–88, 93; chess lessons from, 87–88; and Dada, 74; *Fountain*, 87; *L.H.O.O.Q.*, 87; *Musical Erratum* (with his sisters), 87; *Nude Descending a Staircase, No. 2*, 86; "ready-mades," 87
Duchamp, Teeny, 86
Duckworth, William, 186
duhkha (life as frustration), 141
Dvořák, Antonin, *New World Symphony*, 25

EAR magazine, 198
Eckhart, Meister, 71, 98–102; background of, 99; charge of heresy against, 101; "Dear God" passage of, 99–100; influence of, 67, 100–101; "Talks of Instruction" from, 102; on unity of human and divine, 99, 100
Egan, Charles, 110
EMI label, 205
Emmerson, Simon, 201
empathy, 95
enlightenment, 142
environmental soundscapes, 203–4
Erdman, Jean, 9, 62
Ernst, Max, 61
Etude, The, cartoon, *119*, 120
Expositions des arts incohérents, 120

Farolino, Audrey, 210
Farwell, Arthur, 25
Feldman, Morton, 8, 33, 72, 88, 112–15; death of, 208; *Extensions #3*, 5, 6, 7; friendship of Cage and, 113, 148; influence of, 108, 114; *Intersections*, 115; as intuitionist, 114; *Projections*, 115; String Quartet II, 114
Fergusson, James, 89
Ferrari, Luc, *Presque rien no. 1*, 201
Fetterman, William, 165, 175
50 Cent (performer), 206
First Amendment: and forced listening, 133; and free speech, 130

Index

Fleming, Ian, 42
Fluxus, 185, 193, 194, 196
Fort, Syvilla, 50, 57
4'33": ambient sounds heard
during performance of, 3–4,
16, 28, 141, 144–45, 168, 186,
188, 191, 194–95, 201, 211, 213;
in American cultural history,
22–28, 195–96; and audience
expectations, 17, 168, 191–92;
audience reactions to, 4, 12,
19; as cell phone ringtone,
205–6; chance procedure
in, 200; critical reactions
to, 18–19, 192, 209–11, 213;
as Dada, 16–17; dedication
of, 106; effect of, 20; events
leading to composition of,
14, 16, 22, 28, 59, 82, 95–97,
121, 160; as *45"18"*, 190; and
gamut concept, 169–70; and
haiku, 140–41; as hoax, 11–12,
15; as iconic work, 195; in-
come from, 12–13; influence
on later music, 10–11, 15, 30–
31, 194–201, 204–5; as joke,
15–16, 30, 118–20; legacy of,
206–7; length of, 128, 176–78,
181, 183, 185–86; in live per-
formances, 3–4, 141, 205; and
Music of Changes, 54, 152–53,
168, 174–75, 178, 200; New
York City premiere of, 190–
91; nonmusical performances
of, 196; notations of, 167, 179,
182, 185; original manuscript
of, 11; parallel creations, 87;
as philosophical idea of, 188,
209, 211; premiere of, 2–4,
7, 10, 12, 27, 28, 166, 178–79,
183, 186, 210–11; public re-
actions to, 10–11, 14–15,
212–13; recordings of, 188–90,
195, 215–17; redefinition of,
183, 185, 187; scores for, 11,
177–79, *180*, 181–83, *182*, *184*,
185, 196; silent performer
in, 19; and *Silent Prayer*,
127, 163; sonic identity of,
17, 203; *tacet* appearing in,
182–83, 185, 196; in tattoo,
212; as theater, 17–19, 188–89;
as thought experiment, 20;
three movements of, 4, 11,
16, 54, 167–68, 174, 176, 183,
200; as ultimate expression
of tranquility, 97; writing of,
152–53, 166, 168–70, 174–77;
and Zen, 4, 21–22, 104–5,
144, 206, 211
4'33" (No. 2); also 0'00", 196
frame, shifting of, 195, 197
framing, 11, 20
Frankfurter, Felix, 132
Fry, William Henry, 24
Fuller, Buckminster, 72, 207

gamut technique, 169–70, 172,
174
García Caturla, Alejandro, 51
Gena, Peter, 65, 137, 164
Geological Survey of Ceylon,
88
Germany: Bauhaus in, 60–61;
Nazi government in, 47, 60,
153

Glass, Philip, 200; *Einstein on the Beach*, 212
Goldfinger, Ernö, 41–42
Górecki, Henryk, 200
Gorky, Arshile, 61
Gottschalk, Louis Moreau, 24
Graham, Martha, 49, 62
Graves, Morris, 89
Great Depression, 27, 43, 59
Grieg, Edvard, 38
Guggenheim, Peggy, 61, 62, 85
Guggenheim Museum, New York, 156

haiku, 29, 125, 139–41
Hansen, Al, 193
happenings, 154, 165
Harrison, Jonty, 202, 204
Harrison, Lou, 28, 29, 49, 60, 67; at Black Mountain, 153; *Canticle*, 62; *Counterdance in the Spring*, 62; and Mace, 122, 123; Six Sonatas for Cembalo or Pianoforte, 70
Harvard University: anechoic chambers, 160–61, 165; Charles Eliot Norton Lectures, 208; *I–IV*, Cage's lectures in, 174–75, 207, 208
Hawthorne, Nathaniel, *The Scarlet Letter*, 23
Heade, Martin Johnson, 23
Heinrich, Anthony Philip, 24
Higgins, Dick, 193
Hindemith, Paul, 42, 208
Hindu mysticism, 29
Hines, Thomas, 65
hoax, definitions of, 11–12

Hochheim, Eckhart von, 99; *see also* Eckhart, Meister
Holzaepfel, John, 178
Hopps, Walter, 110–11
Hovhaness, Alan, 28, 60, 68
Huang-Po, 71, 143; *The Doctrine of Transmission of Mind*, 67
Hudson River School, 22–23, 28
Hui-neng, 142
Huxley, Aldous, 29, 98; on noise, 136–37; *The Perennial Philosophy*, 67, 124, 135, 137–38

I Ching, 148–53; Cage's uses for, 106, 151–52, 172, 176, 199; divination in, 149–50; and gamut method, 174; hexagram 55, "Feng/Abundance," 150–51; and *Music of Changes*, 152, 175; as random number generator, 151–53, 199; structure of, 149; thinking behind, 150; translation of, 149; and the writing of *4′33″*, 152–53, 176–78
Ichiyanagi, Toshi, 193, 196
Institute of Design, Chicago, 61
Italian Futurists, 82, 204
Ives, Charles, 26, 37, 46, 49; *Essays Before a Sonata*, 116

Jacob, Max, 75
Japan, philosophy from, 29
Jewish Museum, 112
John Cage Trust, 188
John of the Cross, Saint, 135
Johns, Jasper, 108
John XXII, Pope, 101

Jung, Carl, 103; *The Integration of the Personality*, 67

Kafka, Franz, 148
Kahn, Douglas, 18–19, 39, 135, 137, 141
Kant, Immanuel, 141
Kaprow, Allan, 193
Kashevaroff, Xenia, 48–49, 51, 64
Keats, Jonathan, 205–6
Kline, Franz, 110
koans, 138–39, 142, 145
Koch International label, 189
Kooning, Willem de, 20, 110, 146
Kootz, Samuel, 110
Korm Plastics label, 190
Kostelanetz, Richard, *John Cage*, 40
Kotz, Liz, 185, 195–96
Kremen, Irwin, 106–7, 111, 179, 181
Kwang-Tse, 71

Lanza, Joseph, 132
Lao Tzu, 136
Law, William, 135–36
League of Composers, 63
Lebel, Robert, 86
Leger, Fernand, 75
Lennon, John, 30, 196
Leonardo da Vinci, *Mona Lisa*, 87
Life, 9, 63
Lippold, Richard, 33
London *Independent*, 211
Luening, Otto, 201

Mace, Thomas, 122–24; *Musick's Monument*, 123
MacLow, Jackson, 193
Magnetic Fields, *The Wayward Bus/Distant Plastic Trees*, 205
Mahayana Buddhism, 98, 105
Marinetti, Filippo Tommaso, 82
Matta, Roberto, 62
Maverick Concert Hall, Woodstock, New York, 1–2, *2*, *3*; ambient sounds of, 141; benefit concert in, 13; premiere of *4'33"* in, 2, 7, 10, 166; program of 1952 concert, 4–8, *6*
McCann, Dick, 134
McLellan, Joseph, 209
McLuhan, Marshall, 72, 207
McPhee, Colin, 29
Melville, Herman, *Moby Dick*, 23
Mendelssohn, Felix, 24
Menil Collection, 110
Mens, Radboud, 190
Merce Cunningham Dance Company: Cage as music director of, 64; Cage's compositions for, 74, 127, 207; and happening (1952), 154
Messiaen, Olivier, *Turangalîla*, 212
Milhaud, Darius, 75–76
minimalism, 190, 199–201; Cage as influence on, 69, 97, 195; and *4'33"*, 21, 195, 199, 200, 201; as international movement, 200; postminimalism, 69; and Rauschenberg's work, 156

Mitropoulos, Dimitri, 112
Modern Music, Cage as critic for, 61
Moholy-Nagy, László, 60, 61
Mondrian, Piet, 62
Monk, Meredith, 200
Moore, Thurston, 190
Motherwell, Robert, 62
Mozart, Wolfgang Amadeus, 37, 42
Museum of Modern Art, New York, Cage's concert in, 9, 62–64, 85
Music & Arts label, 189
music: acousmatic, 201–3, 204; affective athleticism in, 8; American, 22, 23–28; atonal, 44; audience expectations for, 144, 168; background, 127–34; boundaries dissolved in, 195; Cage's four-part division of, 53–54, 79; chance methods used in composition of, 5, 10, 21, 115, 138, 147, 170, 173; chaos in, 21; commissioned, 13; communication in, 54, 66; content (form) in, 53, 54; Cuban, 51; defined by words alone, 196–97; dissonance vs. consonance in, 55; as environmental sound, 74–76; ethnomusicologists, 46; expanding definitions of, 197, 198; functions of, 122, 123, 144; gamut technique in, 169–70; happenings, 154, 165; harmony in, 33–34, 50, 79, 82; hyper-

structured, 21; income from, 13; isorhythmic motets, 81; macro-microcosmic rhythmic structure in, 52–54, 81, 172; materials in, 53, 54–55; melody and harmony in, 50; method and continuity in, 53; microtonality in, 60; of nature, 28; New Age, 69; originality in, 54; parallel fifths, 38; percussion in, 10, 43, 50–52, 55, 56–57, 59, 60, 62–64; played with palm or forearm, 45; political, 149; pop culture, 204–5; reasons for composing, 13; relationship of performers and audience in, 18; rhythm, dynamics, and timbre in, 21, 27; separation of processes in, 199–200; shape-note singing, 23; sound as, 11, 16, 55, 82–85, 94, 197; structure in, 53–55, 79–82, 167; technological advances in, 195; time constraints on, 128; tone clusters, 45–46; total serialism in, 172–73, 193; transposition of, 169; twelve-tone, 7, 21, 44, 112, 114, 172; and Zen, 144
musique concrète, 201, 204
Mutt, R. (Duchamp), 87
Muzak, 127–34, 176; creation of, 128; expansion of, 128, 129; features of, 129–30; forced listening to, 131–33, 163; generic use of term, 129; hearings against, 130–

32; reputation of, 127–28, 129; and Satie's *Musique d'ameublement*, 76, 134; and "Silent Prayer" idea, 126, 127; workplace use of, 129

mysticism, 29, 140

Nam June Paik, 193

Nancarrow, Conlon, 132

nature: and art, 93, 94; imitation of, 22, 27, 94; music of, 28; and randomness, 198; sounds of, 82–83, 116–17

New Age music, 69

Newport, Rhode Island, synagogue in, 165

New School for Social Research, 47, 107, 185, 192–93

New York Newsday, 210

New York Post, 133–34, 192, 210

New York Times, 192, 211

Nielsen, Carl: *Humoreske*, 51; Sixth Symphony, 50–51

noise, *see* ambient sounds; sound

O'Keeffe, Georgia, 89

Oliveros, Pauline, 190

Ono, Yoko, 30, 196; *Fly*, 197; *Grapefruit*, 197; "Toilet Piece/Unknown," 197; "Two Minutes Silence" (with Lennon), 197; *Unfinished Music No. 2: Life with the Lions* (with Lennon), 197

Page, Tim, 210

Paik, Nam June, 193

Pan American Association of Composers, 46

Pan-American relations, Cage's youthful address (1928) on, 39–40, 137

paradox: of Dada movement, 17; of nothing, 145

Parsons, Betty, 110, 111, 157

Pärt, Arvo, 200

Partch, Harry, 28–29, 60

Patchen, Kenneth, 61

Patterson, David W., 34, 67, 89, 103, 165

Peters, C. F., 177, 179, 182, 184, 196

Piaf, Edith, 154

Picabia, Francis, 74

Plato, 90, 91

Polignac, Princess Edmond de, 74

Pollock, Jackson, 62, 110

Pomona College, Cage as student in, 40–41

Pop Art, 108

pop music culture, 204–5

postminimalism, 69

Poysden, Mark, 190

Pritchett, James, 173

Public Utilities Commission, D.C., 130

Pythagoras, 202

Rachmaninoff, Sergei, Romantic Symphonic Dances, 112

Ramakrishna, Sri, 68, 71, 146; *The Gospel of Sri Ramakrishna*, 124

randomness, *see* chance methods
rasas, 94–97, 138
Rauschenberg, Robert, 71, 107, 108–12; background of, 108–9; at Black Mountain, 109, 110–11, 154, 155; Black Paintings, 157; Cage's article about, 158–60; collage style of, 108, 110; on color, 109–10; critical reactions to work of, 158; *Crucifixion and Reflection*, 157; *Mother of God*, 157; White Paintings, 111, 121, 154, 155–60, 181
Ray, Man, 74
Reich, Steve: *Come Out*, 199; *It's Gonna Rain*, 199; and minimalism, 199, 200; *Piano Phase*, 200
Renaissance, 122
Revill, David, 65, 104, 175
Reynolds, Roger, 134
Rhein, John von, 211
Richards, M. C., 107, 154
Riegger, Wallingford, 46
Riley, Terry, 200
Rilke, Rainer Maria, 66
Rockefeller Foundation, 103
Rockwell, John, 211
Roldan, Amadeo, *Rítmicas V* and *VI*, 51, 62
Roosevelt, Franklin D., 59
Rothstein, Edward, 17
Roussel, Albert, 74
Rowe, Keith, 190
Rudy, Paul, 204

Ruggles, Carl, 46
Russell, William, 60
Russolo, Luigi, 18, 82–85, 202–3; The Art of Noises (*L'arte dei rumori*), 55, 82
Rzewski, Frederic, 149

Saint-Saens, Camille, 75
Salon des Indépendants, 86
Sarabhai, Gita, 67, 72, 122, 123, 124
Satie, Erik, 60, 68, 71, 72–82, 73; Cage's lecture/defense of, 53, 72, 73, 79–80, 153; and Dada, 16, 74, 78; *Embryons desséchés*, 74; *Entr'acte* (film), 81; *Gymnopédies*, 69, 73–74; *Musique d'ameublement*, 74–76, 134; *Parade*, 74; *Relache*, 74, 81; *Socrate*, 74, 81, 96–97; *Sonatine bureaucratique*, 74; *Vexations*, 76–78, 78
Schaeffer, Pierre: and acousmatic music, 201–2; *Etude aux chemins de fer*, 201, 202
Schafer, R. Murray, 203–4; as father of acoustic ecology, 203; *Music for Wilderness Lake*, 203; *Patria*, 203
Schoenberg, Arnold, 44–45, 71; Cage's study with, 33–34, 46, 47–48, 104, 149; Opus 11 piano pieces, 45; Second String Quartet, 44; and serial style, 57; and twelve-tone idiom, 7, 21, 34, 44, 172
Schumann, Robert, 24

Scriabin, Alexander, 42
Seattle Sonic Arts Society, 55
sensed phenomenon, 141, 143–44
Shakespeare, William, *Hamlet*, 125
Shaku Soen (Soyen), 102
Shimizu, Jio, 190
Shingyo sutra, 105
Shostakovich, Dmitri, Fifth Symphony, 57
silence: of anechoic chamber, 160–66; electronic metaphors for, 190; of gay men, 220n18; no such thing as, 160, 163, 164, 165, 206; structured by time lengths, 80, 82; as ultimate expression of tranquility, 97; virtual, 164
Simonetti, Gianni-Emilio, 189
Smalley, Denis, 201
Snyder, Ellsworth, 4
Solomon, Larry J., 165, 175, 177, 178
Sonic Youth, 190
sound: ambient, *see* ambient sound; appreciated for its own phenomenological qualities, 203; as art, 20, 203–4; bodily production of, 164; electronic, 56, 61; framing, 11, 20; as music, 11, 16, 55–56, 82–85, 94, 197; quiet, 68–69; repetitive, 198; silence vs., 80, 165; static, 198; steady, unchanging, 198; structure of, 80; technological advances

in, 195; of vinyl recordings, 190
soundscape composers, 203–4
Source magazine, 179, 181
spontaneity, 148, 175
Squier, George Owen, 128
Stable Gallery, New York, 156
Start Mobile, 206
Stein, Gertrude, 40, 71
Steinberg, Julie, 189
Stevens Institute of Technology, New Jersey, 129
Stieglitz, Alfred, 89
Still, Clyfford, 110
Stockhausen, Karlheinz, 21, 193; *Gruppen*, 212
Stony Point, 14
Stravinsky, Igor, 42, 208; *Le sacre du printemps*, 3; *Les noces*, 50
Supreme Court, U.S., 131–32
Suzuki, Daisetz Teitaro, 71, 98, 99, 102–6; background of, 102; Cage's studies with, 145, 147; Columbia lectures of, 104, 137, 146–47; on emptiness, 105; and haiku, 140; *Manual on Zen Buddhism*, 105; reputation of, 103

Taoism, 138
Tarot cards, Cage's use of, 175–76
Täuber, Sophie, 16
Tenney, James, 77, 108
Thomas, Ambroise, 75
Thomson, Virgil, 60, 68

Index

Thoreau, Henry David, 71, 115–18, 213; "Civil Disobedience," 116; *Journal*, 116, 117, 118; *Walden*, 117
"Three Minutes of Silence" (juke box), 133–34
tinnitus, 164
Toop, David, 204
Truax, Barry, 204
Tudor, David, 62, 72, 106, 114, *155*; background of, 8; at Black Mountain, 9, 153–54; as composer, 9; and Darmstadt courses, 193; European tour of, 192; *4′33″* reconstructed by, 178, *180*, 183, 185; friendship of Cage and, 9–10, 148; and Maverick 1952 concert, 4–8, *6*, 155, 178, 183; and New York premiere of *4′33″*, 192; performance skills of, 10; and premiere of *4′33″*, 2–4, 10, 12, 166, 178–79, 183, 186, 210–11; and premiere of *Music of Changes*, 10; reputation of, 8–9; and Satie's music, 77
twelve-tone idiom, 7, 21, 34, 112, 114, 172
Tzara, Tristan, 16, 74

Ussachevsky, Vladimir, 201

Varèse, Edgard, 26, 27, 46; *Ionisation*, 51
Vassar College, Cage's lecture at, 82, 125–27, 176
Venice Biennale (1964), 112
Village Voice, 209

visual education, 92–93
Voice Crack (duo), 190

Washington, George, 36
Washington Post, 209
Watts, Alan, 71, 99, 138, 141, 147
Webern, Anton, 79, 80–81; Symphony, 112
Weiss, Adolph, 46
Werfel, Franz, 148
Wesleyan University, Cage as fellow of, 194
Westercamp, Hildegard, 204
White, Hervey, 1
Wilhelm, Richard, 149
Winslow, Richard K., 194
Wired Radio, 128; *see also* Muzak
Wolff, Christian, 72, 77, 108; *For Prepared Piano*, 6, 7; and the *I Ching*, 148–49; and Maverick program, 5, 6, 7
Wolff, Helen, 148, 191, 192
Wolff, Kurt, 148, 149
Wolpe, Stefan, 8, 113; *Enactments*, 212
Woodstock Artists Association, 5
Works of Calder (film), 5
Works Projects Administration (WPA), 59
World Parliament of Religions (1893), 102
World Soundscape Project/ World Forum for Acoustic Ecology, 203
Wright brothers, 128

Yates, Peter, 35, 47–48
Young, La Monte, 193, 196,
 197–98, 200; B and F-sharp,
 198

Zappa, Frank, *A Chance Opera-
 tion—The John Cage Tribute*,
 189–90
zazen, 138, 142, 143, 144
Zen: answer in the question,
 106; beginnings of, 138; and
 Blyth's writings, 67–68, 125;
 Cage's interest in, 10, 29, 33,
 35, 68, 78, 94, 99, 134–48;
 dualities dissolved in, 163;
 and Eckhart's thought, 100;

and enlightenment, 142; in
 4'33", 11, 21–22, 104–5, 144,
 206, 211; in great art, 148;
 and *koans*, 138–39, 142, 145;
 and meditation, 138, 142, 168,
 198; and mondos, 139; and
 music, 144; and mysticism,
 140; and *rasas*, 94–97, 138;
 reality as illusion in, 141;
 response to anechoic cham-
 ber, 162; and satori (enlight-
 enment), 138; *Shingyo* sutra,
 105; and Suzuki's teachings,
 102–6
Zhuangzi, 146
Zukofsky, Paul, 207